Title Sequences as Paratexts

In his third book on the semiotics of title sequences, *Title Sequences as Paratexts*, theorist Michael Betancourt offers an analysis of the relationship between the title sequence and its primary text—the narrative whose production the titles credit. Using a wealth of examples drawn from across film history—ranging from *White Zombie* (1931), *Citizen Kane* (1940), and *Bullitt* (1968) to *Prince of Darkness* (1987), *Mission: Impossible* (1996), *Sucker Punch* (2011), and *Guardians of the Galaxy, Vol. 2* (2017)—Betancourt develops an understanding of how the audience interprets title sequences as instances of paranarrative, simultaneously engaging with them as both narrative exposition and as credits for the production. This theory of cinematic paratexts, while focused on the title sequence, has application to trailers, commercials, and other media as well.

Michael Betancourt is an artist/theorist concerned with digital technology and capitalist ideology. His writing has been translated into Chinese, French, Greek, Italian, Japanese, Persian, Portuguese, and Spanish, and published in magazines such as *The Atlantic, Make Magazine, Millennium Film Journal, Leonardo, Semiotica*, and *CTheory*. He wrote *The _____ Manifesto*, and other books such as *The Critique of Digital Capitalism, The History of Motion Graphics, Semiotics and Title Sequences, Synchronization and Title Sequences, Glitch Art in Theory and Practice*, and *Beyond Spatial Montage: Windowing*. These publications complement his movies, which have screened internationally at the Black Maria Film Festival, Art Basel Miami Beach, Contemporary Art Ruhr, Athens Video Art Festival, Festival des Cinemas Differents de Paris, Anthology Film Archives, Millennium Film Workshop, the San Francisco Cinematheque's Crossroads, and Experiments in Cinema, among many others.

Routledge Studies in Media Theory & Practice

Title Sequences as Paratexts

Narrative Anticipation and Recapitulation

Michael Betancourt

Routledge
Taylor & Francis Group

NEW YORK AND LONDON

First published 2018
by Routledge
711 Third Avenue, New York, NY 10017

and by Routledge
2 Park Square, Milton Park, Abingdon, Oxon OX14 4RN

*Routledge is an imprint of the Taylor & Francis Group, an
informa business*

The periodizing framework for the history of title
sequences is adapted from my book *The History of Motion
Graphics: From Avant-Garde to Industry in the United
States*, published by Wildside Press in 2013.

The discussion of *Bullitt* in Chapter 6 was adapted from
"Pablo Ferro's Title Montage for Bullitt (1968): The
Criminality Beneath the Surface of Civil Society," in *Bright
Lights Film Journal*, April 29, 2014.

Library of Congress Cataloging-in-Publication Data
A catalog record for this book has been requested

ISBN: 978-1-138-57262-1 (hbk)
ISBN: 978-0-203-70103-4 (ebk)

Typeset in Times New Roman
by Apex CoVantage, LLC

For Leah

Contents

Figures

Acknowledgements

This book would not have been possible without the discussions with my students, especially Noël Anderson, Dominica Jordan, Kalin Fields, Joel Desmond, Madeline Miller, and JungWoo Lee. Special thanks go to my brother, John Betancourt, for his assistance with locating many of the title sequences that inform this study.

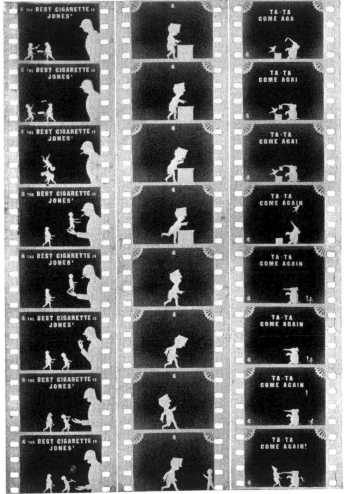

THE POSSIBILITIES OF TRICK SILHOUETTE CINEMATOGRAPHY.

1.
A quaint advertisement film.

2.
Mr. Asquith in cartoon.

3.
A novel curtain idea.

Frontis "The Possibilities of Trick Silhouette Cinematography" showing early integrations of text, story, and animation from *Moving Pictures: How They Are Made and Worked* (revised edition, 1912) by Frederick A. Talbot

1 Introduction

The choice of the commercial title sequence as a site of theoretical analysis concerned with *narrative* might seem strange: coming at either the start or conclusion of the motion picture, it is commonly understood as being *outside* the narrative itself.[1] Early films did not always mark the familiar separation between titles, intertitles, and exposition, reinforcing their marginal status in both film history and theory.[2] The title sequence is easily distinguished by *how* their découpage differs from the rest of the production in style, technique, and the use of on-screen text. The relationships between the title sequence and the motion picture it credits depend equally on their structural connection to the main text, "narrative," and the audience's separation of exposition, "credits."[3] The imagery and audio-visual structures employed in titles are more typically reserved only for specialized parts of the story, as in transitions, dream sequences, and montages that condense narrative time. These superficially simple differences are neither obvious nor inevitable, identifying the opposition of "paratext" and "main text,"[4] and linking the title sequence more closely to the forms and approaches of avant-garde video or experimental film; however, in 'becoming-commercial,' the avant-garde's disruptive and challenging aspects become *aesthetic*, neutralized, their politically oppositional and confrontational aspects elided, reduced to so much "visual decoration."[5] However, the title sequence remains valuable to theoretical analysis precisely because of its differences from both types of productions: these designs are revelatory of the semiotics shared by commercial and non-commercial (avant-garde) motion pictures alike. The ambiguities and ambivalences of découpage, articulated via editing, text::image composites, with musical cues through the synchronization, and using optical effects to identify transitions are precisely *why* title designs are of interest: they are one of the few overlaps between commercial and non-commercial semiosis, productions containing what are more commonly considered to be mutually

exclusive ranges of découpage and signification. The "formalist" aspect of the present analysis is more precisely an engagement with how cues guiding audience interpretation are implicitly governed by the dynamic range of naturalism::stylization that is realist ideology: the belief that what appears on screen should have the same vividness and truth as reality, demonstrated as narrative form. Even though this realist identification is so basic as to seem insignificant, it is a historical product, learned and internalized by viewers—guiding their interpretations—their apparently immediate understanding of the transition from titles into narrative encodes on-screen depiction as being outside critical assessment, as fact. Realism is a powerful ideology in cinema: *what* appears can be analyzed, critiqued, challenged, but not the question of mimesis, that it appears at all. Representation is both historically and socially contingent.[6]

This book emerged from the same disparate historical analysis of articulation in motion graphics as my earlier critiques of cinematic semiosis: *Semiotics and Title Sequences: Text-Image Composites in Motion Graphics* and *Synchronization and Title Sequences: Audio-Visual Semiosis in Motion Graphics*, a pair of short books that engaged with title sequence designs (mostly) produced for feature films and television programs in the United States. The role of title sequences in semiosis arises from their pseudo-independence; these earlier studies engage with the foundational relationships of text superimposed over photography (text::image), and the emergent (definitional) role of synchronized sound in parsing the *statements* in title sequences. My earlier books did not address *how* the audience interprets the "excess" meaning in a title sequence such as *Touch of Evil* (1958)—the linkages between the credits and the narrative they accompany were simply accepted as a "given," beyond the scope of these studies. Audience interpretations of distinct sequences (including the title sequence) produces story—narrative articulation is fundamentally intratextual—in recognitions of internal divisions and understanding their importance through lexia established by past experience. The lower-level semiotics that construct the "title sequence" informs this emergent higher-level organization without prescribing it: anticipation/recapitulation of narrative in the title sequence does not alter the necessary, inherently subordinate role of *crediting* that provides the credits *raisonne d'être*—the titles remain apart from the main text even when they interpenetrate and coincide with its narrative exposition.[7] The semiotics these books proposed did not include a thorough consideration of the paratext::text dynamic. *Any* semiotics, whether "of motion pictures" or of anything else, depends specifically on an

idealized, "average reader," whose interpretations are guided by, rather than challenging, encultured lexical codes: the identification of credits and narrative derives from encultured lexical conventions gleaned from past experiences with other media. The need for the present, higher-level semiotic analysis proceeds directly from the apparent simplicity of what is described. Expertise enables audiences to fluently separate credits::narrative, without any acknowledgement of their shift in engagement. That these connections are apparently immediate and autonomous justifies their analysis. In theorizing this semiotics of narrative exposition, the results have a taxonomic aspect—a concern with morphology and structure—used to organize and address the ambiguous and subjective *linkage* between one sequence and another. Analysis rapidly exceeds the merely formal features of the work due to the mediating role of past experience, as Umberto Eco has noted in his work on the semiotics of fictional narratives.[8]

The title sequences considered in this study of cinematic paratexts range across an international spectrum that nevertheless remains primarily focused on Hollywood productions. The exemplars were chosen not for their historical or aesthetic significance, but for their typicality, enabling a generalization of principles. Although these selections reflect their utility for the present analysis, the works chosen for discussion are well-known works whose designs provide a clear, coherent sampling of what are more commonly complex, ambivalent, and often even indistinct approaches. The limitations of this taxonomic description illuminate the complexity of more elaborate designs by acknowledging the distinct semiotic modes that parse the same text. The close readings in this book are meant to provide illustrations of abstract principle, allowing consideration of an "idealized" typical form. In selecting the title sequences used for this analysis, what was of concern was each example's capacity to direct attention beyond its own parameters, rather than serve as models to emulate. In developing the more basic semiotic relations of text::image and synchronization in my earlier books on title sequences, the complexities of the linkage to the narrative that provides the "excuse" for the title sequence itself was set aside, pending later consideration; this book is that analysis.

Limina

Every title sequence mediates its relationship to the narrative it accompanies, separating the "story" from "reality"—distinguishing

between *outside* and *inside* the motion picture—providing a threshold between artifice and actuality, as Jonathan Gray noted in his study of cinematic paratexts:

> Opening credit sequences, in short, serve an important ritual function. . . . Open credits help to transport us from the previous textual universe to a new one, or out of "real life" and into the life of the program (even if a growing number of shows are opting for cold starts to throw the viewer right into the action).[9]

This alchemical assumption explains title sequences' importance for the narrative as more than simply a 'giving credit,' the cliché view of titles renders them as an evocation of a "magic circle" where the fiction exists apart from the rest of life. The problem arises immediately. What about those designs that *do not* symbolically encapsulate the narrative as an evocative, pseudo-independent entity placed at the threshold of the film, but are integrated into it—those openings that convey and contain essential narrative information—functioning as a prologue to the fiction that follows? These connections of title sequence to narrative are so common, such an innate relationship that the designs are *not* somehow linked with the narrative are the exceptions; only the logo is a pure *crediting function*—it is always and first a signifier of the company responsible for the production, whatever other associations it might have about the nature or quality of the motion picture that follows.[10] In the designs common to early films at the start of the twentieth century, the titles function precisely as a "label"—an *identifier*—that designates the initiation of the production.[11] For later title sequences, both studio logos and production company title cards make this identification obvious, but also enable a complexity that early credits-as-label do not have.[12] Only in unusual, rare designs such as *Citizen Kane* (1941) that consists of only the RKO Radio Pictures logo and a few, brief title cards [Figure 1.1], do later titles have *only* this explicit role as label.

In establishing the beginning of the film—the "classic" understanding of the title sequence assumes it comes at the start of the motion picture, but before the narrative itself—the *crediting function* masks any other roles a title sequence could perform in relation to the narrative. The titles are exemplars of how the multifaceted systems of representational, narrative, and symbolic processes begin the construct of 'cinema.' Paratexts offer audiences no confusion between their role [1] as identifier and their opposed role [2] as part of the narrative. These roles are obvious to audiences watching: the *crediting* and

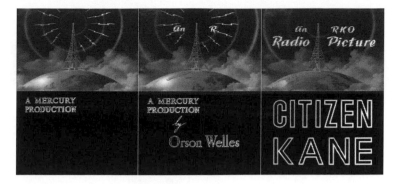

Figure 1.1 The RKO Radio Pictures studio logo and all the title cards in opening credits for *Citizen Kane* (1940)

narrative functions are always clearly separate.[13] The graphic presence of credits on-screen means that title sequences stand apart from the rest of the production, an independent "introduction" for the cast and key members of the production such as the producer and director. For designs that are *not* integrated with the narrative, this separation makes their pseudo-independence readily comprehensible because the *crediting function* dominates their understanding. In watching such an opening, the audience waits for the story to begin; this "wait" is literal in the title design for *Key Largo* (1948) [Figure 1.2] where the four optically printed frame holds on aerial views of the seven-mile bridge in southern Florida arrest the motion of a bus driving on the causeway until the credits finish scrolling past—the film only comes to life when the credits end for a second, then cuts to a different, closer view of the bus.

Title sequences that function *only* as labels are rare for commercial feature films, and rarer still in television. Interpreting these designs is balanced between antithetical roles as credits or as integrated with narrative: the separation between these functions is immediately apparent—the more a design acts to "label" the production and introduce the cast, the less the sequence engages (as exposition) with the narrative that follows. The basic difference between similar designs such as *She Done Him Wrong* (1933) [Figure 1.3, TOP] or *The Wolf Man* (1941) [Figure 1.3, BOTTOM] that are simple introductions of their cast, and *The Big Broadcast of 1937* (1936) [Figure 1.4] lies with how the narrative contents of *The Big Broadcast of 1937* informs its interpretation, commenting that this story takes place in a radio

Figure 1.2 All the title cards in *Key Largo* (1948)

station—the titles begin with a child dressed as an usher silencing the audience with "Quiet! Quiet! Quiet! We're on the air!"—narrative information about setting reinforced by the visual design. These titles function as a series of credits, *and* as an introduction to the story: neither *She Done Him Wrong* nor *The Wolf Man* have this narrative excess—both designs simply and directly introduce the cast, their calligram mode title cards connecting actors to roles. The "background" shots for the other title cards provide only an oblique connection to their narrative—they illustrate the setting for the story, a connection the audience may not realize while watching. This ambiguous connection is absent in *The Big Broadcast of 1937*: the start of the program explicitly connects it to the narrative of "radio show"—there can be no confusion about this *narrative function* during these credits. In watching this sequence, even though the narrative and crediting functions have antithetical foci, they nevertheless comingle and converge in the design, each function immediately apparent and comprehensible as an independent aspect of how the audience interprets the title sequence—once as "label," and then again, simultaneously, as a parallel exposition of "story."

Defining title sequences based on their *crediting function*—the understanding of the sequence as specifically a "label" identifying the production—while it may seem essential to the "titles," is a minor aspect of their role as paratext, even if it is the most easily recognized element of its construction; their relationship to the narrative is often

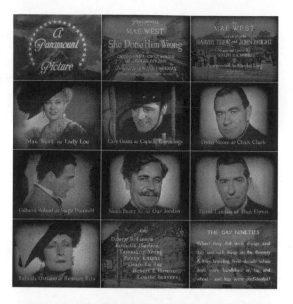

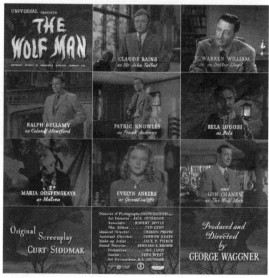

Figure 1.3 All the title cards in (TOP) *She Done Him Wrong* (1933) and (BOTTOM) *The Wolf Man* (1941)

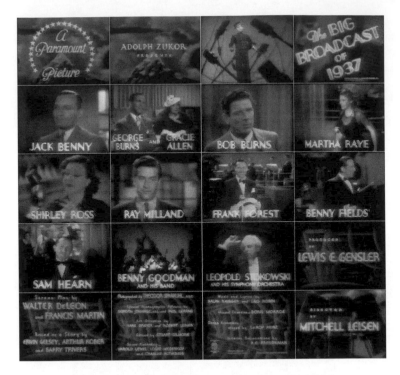

Figure 1.4 All the title cards in *The Big Broadcast of 1937* (1936)

more important to their comprehension. The complex parameters of the semiotic shifts required by the audience to associate a title design to the main text it accompanies are not an area of critical and theoretical analysis. While this modal change may seem self-evident, an easily comprehended part of the semiosis that is cinema, title sequences are *untheorized,* as film historian Valentina Re notes:

> title sequences can be considered as a remarkable example of 'marginality' in the context of the short format; literally placed at the fringes of films, title sequences have been long considered as peripheral and insignificant. . . . Film studies has long neglected the history, modes of production, stylistic features, and semantic/pragmatic role of opening credits.[14]

The titles are commonly assumed to be a fundamental part of motion pictures, their distinctions from and connections to the narrative being so obvious and immediate that they pass without notice.

Film historian David Bordwell defined "narrative" in *The Classical Hollywood Cinema* as relaying the 'events of a motion picture,' creating them as coherent depictions of cause-effect, and character motivation that seemingly self-organize a "world on-screen" extending into the exposition of title sequences:

> motifs revealed in the credits sequence or in the early scenes accumulate significance as our memory is amplified by the on-going story. . . . The classical aesthetic of 'planting' and foreshadowing, of tagging traits for future use, can be seen as laying out elements to be recalled later in the cause-effect logic of the film. If temporality and causality did not cooperate in this way, the spectator could not construct a coherent story out of the narration.[15]

"Narration" presents the constitutive material of the story, but is actually composed from a disparate collection of elements, some contained within the imagery of individual shots, others emergent from their editing into sequences; sound figures in this "narration" as speech, noises, and music—but always as an element whose significance comes from how it combines with the other, *visible* elements. These more basic articulations do not directly figure in his analysis, instead being assumed to be a series of linkages and connections that are so immediate and obvious as to not require analysis or theorization. Bordwell's omission precisely reveals the constructive effects of Michel Foucault's "gaze" that imposes an ordered hierarchy of reading::seeing::hearing in which interpretation arises through the use of established expertise.[16] For Foucault, *vision* provides a paradigm for comprehension where understanding sight as an actively engaged, organizational process results in the translation of ideology into interpretation;[17] this framework is instrumental in the organization of individual title cards, as well as the *statements* created by audio-visual synchronization. His assertion of language as defining the limits of interpretive and conceptual understanding reveals the semiotic foundations of his critique of the relationship between text::image in discussing the calligrams and other composites commonly appearing in title sequences. The pseudo-independent nature of the title sequence as an exposition separate from narrative—its identity as "paratext"— reflects and depends on how the semiotics of narrative interpretations arise from the associative/reiterative organization of media narratives in earlier works.[18] Audience recognition of these intertextual elements reveals the centrality of viewer's past experience with similar types to construct their understanding of story, a shift in engagement that

separates narrative from the limitations of lexical and linguistic form, while remaining within the broad scope of semiotics.[19] The coherent interpretation of the title sequence arises from its indexical (thus semiotic) relationship to the proximate, but separate primary text. However, as Bordwell suggests, the semiosis arising from the title's arrangement is not only guided by formal morphology, but by the audience's memory and established interpretative expertise. Pseudo-independence demonstrates the constructive action of semiotic modes in understanding how title sequences are interpreted in/as part of the larger narratives they accompany. The concerns in my earlier books on text::image composites and synchronization are foundations for the current analysis of this higher-level conception of narrative exposition in the title sequence. Their lower-level articulations in these sequences were the focus of the semiotic analysis developed in my books *Semiotics and Title Sequences* and *Synchronization and Title Sequences*; however, both studies were focused on the emergent comprehension of the structures *internal* to the title sequence, rather than structuring the link between otherwise disparate sequences within the same motion picture.

Audiences engage the anticipatory/recapitulative exposition in the title sequence as a liminal, or even marginal element, whose role in the primary text is necessarily attenuated by its placement—in the beginning or at the end—of the narrative itself. They are necessarily integral to the program they accompany, not peripheral, making their role as "paratexts" problematic.[20] These different positions, however, do not require different analysis or structural protocols for their relationship to the narrative since the range of potential relationships between title sequence and narrative is formally limited by the role of the narrative in the design and organization of the sequence in question: for example, employing a title sequence as a narrative preamble to the drama that follows, as in the title sequences for TV shows such as *The Beverly Hillbillies* (1962–1971), *The Addams Family* (1964–1966), *The Incredible Hulk* (1978–1982), or *The Prisoner* (1967) are typical of how TV uses 'cut scenes' in the title sequence to summarize the program's backstory and premise. These expositions necessarily require the credits come at the start of the program—they must come at the beginning to explain the story.

In contrast, a design that symbolically reveals the main characters in an allegorical fashion can come either at the beginning or the end—as in Richard Morrison's design for *Batman* (1989) that comes at the start of the film, or Steve Volta's design for *The Avengers* (2012) that comes after the narrative concludes; however, a title sequence is not simply a series of words on-screen, nor is it only a collection

of images. The title sequence is the site of a complex intersection of concerns, some formal (drawn from motion pictures, visual music, graphic design, and animation), others conceptual (the narrative and thematic relationship between the title sequence and the narrative it accompanies), and finally social (the use of title sequences and design not just for informational purposes but as badges of honor and prestige), that combine to direct the organization and placement of that design in relation to its narrative. Title sequences *do* provide credits—an account of who worked on the production—this *crediting function* is essential to their identification *as* a title sequence; at the same time, the relationship produced by this function does not preclude the *crediting function* acting in parallax to a complex conceptual interaction with the narrative itself. This additional relationship—beyond the *crediting function*—allows the credits to be intercut with the opening scenes of the narrative in a simultaneous montage "along side" the initial scenes of the narrative, an approach used by the British ITV series *Inspector Morse* (1987) [Figure 1.5] to allow the drama to begin immediately. The six title cards appear at uneven intervals during the opening 3:45, separating two parallel actions that

Figure 1.5 Title cards intercut with shots in *Inspector Morse* (1987)

ultimately converge: a choir practicing and a police arrest of a "chop shop" where a stolen car is being repainted; Morse is the connecting element. He arrives at the choir practice in time for it to end. This title sequence has no specific main title card stating "INSPECTOR MORSE." Instead, show title is incorporated into the card for John Thaw—"John Thaw as Inspector Morse." Although the connection of this title card to the actor is slightly displaced—he only appears in the third shot following it—there is no ambiguity that this title card is his. Thaw's actor credit/main title is the first title card appearing in the sequence—allowing the narrative to begin with one fewer title card than it would otherwise require; both the prequel series *Endeavour* and the sequel *Inspector Lewis* retain the immediacy of this opening integration narrative, but these later designs also include more than the minimal six title cards appearing in the original program's title sequence. Music functions to separate this opening/credit sequence from the rest of the program, the transition marked by a dissolve, reinforcing the "conclusion" to the opening sequence, a statement that the narrative has fully begun.

The *narrative function* of these titles dominates their organization as exposition for the main text: Morse at work, then meeting the woman whose murder will form the substance of the mystery. The title cards divide these two parallel actions, making their eventual convergence the implied subject of this opening: Morse meeting the woman who responds to his uncomfortable smile after arriving so late that his part in the practice is simply to sing "ah, men" as they finish practicing. That his meeting this woman is the "real" focus of this opening sequence is revealed in the shots at the pub where he brings her a drink and (sometime later) as they walk away. The dissolve that concludes the title sequence appears *after* these events. The information presented during this opening montage is an excess to the crediting function. The title cards that separate the convergent events *accentuate* the montage, drawing attention to its displacements.

The *narrative* rather than *crediting function* of the title sequence always contains any exposition in relation to the story it accompanies: this fact means the narrative has a decisive role in the morphology, structure, placement, and interpretation of the title sequence within the motion picture as a whole. The narrative presented in the main text (the *raisonne d'être* for the title sequence's existence, and generative of its status as a liminal marker at the beginning/ending of that work)[21] makes it possible to refer to the title sequences' "*paratextual function*," contra-Genette, not in spite of their narrative role, but because of the parallel distinction created by their immediate and obvious

function as "labels" identifying the material production itself (this role is the *crediting function*). For Genette's theorization, the *crediting* and *narrative functions* are antithetical, mutually cancelling actions whose duality in motion pictures is redolent of paradox. However, title sequences simultaneously refer to both this material production *and* to the dominant narrative itself: the *crediting function* acts to explain and identify *how* and *who* made the film, but the imagery chosen to appear with this information offers more complex potentials than just illustrating or accompanying typography. The material forming the "background" in figure–ground mode superimposed text::image combinations does not preclude its having narrative meanings parallel to the *crediting function*. The images providing this "background" can anticipate/recapitulate the narrative, providing information *about* the story beyond simply a statement of production personnel offered in the composited text.[22] The complexity and ambivalence of these relationships renders the commonplace assumption that title sequences are an insignificant appendage separate from the film narrative moot.

Anticipation and Recapitulation

Audience expectations constrain their understanding of the title sequence. The play of memory and immediacy—those necessary and sufficient elements for any expectation—in the identification of innovative strategies and the recognition of quotations reflect the audience's past knowledge and experience. Audience interpretations and understandings always begin with fundamental recognitions. Language dominates sight, a hierarchy learned from early childhood experiences with elementary readers that accompany an image with a text identifying it. These engagements begin as the low-level semiotics of sound::image and text::image that establish the encultured hierarchy central to Michel Foucault's argument in *This Is Not a Pipe*:

> What misleads us is the inevitability of connecting the text to the drawing . . . the calligram aspires playfully to efface the oldest oppositions of our alphabetical civilization: to show and to name; to shape and to say; to reproduce and to articulate; to imitate and to signify; to look and to read. Pursuing its quarry by two paths, the calligram sets the most perfect trap. By its double formation, it guarantees capture, as neither discourse alone, nor a pure drawing could do.[23]

The simultaneous interpretation/presentation of text::image in the calligram that Foucault describes is also an impossibility for

interpretation—each action is categorically distinct, separated by the duration required in their individual and sequential recognition; his dynamic of reading::seeing is an opposition that ultimately subordinates image to word in an assertion of the hierarchy that is language as a dominating force transforming what is seen into what is known, an effect of the "empirical gaze" he identifies in *The Birth of the Clinic*:

> seeing consists in leaving to experience its greatest corporeal opacity; the solidity, the obscurity, the density of things closed in upon themselves, have powers of truth that they owe not to light, but to the slowness of the gaze that passes over them, around them, and gradually into them, bringing them nothing more than its own light. The residence of truth in the dark center of things is linked, paradoxically, to this sovereign power of *the empirical gaze* that turns their darkness into light.[24]

In conditioning the audience's expectations of relationship—obvious in how the spatial displacement between an image and its caption is also a displacement that becomes apparent in the *time* required to make the recognition of their proximity—to interpret the convergence of name and thing named takes place over a specific duration, making each shift in interpretation a sequential engagement by its audience. Readers/audiences learn to make the association of disparate elements located in proximity, comprehending them through conventional relationships that depend on encultured expertise. As their interpretive skills mature and increase with experience and practice, this association/displacement expands to accommodate structures that are less-than-proximate, displaced either temporally or spatially within singular works and between works in the forms of quotation, parody, and satire (all intertextual recognitions dependent on past expertise). The relational and "organic" organization of intratextuality, just as with the quotational identifications of intertextuality depend on these internalized interpretive protocols.

Foucault's conception of the dominance of language at the lower levels of identification and recognition links the phenomenal encounter to epistemic knowledge and lexical expertise; his is a concern with the power of naming and the superficial dominance this action produces. At higher levels, Foucault's insight becomes attenuated, requiring adaptation into a different form, one not directly linked to language in the same way. At higher levels, such as the relationship of paratext to main text, the link created across the displacement is crucial: the associative connections of different materials immanent, yet separated, describes both the text::image relationship of the calligram and the connections

between a title sequence and its film. Their distinction is simply a matter of degree: the greater separation between credits and exposition is countered by the organization of the title sequence as such—its identification as a singular coherent unit in parallel to that of the narrative allows their connections to emerge from the juxtaposition of each 'unit' in itself. Arrangement into series and composition into larger passages is only part of what enables their interpretation: of equal importance is the audience's past experiences and established expertise (enculturation) with inventing the relationships between images that enables their meaning; a similar (perhaps even the same) problem arises for both the identification of cause-effect from disparate shots and the identification of exposition. The unity of each sequence as a separate entity—much like the shots of editing—suggests the 'jump' from the propositions of montage to the associative and relational grouping of different sequences into passages; however, while such a shift seems valid, with the audience marking the extent of the exposition through their fluency with the conventions of its construction, it demonstrates how enculturation inhibits any analysis of this interpretive process.

The superficially different expositions of 'anticipation' and 'recapitulation' reveal themselves as mirror images of the same audience engagement, but displaced by their location in the narrative, a relativistic effect created by whether the main text comes before or after its credits. The titles as a pseudo-independent construction can assume either engagement, because the distinction between a design that anticipates or recapitulates is not a formal issue of its construction. These understandings arise from how the audience relates the proximate materials of the title design to their expectations and memories of the main text: when the emphasis in this relationship falls on memory and knowledge of what happened in that main narrative, the relationship is recapitulation; however, when the emphasis falls on created expectations—for what will happen—it becomes anticipatory.

Audience engagement is thus central to the construction of meaning, but it is an engagement that depends on the actual and precise encounter—what is present on-screen, heard in the soundtrack, and what their relationship is—combined with their own internal expectations for that material. This dimension of expectations is Janus-like, impacting paratexts generally, shaping how they are understood, while at the same time, the main text is also subject to their attractions: the resulting dynamic relationship between the paratext and the main text always returns to the audience. In a title sequence, this link emerges first through recognitions of conventional structures, cut scenes for example, that the montage of short vignettes and isolated

narrative fragments are synecdotal. Understanding these momentary scenes as extractions from the program—even if they are not present in the proximate narrative—creates paired expectations: first, that these scenes *will* eventually appear in the program, and second, that the characters and their relationships are an accurate portrayal of what happens in *all* the narratives, including the one immediately attached to the titles. These expectations arise because the cut scenes are an introduction to programs such as *Castle* or *Magnum, P.I.* and are understood by their audience as an explanation of what follows; without this internalized relationship of immanence and memory the audience learns to create from childhood experience, the play between title and narrative cannot happen. The semiotics of this structural transfer depend on lower-level identifications of relationships within individual title cards, the shots they accompany, and the enunciative functions provided by synchronization in distinguishing the title sequence as a singular unit. These formative elements all serve to create the internal unity required for the interpretation of "title sequence" as a distinct construction within a larger production.

The 'marginality' of the title sequence (and all cinematic paratexts) is ensured in its distinction from the main text: the same conventions that contain the titles also render their organization and placement within the production as of lesser significance when appraising the meaning of that primary text. The critical dismissal of title sequences that Valentina Re noted is entirely logical given their exteriority to the main narrative; this relationship does not mean the titles do *not* contain exposition that informs or impacts the interpretation of the main text, but that their impacts are necessarily muted by the markers that allow the separation of the credits from the narrative. This distinction is essential. It arises from the semiotic organization of expositional modes that set title sequences apart from the narrative itself, a necessity for their *crediting function*, and which is simultaneously the definitional aspect that makes them identifiable *as* credits.

These identifications of the credits as a unit are incidental, a collateral effect of the interpretative process required to comprehend them in relation to the main text; for a cinematic paratext that is not factually separate from the main text—as with every paratext—this identification is circular, both a definitional precondition and a product of that recognition. The distinction between title sequence and narrative is not necessarily a 'given,' being instead an interpretation: for those designs whose exposition blurs the boundaries between opening narrative and credit sequence, the end of the credits still aligns with the end of the theme music—as in *Touch of Evil*, or in the ITV drama series *Inspector*

Morse where the insertion of still title cards with white text on a black background as "transitions" between single shots or short sequences has the same affect. When this compartmentalization *does* break down the distinction between title sequence and narrative—collapsing the boundary of paratext::text—the presence of the title sequence itself comes into question. It is not a blurred boundary, but the removal of the boundary entirely: in *The Adventures of Baron Munchausen* (1989) the "conclusion" of the title sequence coincides with the appearance of the film's title on-screen, but not as a title card [Figure 1.6]. Instead, the "film title" appears on a poster within the mise-en-scène, marked only by the conclusion of the theme music: without this audible cue, it becomes a background element within the narrative action of "Sally" (Sarah Polley) crossing-out "son" and writing-in "daughter" on that same poster. This opening reveals the ambivalence of the title sequence to both exposition and narrative, that its paratextual role depends on precise semiotics that separate it into a what Michel Foucault identifies as the product of enunciation, the "statement":

> The relation of the proposition to the referent cannot serve as a model or as a law for the relation of the statement to what it

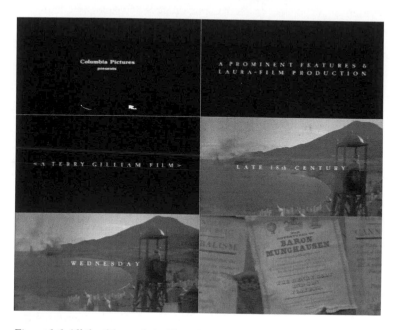

Figure 1.6 All the title cards in *The Adventures of Baron Munchausen* (1989)

states. The latter relation not only does not belong to the same level as the former, but it is anterior to it. . . . How, then, can we define this relation that characterizes the statement as statement— a relation that seems to be implicitly presupposed by the sentence or proposition, and which is anterior to it? . . . The referential of the statement forms the place, the condition, the field of emergence, the authority to differentiate between individuals or objects, states of things and relations that are brought into play by the statement itself.[25]

Statements are necessarily self-contained, self-productive: to ask, as Foucault does, about its referent opens onto an infinite regression of circular claims and supports. The function of the statement is precisely as a delineation of boundaries within which there arises the possibility of meaning. It is a marker allowing the parsing of continuous materials into units that can then be interpreted in themselves—a superstructural element of interpretation that begins for language with the division into signifying elements and continues into increasingly complex arrays of discrete elements aggregated into higher-level relationships: sentences, paragraphs, sections, chapters, books. For cinematic forms, these enunciative frameworks have a greater fluidity—motion pictures are not written language—but retain the same divisive and superstructural identifications: the role of synchronization in identifying the title sequence's conclusion with the end of the theme music is the most apparent example of these divisions. The fluidity of audience interpretations suggests discrete, interactive levels to interpretation: this abstract realm of (un)realized-yet-*potentially*-immanent possibilities, a 'state of information,' enables the interpretative ability to "back-up" and change initial assumptions based upon their applicability to a given situation.[26] Recourse to a range of mutually supporting potentials resolves the apparent paradox of mutually exclusive interpretations: for those ambivalences of enunciation posed by designs where the boundary between narrative (main text) and title sequence (paratext) appears porous or even absent, as in *The Adventures of Barron Munchausen*, significant changes mark the shifts in mode and organization. In place of the singular and rigid statement common to language, the cinematic statement has a fluid and contingent nature, always ambivalent and unstable.

Problems of *Cinematic* Paratext

There is no semiotic theory for the higher-level relationships and transfers between the different, and pseudo-independent, component

parts of motion pictures: those separate productions whose individuality is immediately apparent in the distinction between the "credits" and "movie." The commonly employed label describing these relations, "paratext," masks this ambivalence: its applicability (and even utility) when applied to cinema is unstable. Paratext was originally theorized by literary critic Gérard Genette in his book *Paratexts: Thresholds of Interpretation*. In his analysis, he proposes a wide range of paratexts, both located within the book such as the cover, title page, the preface or introduction, issues of typography and design, even the paper stock it's been printed on. These elements all align with the creation of meaning in parallax to those meanings available through language—the text itself. Genette's designation *paratext* is a higher-level category that contains all those elements that are not part of the narrative, but relatable to the author: the paradox of the *title-sequence-as-narrative-exposition* emerges from this fundamental definition. His two sub-categories of *peritext*, which includes the title, preface, author's name (credit), and *epitext*, which includes all the tangentially related materials *not* included in the physical book itself (such as interviews, publicity materials, and any ads or reviews) identify distinctions of placement in relation to the main text: there can be no overlap between the *epitext* and the *peritext* in his construction of *paratext* [Figure 1.7].

The term "paratext" has been used to describe a wide range of materials and practices *around* feature films, television programs, and even video games that include not only the title sequence (peritext), but the posters, trailers, theme songs, marketing and publicity, as well as product tie-ins, giveaways, and toys used to promote and popularize media productions (epitext).[27] This application to motion pictures is necessarily an adaptation, yet it is one that has been embraced, particularly the concept of "epitext," as identifying the marketing and

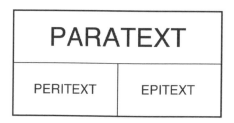

Figure 1.7 "Paratext" is a higher-level description composed from two distinct subordinate classes: the "peritext," contained within the main text, and the "epitext," separate from the main text

promotion of motion pictures. Andy Bird, chairman of Disney International, discussed the need for epitexts, explaining their importance in attracting audiences outside the United States:

> Whether it's releasing posters, releasing footage from onset, whatever it happens to be, the story happens way before you actually see the event. So the movie now becomes like the main event of a much longer story. It has sort of this prequel and then it has this much more longer tale.[28]

The cinematic paratext is typically understood in marketing as an expansive presence, outside and beyond the main text. This prominence for epitexts in the promotion of media gives the theorization and analysis of paratext an urgency derived from its commercial use; however, the peritext does not have the same prominence in this expansion of marketing since it is part of the exposition "in" the main text—only when they are separated from that text (i.e., made into epitexts) do title sequences become marketing and promotional materials. Unlike literature where paratexts occupy particular, well-defined and easily separated sections—forward, epigraph, etc. that Genette considers in his book—the cinematic parallels are troubled by an inability to clearly and unambiguously mark differences *within* the text. The material elements of the publication are language, typefaces, layout, etc. that can be unquestionably separated from the meaning of the words themselves, as Ellen Lupton and Abbott Miller explain in their book *Design Writing Research*:

> Spacing and punctuation, borders and frames: these are the territory of typography and graphic design, those marginal arts that render texts and images readable. The substance of typography lies not in the alphabet as such—the generic forms of characters and their conventional uses—but rather in the framework and specific graphic forms that materialize the system of writing. Design and typography work at the *edges* of writing, determining the shape and style of letters, the spaces between them, and their placement on the page.[29]

Design is a mediator of meaning for literature; however, for cinema, few material parts of a motion picture are *unquestionably* independent in the same way. In motion pictures, title sequences are unproblematic when their distinction from the narrative exposition of story (what in literature is easily identified by its separation from the main text)

is readily apparent: only the *crediting function* of the title sequence definitively meets the requirements for a *peritext*, while the various film trailers and promotional materials are readily and unproblematically identified as *epitexts*.

Genette concludes his study by challenging this focus on the paratext as a directing attention away from what was of "real" interest— the actual substance of the text itself. While the title sequence is a "pseudo-independent entity," it is at the same moment a parallel one, intersecting with the main text, reflecting on its contents and form, a relationship that dramatizes his definition of the paratext as a dependent construction, relying on the main text for its existence:

> The paratext is only an assistant, only an accessory of the text. And if the text without its paratext is sometimes like an elephant without an mahout, a power disabled, the paratext without its text is a mahout without an elephant, a silly show.[30]

The descriptor "cinematic paratext" affirms an underlying critical overlap and convergence between the historical film studies (often concerned with narrative films and the history of theatrical cinema) and its expansion/extension into both new media and cultural studies in which cinema/film/TV/etc. are areas of focus. The occasional and *en passant* consideration of title sequences as paratext appears within this expansive context. Conceptualizing the title sequence as a pseudo-independent part of the motion picture as a whole reflects the recognition that lower-level enunciations guide the interpretation of title sequences *as* credits or *as* narrative. A paratext is always tangential to the main text, but simultaneously an integrated, necessary element that cannot readily be separated from it. The relations between the title sequence and the narrative in motion pictures reveal the difficulty in transferring Genette's theory to cinema: the *crediting function* makes the distinction of peritext::text seem inevitable and unquestionable, while their role as *exposition* makes their narrative link equally necessary. While the titles *are* appended to the narrative and *do* "label" the production, this role is only partially descriptive of their function: a singular concern with the *crediting function* neither addresses the fundamental issues of *how* audiences understand the expositional role of title sequences, nor allows the (dis)integration of title sequences into that narrative.

However, the difficulties surrounding the utility of the term paratext are a product of its varied context of use in media, but without a theoretical elaboration of its utility *for* cinema, as media historian

Alessandro Cecchi observes in his discussion of title sequences in Italian industrial films:

The concept of film 'paratext' is problematic, and this is not because it emerged in literary theory in relation to the book form, but because it remains under-theorized within the context of film studies. In structural terms a paratext should be distinct from the text, i.e. lie outside of its borders. Because of their clear structural separation from the film, audiovisual forms such as teasers, trailers, making of's, interviews and so on can be congruently defined as pertaining to the paratext; more precisely, this is the zone Genette calls the 'epitext'. Similarly, the title, when intended as the label that designates a film, can correctly be attributed to the 'peritext.' Just like the title of a literary or musical work, a film title exists primarily outside of the text.[31]

Genette's term appears simple and direct for cinema, but produces paradoxes in how it precludes *narrative function*: paratext for motion pictures reifies the self-contained nature of the pseudo-independent title design. The paratext (or peritext) cannot be outside of the borders of narrative and have a narrative role at the same time. The term's application to cinema depends on the cliché assumption of the title sequence as an unquestionably 'independent unit.' That organization of title sequences is liminal, defining interpretive potentials within the larger text without engaging the narrative.[32] Unlike literature where most paratextual elements are tangential to the communication of language giving and inflecting the meaning of the text in ways that are fundamentally different from it (forwards, preambles, and epigraphs being obvious exceptions), in the case of cinema, this distinction cannot be drawn with the same degree of certainty: the hierarchies of text, image, synchronization, and musical cues allowing audiences to understand the title sequence as a distinct part within the continuous motion picture are ambivalent. The literal material that composes title sequences is of the same basic nature as the rest of the motion picture, an essential difference from lexical texts is especially apparent in title designs.

Embedding credits *within* narrative scenes that run continuously, as in Wayne Fitzgerald's design for *Touch of Evil* (1958) [Figure 1.8], challenges the separation of "credits" versus "story," demonstrating the difference between *crediting* and *narrative functions*. This design reveals the problems with transferring Genette's definition of paratext to cinema: the subject matter of the *Touch of Evil* opening sequence,

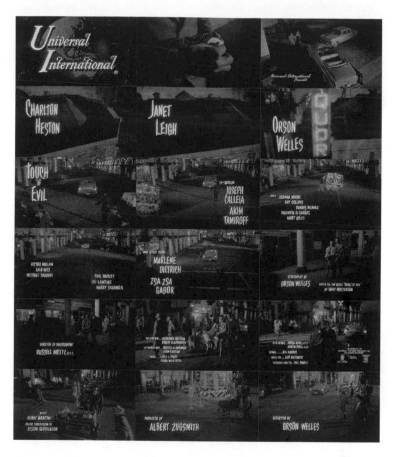

Figure 1.8 All the title cards in *Touch of Evil* (1958)

murder, sets the entire drama in motion—the first cut arrives in this four-minute-long continuous camera run almost a minute *after* the theme music ends, a literal interruption of the happy "newly weds." The *narrative function* of the long take is more important than the credits that appear on screen. Low-level articulations enable higher-level interpretations to form the story. These connections require a careful decoding made possible by treating the link to the narrative as a type of synecdoche, one where a full understanding of the titles only becomes available retrospectively. Theme music separates peritext::text—otherwise, they are essentially comingled in *Touch of*

Evil. The titles end when the theme music ends, immediately before the first lines of dialogue.

The audience fluently navigates openings that integrate the titles and narrative presentation such as *Touch of Evil.* Contra-Genette, viewers precisely separate paratext::text without difficulty, understanding them as *narrative.* This identification of *credits* as a higher-level statement renders their 'paratextual' role apparent in the consolidation of "title sequence" as a distinct unit of enunciation, a division film historian Georg Stanitzek explains in his discussion, "Texts and Paratexts in Media":

> The paratextuality theorem, which was first developed in literary studies is thought to be particularly useful for determining what kind of text or, as it should now be expressed more precisely, what kind of textual unity one is dealing with.[33]

The concept of "textual unity" is crucial to the interplay between titles and narrative: the statement provided by the theme music identifies (marks) the boundaries between title sequence and narrative as clearly as the presence of text on-screen. These peripheral aspects of the film remain a crucial element in its interpretation-identification by its audience. Its application to film is problematic, but has utility in describing the title sequence: invoking this model acknowledges the audience recognition of the title sequence as a peripheral element, created as a quasi-independent form indexically connected to the main work.[34] This recognition of titles as a higher-level statement originates in the synchronization of music-text to a limited duration that then creates the recognition "title sequence," distinguishing the credits in *Touch of Evil* from the rest of the film even though the long take continues for almost sixty seconds after the theme music ends. The distinctions of *crediting* and *narrative functions* are maintained, contra-Genette: the paradox suggested by his definition is an illusion. Audience identification of the title sequence *as* pseudo-independent through *both* functions acting together is what enables its recognition as paratextual. These distinctions render title designer Saul Bass' conception of his title designs as a separate "film before the film" coherent.[35] The shifts between *crediting* and *narrative functions* is an interpretive change *within* the singular construction of the titles, thus maintaining the boundaries of peritext::text as the distinction between discrete, integral sequences within a larger, singular unit.

Considering the opening of a motion picture as a paratext—specifically a *peritext*—does not identify the audience's engagement with this

material so much as provide a critical descriptor that marks the difference felt between the title sequence and the other sequences. That distinction is important for considering these structures as the product of a semiotic process marking *statements* within the continuous flow of events. This relationship is an autonomously arising side effect of the identification of the 'title sequence' as a self-contained entity: the marking of boundaries that the theme song provides for *Touch of Evil* allows the separation of the credits from the narrative even though they are otherwise part of a continuous whole, comingled and overlapping. The importance of this marker is not for the narrative, but the titles themselves—in identifying their conclusion, it signals a shift in attention to the details of narrative. The problem paratexts mask through the apparent simplicity of this distinction have to do with the function of the paratext: its contributions to the meaning of the primary text, its role in establishing expectations, creating context, and otherwise modifying the audience encounter with the narrative. For those title designs that come at the conclusion of the film, these issues become more explicit since instead of offering an anticipated statement about the film, the titles become instead a recapitulation—an effect created simply by their placement in relation to the narrative itself.

Jonathan Gray's argument in *Show Sold Separately* depends on precisely this distinction between anticipation and recapitulation, a concern of precise significance to his main focus—epitexts and other promotional materials—that exist *around* rather than *within* a film.[36] The distinction between these epitexts and the peritext that is the title sequence seems simple, but the capacity to anticipate and recapitulate—a function of how the titles relate to and describe the narrative they accompany—applies equally to all paratexts, not just those explicitly employed to promote such as film trailers. It is a relationship between immanence and audience expectation, something that inevitably arises for marginalia of all kinds. This conception of audience engagement easily assimilates metaphor and allegory—apparent in how Saul Bass explained his design approach to film historian Pamela Haskin. His title designs employ the associative character of peritexts to introduce the film that follows through symbolic and interpretative re-presentation:

My initial thoughts about what a title could do was to set the mood and to prime the underlying core of the film's story; to express the story in some metaphorical way. I saw the title as a way of

conditioning the audience, so that when the film actually began, viewers would already have an emotional resonance with it.[37]

Bass promoted his "allegorical method" extensively during the 1950s[38] as *the* approach to relating titles to narrative, thus establishing the credits as a parallel, pseudo-independent or quasi-independent production driven by its own internal demands to allegorize or metaphorically engage the content and meaning of the film that follows. The allegorical approach that Bass employed is only one of the potential relationships between titles and narrative, even if it is the most prominent historically. His idea of "emotional resonance" is a reflection upon anticipation and/or recapitulation arising from the audience recognizing the film "in" the titles—the distinction between one experience and the other simply being a product of the placement—at the start as a "main title," or after the conclusion as a "main-on-end."

Considering the relationships between title sequence and dramatic narrative offers the potential to theorize this aspect of paratextual form more specifically, in the process revealing the ambivalence that peritexts necessarily have precisely because they are *included* within the production itself. To simply focus on them as mediating the transition—as an introductory preface or threshold, demonstrative of the *crediting function* itself, as Jonathan Gray's view of them as "ritual" does in *Show Sold Separately*—is an approach that necessarily marginalizes those designs that are closely integrated with the dramatic narrative. Such an omission of a major subset of title designs means that any theorization of peritexts—those internal paratexts, such as title sequences—may not be applicable or descriptive of the epitext; their association as paratext may be a convergence produced by a poorly considered definition or general framework. In considering the role of narrative relationships as a central dimension of the title sequence peritext, it becomes clear that the taxonomic classification as paratext, so readily comprehensible and apparent for literature, is only superficially so for motion pictures.

Notes

1. Stanitzek, G. "Texts and Paratexts in Media," *Critical Inquiry*, no. 32 (Autumn 2005), pp. 27–42.
2. Gaudreault, A. and Barnard, T. "Titles, Subtitles and Intertitles: Factors of Autonomy, Factors of Concatenation," *Film History*, vol. 25, no. 1–2 (2013), pp. 81–94.
3. Powrie, P. and Heldt, G. "Introduction: Trailers, Titles, and End Credits," *Music, Sound, and the Moving Image*, vol. 8, no. 2 (Autumn 2014), p. 111.

4. Picarelli, E. "Aspirational Paratexts: The Case of 'Quality Openers' in TV Promotion," *Frames Cinema Journal* (2013), http://framescinema journal.com/article/aspirational-paratexts-the-case-of-quality-openers-in-tv-promotion-2/ retrieved September 14, 2016.
5. Betancourt, M. *The History of Motion Graphics: From Avant-Garde to Industry in the United States* (Rockport: Wildside Press, 2013).
6. Altman, R. *Silent Film Sound* (New York: Columbia University Press, 2004), p. 16.
7. Zagala, A. "The Edges of Film," *Senses of Cinema*, no. 20 (May 2002), http://sensesofcinema.com/2002/feature-articles/titles/ retrieved September 14, 2016.
8. Eco, U. *The Limits of Interpretation* (Bloomington: Indiana University Press, 1994).
9. Gray, J. *Show Sold Separately: Promos, Spoilers and Other Media Paratexts* (New York: NYU Press, 2010), p. 75.
10. Mahlknecht, J. *Writing on the Edge* (Heidelberg: Universitatsverlag Winter, 2016), pp. 21–23.
11. Gaudreault, A. and Barnard, T. "Titles, Subtitles and Intertitles: Factors of Autonomy, Factors of Concatenation," *Film History*, vol. 25, no. 1–2 (2013), p. 83.
12. Mahlknecht, J. *Writing on the Edge* (Heidelberg: Universitatsverlag Winter, 2016), pp. 17–34.
13. Genette, G. *Paratexts: Thresholds of Interpretation* (New York: Cambridge University Press, 1987), p. 410.
14. Re, V. "From Saul Bass to Participatory Culture: Opening Title Sequences in Contemporary Television Series," *Necsus: European Journal of Media Studies* Spring 2016_'Small Data', published July 11, 2016, www.necsus-ejms.org/saul-bass-participatory-culture-opening-title-sequences-contemporary-tv-series/ retrieved March 22, 2017.
15. Bordwell, D., Staiger, J. and Thompson, K. *The Classical Hollywood Cinema* (New York: Columbia University Press, 1985), pp. 43–44.
16. Foucault, M. *The Birth of the Clinic* (New York: Vintage, 1975).
17. Foucault, M. *The Birth of the Clinic* (New York: Vintage, 1975), pp. xiii.
18. Eco, U. *The Limits of Interpretation* (Bloomington: Indiana University Press, 1994), pp. 84–84.
19. Eco, U. *The Limits of Interpretation* (Bloomington: Indiana University Press, 1994), pp. 91–93.
20. Cecchi, A. "Creative Titles: Audiovisual Experimentation and Self-Reflexivity in Italian Industrial Films of the Economic Miracle and After," *Music, Sound and the Moving Image*, vol. 8, no. 2 (Autumn 2014), pp. 180–181.
21. Re, V. "L'ingresso, l'effrazione. Proposte per lo studio di inizi e fini," *Limina/le soglie del Film: Film's Thresholds*, ed. Veronica Innocenti and Valentina Re (Udine: Forum, 2004), pp. 105–120.
22. Betancourt, M. *Semiotics and Title Sequences: Text-Image Composites in Motion Graphics* (New York: Routledge, 2017), pp. 33–42.
23. Foucault, M. *This Is Not a Pipe* (Berkeley: University of California Press, 1982), pp. 20–22.
24. Foucault, M. *The Birth of the Clinic* (New York: Vintage, 1975), p. xiii.
25. Foucault, M. *The Archaeology of Knowledge* (New York: Pantheon, 1972), pp. 90–91.

26. Betancourt, M. *The Critique of Digital Capitalism* (Brooklyn: Punctum Books, 2016), pp. 153–190.
27. Gray, J. *Show Sold Separately: Promos, Spoilers and Other Media Paratexts* (New York: NYU Press, 2010).
28. Kimmorley, S. "Disney's Top Global Exec Explains Why the Company Has Had to Change the Way It Sees the World," *Business Insider*, July 13, 2017, www.businessinsider.com.au/why-disney-had-to-change-andy-bird-2017-7 retrieved July 13, 2017.
29. Lupton, E. and Miller, A. *Design Writing Research: Writing on Graphic Design* (New York: Phaidon, 1996), p. 14.
30. Genette, G. *Paratexts: Thresholds of Interpretation* (New York: Cambridge University Press, 1997), p. 410.
31. Cecchi, A. "Creative Titles: Audiovisual Experimentation and Self-Reflexivity in Italian Industrial Films of the Economic Miracle and After," *Music, Sound and the Moving Image*, vol. 8, no. 2 (Autumn 2014), p. 180.
32. Foucault, M. *The Archaeology of Knowledge* (New York: Pantheon, 1972), p. 91.
33. Stanitzek, G. "Texts and Paratexts in Media," *Critical Inquiry*, no. 32 (Autumn 2005), p. 29.
34. Gray, J. *Show Sold Separately: Promos, Spoilers and Other Media Paratexts* (New York: NYU Press, 2010), pp. 23–46.
35. Horak, J. *Saul Bass: Anatomy of Film Design* (Lexington: University of Kentucky Press, 2014).
36. Gray, J. *Show Sold Separately: Promos, Spoilers and Other Media Paratexts* (New York: NYU Press, 2010).
37. Haskin, P. and Bass, S. " 'Saul, Can You Make Me a Title?': Interview With Saul Bass," *Film Quarterly*, vol. 50, no. 1 (Autumn 1996), pp. 12–13.
38. Horak, J. *Saul Bass: Anatomy of Film Design* (Lexington: University of Kentucky Press, 2014).

2 Narrative Exposition

The tendency to focus on the elaboration of plot through the varied 'events' shown on-screen in considering "narrative" inevitably leads to a marginalization of the title sequence within critical analyses of cinema. This lack of prior engagement can be attributed to how apparently obvious and immediate the connections and distinctions between *crediting* and *narrative functions* are in the development of exposition. Theorizing this relationship, while essential for understanding them as paratexts, also seems redundant. There is never any confusion of titles and story. The "obviousness" of this separation creates the difficulty of its theorization; the complexity of semiosis between pseudo-independent elements—the title sequence and the main text—is fundamentally a grammatical view of the credits::narrative dynamic. The titles are *not* the story, their morphology and structure are not required to follow the realist, narrative constraints imposed on the rest of the motion picture, as film historian Georg Stanitzek notes in his discussion of the differential between opening titles and narrative:

> Title sequences create a divided focus of attention, the separation of the inside from the outside, of what is the play of the narrative from what is documenting the production, cinematic narrative from film commentary, intradiegetic from extradiegetic information. The title sequence achieves this as a film within a film, in that it introduces, in that it—semi-autonomously—establishes itself as distinct from the main film.[1]

The recognition about the "title sequence" Stanitzek describes is obvious, requiring neither explanation nor definition. It is "common knowledge." This typical understanding of the credits as an opener (or occasionally conclusion) indicates the parameters of the narrative

engagement through its exclusion. As Stanitzek observed, the *crediting function* means the titles are *literally* integrated with the motion picture itself, their presence on-screen a contractually determined necessity separate from story.[2] Audiences ambivalently understand title sequences as distinct units in this progression, both apart from and integral to the narrative itself: precisely this (dis)connection is apparent in the audience's expectation of a distinct stylistic and technical organization in title sequence unlike what appears elsewhere in the motion picture.

Crucial to Stanitzek's observations is the idea that the (idealized, typical) audience understands the sequences, sections, and scenes as distinctions within the *same* text without conscious effort. This higher-level organization of *narrative function* distinguishes between the trailers (epitext), titles (peritext), and the motion picture narrative they credit (text). Some title designers, such as Maurice Binder,[3] designed both the titles and the trailers for the productions they worked on, giving them a degree of overlap. Film historian Tom Gunning explains the difference between "attraction" and "narrative" for cinema. The closer the titles are to "attraction" (*crediting function*), the more their pseudo-independence allows their separation from this main text, giving some peritexts a superficial similarity to epitexts:

> Attractions could be opposed to narrative construction in a number of ways. First, attractions address the viewer directly, soliciting attention and curiosity through acts of display. As moments of spectacle, their purpose lies in the attention they draw to themselves, rather than in developing the basic *données* of narrative: characterization (motives and psychology); causality (or the causal concatenation of actions, which Roland Barthes calls the proairetic); narrative suspense (spectator involvement with the outcome of events, which Barthes calls the chain of enigmas); or the creation of a consistent fictional world (the diegesis of classical film semiotics).[4]

The *crediting function* is apparent in the superimposed text::image composites that illustrate the title cards in the trailer for *Sh! The Octopus* (1937) [Figure 2.1]. Like the film it advertises, this trailer is a typical example of narrative convention,[5] abundantly demonstrating how what Gunning identifies as "attraction" precludes narrative, but establishes narrative expectations. The text speaks *to* the viewers with a show-and-tell structure—the trailer is conversational. The superimposed "Don't worry, folks" is addressed to the audience, engaging

Figure 2.1 Stills from the trailer for *Sh! The Octopus* (1937)

them. Audiences understand epitexts as separate works, independent from the main text they describe via their use of direct address, solicitation, and spectacle. An epitext's *attraction* is entirely different than *attraction* in a peritext, even though they both use the same conventions of text::image composite (calligrams introduce the lead actors), and both can contain cut scenes from the *fabula*. These similarities do not require a similar response. Context matters. The child usher stating "Quiet! Quiet! Quiet! We're on the air!" at the start of *The Big Broadcast of 1937* (1936) is the closest any title sequence comes to speaking *to* its audience in the way the trailer does; however, there will be no further dialogue with the audience because *The Big Broadcast of 1937* has *literally* begun. His "Quiet! Quiet! Quiet!" is an order silencing and ending that interaction. Naturalism affirms realist depictions as continuous with those of everyday reality; this brief moment of direct address at the very start of *The Big Broadcast of 1937* is rare and unusual, a transition revealing the inherent distance

of epitext and proximity of peritext. The differences were codified in Hollywood productions by the 1920s; their semiotic modes have remained essentially uniform from the 1930s into the present.

The particular articulations in the title sequence that produce its relationship to narrative are not just an issue of text and imagery, but of *position* in relation to the main text. This locative constraint is always significant. In the title sequence to *Fantasia* (1940), the placement of the title card, rather than the design itself, produces the statement that the motion picture *is* a symphony performance translated into visual form. This silent title card is on screen an exceptionally brief thirty seconds, and comes in the middle of the film (not at the beginning or end), replicating the intermission of a symphony performance: it is bounded at both start and conclusion by on-screen curtains opening and closing. Its meaning depends precisely on its location within the main text, announced by narrator Deems Taylor as "a brief intermission" that separates the first and second parts of the symphony.

Audience recognitions of peritext are implicit, autonomously derived, productive of the commonplace assignments of difference that allow us to speak of the emergent 'title sequence' as an individual and separate section *within* the main text as the cinematic event progresses.[6] Duration does not alter the role of semiosis in understanding cinema (all interpretations happen as a process developing over a duration minimally determined by the enunciation itself).[7] The distinction between formative units of titles::narrative reveals how audience interpretation makes the motion picture coherent. Theorist Meir Steinberg described these shifts as fundamental "modes" of lexical engagement with 'story,' the basic building blocks audiences use to establish narrative *in* the text:

> A narrative work is composed of myriad motifs, that is basic and contextually irreducible narrative units. ... The *fabula* of the work is the chronological or chronological-causal sequence into which the reader, progressively and retrospectively, reassembles these motifs; it may thus be viewed as the second-degree "raw material" (postselected and straightforwardly combined narrative) that the artist compositionally deforms and thus re-contextualizes in constructing his work (mainly by way of temporal displacements, manifold linkage, and perspectival manipulations).[8]

The interface between the title sequence and the main text—revealed by the title's *narrative function* apart from their role as credits—is an

interpretive shift from labeling the cast and production personnel to being an exposition that engages with/as the story. Lexical articulation breaks the continuous flow of the motion picture into smaller, discrete parts; meaning originates with the low-level identifications of separate articulations in this continuous flow (Steinberg's "motifs"). Parsing the perceptual encounter into these units is a "spacing out" of shorter enunciations, the "the second-degree raw material," which the title sequence offers a unique opportunity to theorize. Film historian Garrett Stewart's comments on the integration of title sequences with narrative are instructive in marking this transition from one interpretive mode to another:

> We all know that, even though few films end effectively, most begin that way. This is because there is nothing to test the beginning against, nothing for it to fall short of. In David Bordwell's formalist distinction, it is all *syuzhet* with no *fabula* yet constructed—or not quite yet. At least for a second or two: pure structure without narrative. And structure without content is another name for a paradigm—after which the syntagmatic takes over, subordinated to the cause and effect chain of narrative linearity.[9]

It is precisely this distinction between those enunciations that serve as labels and those that provide story (exposition) that makes titles of critical interest: they are an instance where it is possible to consider these higher-level semiotics—the "structure"—as an internal transition marking a fundamental boundary in the narrative itself. This changed comprehension that Stewart invokes through David Bordwell's discussion of the shift between *syuzhet* and *fabula* (terms Bordwell adopts following Sternberg) is dependent on an identification of multiple enunciations (such as the 'title sequence') as separate, individuated units within the whole to render its shift coherent. This aspect of the transition is untheorized. Its invisibility for the audience is precisely what makes these sequences coherent, giving their *isolation* of credits from narrative an easily recognized role comparable to the "punctuation" or "grammar" of language: sequences are composed of multiple enunciations, but they distinguish *between* statements, rendering them as discrete (a separation that is understood by their audiences automatically). Without this capacity, the continuous development of cinema would appear as a constant unfolding of images, rather than specific events that become discrete narrative episodes (cause-effect chains). This organization within/between enunciations allows and enables these superficially self-evident differences between title sequence and the rest of the motion picture.

Syuzhet describes the particular, literal series of narrative events (each of which can be identified as discrete sets of enunciations organized into the higher-level sequence), while *fabula* more correctly corresponds to the "plot" or audience comprehension of how character goals and motivations are organized to become the story itself. In considering the role of abstract causality—*fabula*—Bordwell's engagement with the low-level distinctions of enunciation and sequence is limited, and his work does not address its role in the realist ideology of cinema. What appears is simply what appears. These foundational lexia are vehicles for the distinction between [1] the organization of shots, mise-en-scene and montage into cause-effect sequences that are the physical substance of the narrative construct (*syuzhet*) that becomes [2] the audience's conception of the story (*fabula*); these two high-level interpretations depend on lower-level enunciations he terms *style*:

> In the fiction film, narration is the process whereby the film's syuzhet and style interact in the course of cueing and channeling the spectator's construction of the fabula. Thus it is not only when the syuzhet arranges fabula information that the film narratives. Narration also includes stylistic processes. It would of course be possible to treat narration solely as a matter of syuzhet/ fabula relations, but this would leave out the ways in which the filmic texture affects the spectator's activity.[10]

Bordwell's' construction of narrative is split between the mere recording of events on display, and the manner of that recording (*style*), a pairing that together renders the main text's plot as a coherent unit (*fabula*), but elides the role of the sequences needed for this recognition. His designation of *syuzhet* identifies the collective organization of *all* these lower-level elements—including the title sequence— into the high-level abstraction that emerges through the modal shifts between crediting and narrative functions. What is of semiotic interest in the relationship between titles and narrative is the movement between these individual enunciations, their compilation into sequences productive of exposition, rather than the structural unity that is *fabula*. Formalist approaches specifically reject these distinctions as "stylistic," an irrelevant excess,[11] rather than engaging with their complexity. This refusal results in a fallacy that elides the particulars of these enunciations to assume that the lower-level semiotic relations productive of the distinct passages within the whole do not require theorization or close inspection. In Bordwell's analysis, the title sequence becomes simply and automatically a liminal marker, rendering its particular and complex relationship to the main text as

irrelevant: title sequences are only considered via brief mentions of them as being "self-conscious narration" in both *Narration in the Fiction Film*,[12] and *The Classical Hollywood Cinema*.[13] Titles in these studies follow the traditional realist assumptions of Hollywood studios who viewed credits with suspicion, seeing them as an intrusion into the otherwise continuously presented "world" that draws attention to the apparatus and process of cinematic form; they are a distractive eruption of *style*.

Bordwell's distinction of *syuzhet* has only a limited utility for the consideration of *how* title sequences have been integrated with the main text or their role as exposition. In theorizing the title sequence's peritextual function as anticipating/reiterating the plot or story, the *fabula* becomes a necessary referent, but one that is always deferred, an absent subject dependent on the audience's prior knowledge for its invocation: *an audience unaware of the story cannot recognize it rendered metaphorically in a title design*. The title sequence's position *as* the boundaries of this narrative construction enables the identification of *syuzhet* itself. Pseudo-independence defines the title sequence and attenuates its role as simply one sequence within the larger narrative construction of story: it is this separation that prompted Garrett to erroneously identify the titles as *syuzhet-without-fabula*. The "freedom" from the constraints of narrative development and structure—*syuzhet*—render these designs' exposition as "style" or "excess" distinct from narrative enunciation of cause-and-effect.[14]

The audience's instantaneous comprehension of the difference between the progression of narrative and the anarrativity of the credits demonstrates how paratext *is* the "traditional" conception of title sequences. To understand the title sequence as a paratext (specifically "peritext," related but independent) requires a change in attention from its role in the story's elaboration to a consideration of its morphology and structure—what Bordwell terms "style"—not as an episode within the story, but as a marginal or liminal section bordering it, what Stanitzek calls the paradox of beginning both *with* and *after* the title sequence, the paradox of cinematic paratext itself:

> As the beginning, the title sequence sets itself apart in a particular way; namely, insofar as it is endowed with its own beginning and end, it establishes itself as distinct and develops its own coherence. In turn, its own beginning might possibly be seen as set apart; as a rule, the title sequence starts with the studio's or the distributor's trademark logo, which itself acts as a kind of title to the title sequence proper as the title sequence does to the movie proper.[15]

Discussions of title sequences tend to reproduce commonplace under-standings of their roles and functions that are immediately recogniz-able. Their complexity only becomes apparent in "special" situations where the distinctions between these different roles breaks down—as opening to the motion picture, versus as an opening to narrative. The paradox may not occur to audiences while watching these "special" sequences, attending to the narrative without concern for the titles except incidentally as information about the production; however, when the title sequence is simultaneously an opening to the narra-tive, presenting the initial scenes of the *fabula* without separating the "credits" from the "story"—as in Wayne Fitzgerald's design for *Touch of Evil* (1958) where the opening long take leading up to the explo-sion that sets the plot in motion is established as the title sequence by the combination of text on-screen and theme music, or in Pablo Ferro's design for *Bullitt* (1968) where the title graphics *replace* the montage while the theme music plays—interpreting the resulting titles an enunciation concerned with the meaning and significance of the story requires a disengagement from the immediacy of the events shown, effectively separating the integrated narrative element from the unity and organization of the sequence to assert its pseudo-independence. These are different interpretations. Constructing this statement requires apprehending the design without the narrative it also contains, rendering the paradox Stanitzek describes immanent.

The credits' common position at the beginning of the motion pic-ture demonstrates their tangential relationship to the narrative itself automatically: in coming before the story has yet begun, they nec-essarily have a precarious connection to the story that follows. The uncertainties that surround the yet-to-emerge connections of cause and effect whose elaboration creates not only the *fabula*, but enables its coherent recognition as a product of the various sequences neces-sarily puts the title sequence's relationship to that *fabula* in doubt. This complex linkage to the themes and story understood as a whole differentiates the cinematic peritext from its literary ancestors: it is not simply an element independent, distinguished from the text that follows, but an integral part of its identification, progression, and development.

Pseudo-independence

Unlike other varieties of paratext such as trailers, commercials, and other promotional materials that are separate from the main text, the title sequence always directly accompanies its main text—it is

the necessary and sufficient condition that *defines* the peritext. This pseudo-independence enables the title sequence to be simultaneously *of* the main text *and* distinct from it, a parallel construction with its own internal structure, themes, and formal appearance—this shift insists on an additional level of autonomous signification for both the title sequence, and motion graphics generally, by directing attention to the title design as a self-contained entity. The audience's connection of title design to the production rhetorically masks this apparent separation that serves a semiotic function.

Title sequences are particular to the domain of cinematic form, a role that becomes apparent at the conclusion to Alejandro Jodorowsky's *The Holy Mountain* (1973): the final sequence creates a Brechtian rupture that is also the narrative's end [Figure 2.2]. "The Alchemist" (Jodorowsky himself) offers a final statement on his production and its organization:

> I promised you the great secret and I will not disappoint you. Is this the end of our adventure? Nothing has an end. We came in search of the secret of immortality, to be immortal like the Gods

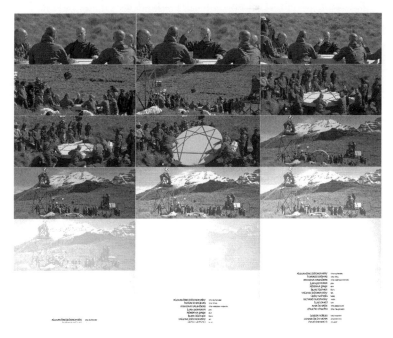

Figure 2.2 Stills from the final sequence to *The Holy Mountain* (1973)

and here we are, mortals, more human than ever. If we have not obtained immortality at least we have obtained reality. We began in a fairy tale and we came to life, but is this life reality? No, it is a film. Zoom back camera. We are images, dreams, photographs. We must not stay here prisoners. We shall break the illusion. This is Maja. Goodbye to the Holy Mountain. Real life awaits us.

While he makes this statement, the shot pulls back from his face revealing the off-screen apparatus of production: the sound boom and other production crew required to film this shot. Jodorowsky and the other actors get up from the table, walk away into the background, and the shot over-exposes to white; a moment passes as the audience becomes aware of the movie theater and the white rectangle of the screen. Then the credits scroll up that screen, returning the white rectangle to the conventional realm of cinema shown in a theater, countering the rupture created by Jodorowsky's final narrative and the shift from projected image to flat white screen; it is precisely this return to "cinema" that the credit scroll performs, its standard role as "the end" undermining the Brechtian rupture produced in the final sequence. The titles assert the "film is only a film" to negate this conclusion's *violation* of the realist and bourgeois demand for entertainment. The credits are ideological. They challenge the political dimensions of this conclusion, rendering the Brechtian moment of rupture into an un-conventional conclusion to a spectacle, neutralizing its challenge to the audience about *what to do next*. The 'change' Jodorowsky calls for is safely contained by having these credits scroll—as an aesthetic proposition, not necessarily a political one—that does not require a conscious response. The presence of these credits act as a marker that the film *has* concluded—the challenge of "now what?" the white screen offered by not having a clear marker for the end would force the audience to decide to get up and leave on their own; the credits indicate that they can leave. It is a distinction between the conscious, individual *choice* to act (get up and leave the theater, go out into "real life") and the conventional marker—end credit scroll—that is the *instruction* to leave. The interpretive shift these credits produce reverses the outwardly directed problem—the "now what?" this narration and fade to white asks—is transformed *back* into the conventional narrative functions of cinema and theater: Jodorowsky's disruptive action is countered by the reassertion of the conventional, cinematic enunciation of "fictional narrative conclusion" imposed specifically as/by the end credits.

This containment of the challenge posed can only happen because the pseudo-independence of the title sequence (in this case the closing

credit scroll) distinguishes the narrative content as a singular, self-contained unit of enunciation—even (or especially) when it is simultaneously integrated with the title sequence. The interspersed montage of title cards in *Inspector Morse*, narrative long take of *Touch of Evil*, and the invisibly integrated title card in *The Adventures of Baron Munchausen* describe distinct positions within a singular range of connections that makes the distinction between narrative comprehension and the paratextual function of title sequences explicit. The recognition that the title sequence is a singular, distinct entity simultaneously contained within the larger construction of the main text reveals its pseudo-independence for what it is: an interpretive conclusion dependent on the enunciative recognition enabled by the encapsulation of the titles through their synchronized soundtrack that marks the start and conclusion of the titles within the larger media-text itself. The *failure* of the Brechtian conclusion to *The Holy Mountain* arises precisely from the *crediting function* presented by the specific enunciation that is the scrolling credits (end titles). In place of the ambivalent and *un*resolved conclusion that would "open" the conclusion of the narrative in such a way as to counter its fictional nature—without the end credits the events of the film potentially become an episode *within* the lives of the audience, rather than a self-contained fictive entertainment engaged with and enjoyed as a domain apart from their lives. The titles serve to bring the audience "back" into the very cinematic experience that Jodorowsky's narrative and fade to white (the Brechtian rupture) undermined. This shift demonstrates how the *crediting function* of paratexts serve as a punctuating marker, signifying the beginning and conclusion for the cinematic text as a self-contained entity.

The integration of the narrative text with these opening/closing statements necessarily proceeds ambiguously, a conventional engagement where contradictory demands must coexist and interpenetrate. Yet this apparently conflicted relationship between liminal containment (as a threshold for the main text) and the self-contained morphology and structure of the title sequence (its pseudo-independence) do not typically stand in opposition to each other for the audience, only in exceptional circumstances such as the end to *The Holy Mountain* does the paratextual function conflict with the narrative it contains. Only exceptional situations demonstrate how the peritext acts to signify the boundaries of the main text by drawing attention to their otherwise unacknowledged conventional role as designating the narrative limits; all title sequences (peritexts) in cinema are integral to their main text, serving as statements indicating not only their own

pseudo-independent composition, but simultaneously designating the boundaries of the main text itself through the shift in enunciation they produce.

Intratextuality

Cinematic *inter*textuality is well theorized; *intra*textuality is not. Its central role in the organization and development of the title sequence means that it also has a central role in the interpretation of title designs generally. The problem of *intra*textuality is precisely its *interiority*— that it emerges in connections not between one text and another, absent reference, but as relations between sequences and structures contained by the same text. In acknowledging the distinction of 'title sequence' from the other narrative sequences, the audience isolates the titles, this separation allowing their deployment of visuals derived from avant-garde cinema, while at the same time rendering any innovative or challenging aspects subvervient to the narrative, a stylistic excess "decorating" the motion picture. This explanatory aspect of the *narrative function* being contained by the internal reiterations of peritext to main text enables what French film theorist and video artist Thierry Kuntzel observed in his psychoanalytic discussion in "The Film-Work 2," published in 1980 concerned with the symbolic meanings emergent in titles for *The Most Dangerous Game* (1932):

> What is fascinating about beginnings is the fact that, in the space of a few images—a few seconds—the entire film can be condensed.[16]

The opening of *The Most Dangerous Game* [Figure 2.3] begins with a brief pull back on an elaborate door knocker showing a centaur carrying a body; the first three title cards are each introduced by a hand reaching into frame and knocking. The door opens in a match-wipe to the title card for the various actors whose names are superimposed over a curtain with two candles on either side. The significance of the centaur as a signifier for both Ivan and Count Zarloff in the narrative, only becomes apparent *after* the audience sees the film; during this title sequence, their meaning remains unknown:

> There is no latent text beneath the manifest text of the credits; rather, after it, as the film unfolds, there is another manifest text in which the elements first displayed in a laconic, abridged (to use Freud's term) or condensed form, are reiterated and expanded in various ways.[17]

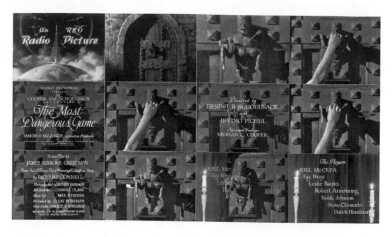

Figure 2.3 All the title cards in *The Most Dangerous Game* (1932)

Kuntzel's symbolic analysis of the linkage of peritext and main text requires that later, intratextual knowledge to make these symbols signify—their meaning only emerges from the later manipulation and contextualization of these earlier images; what is striking about *The Most Dangerous Game* is how the sequence itself is atypical of productions in the 1930s, but its organization of *narrative function* anticipates the later relational forms that become common after the 1950s: narrative function is attenuated by these titles indirect connection to the events of the story. However, in anticipating the *fabula*, the symbols are tied to those causalities—only though that connection can they become coherent, meaningful comments on the narrative. The symbols of death and desire contained by the icon of the centaur and the body it carries return throughout the *fabula* as the discovery that Count Zarloff plans to hunt the ship wreck survivors he welcomed into his house like wild animals for sport. Kuntzel's analysis explains these connections to the imagery of the titles as a series of psychoanalytic transfers in which the woman ("Eve Trowbridge" played by Fay Wray) becomes the "trophy" exchanged among the men ("Count Zarloff" played by Leslie Banks, and "Bob Rainsford" played by Joel McCrea). The location of the title sequence in relation to its narrative thus always constrains its understanding. When titles are placed at the beginning, in anticipation, this location amplifies the role of past experience in their decoding, while to be placed at the end makes any recapitulation immediately apparent.

The endemic ambivalence of title sequences' relationship to *fabula* demonstrates their pseudo-independence as peritexts, since their *narrative* interpretation always already depends on knowledge that parallels the recognitions of the credits contained by the sequence. Their relational positioning (before versus after, anticipating versus recapitulating) precisely constrains the available interpretations for the contents of title designs, but does not alter their modal organization of the materials. To acknowledge the credits requires that the audience also recognize the fundamental nature of fictional constructs— that the roles performed are simultaneously artificial (actors in roles) and a presenting a self-consistent 'reality' in which that artificiality is denied. The matching of horizontal wipe to the opening of the door is precisely such an engagement designed to suggest the entry into the performance, while at the same time being stylized in such a way to simultaneously be recognizable not as a *literal* opening, but a figurative one: the introduction of the players. The physical door opening is a symbolic entry into a narrative-fiction whose presentation remains dominated by the crediting function, as was typical for titles of this period. The *form* of this metaphoric and literal opening contains the dynamic problems of *narrative function* within the same issues of mimesis generally engaged by Hollywood productions, their specifically realist aesthetics of imitating the 'surface appearance' of the world.[18]

In linking the titles and the *fabula*, the connections of peritext::text offers an analogous interpretive *activity* to what Umberto Eco identifies as the "intertextual dialogue" operative in his discussion of serial form. The active engagement of viewers is essential to their comprehension. Past experience and established knowledge are an unavoidable insertion of referential knowledge:

By intertextual dialogue I mean the phenomenon by which a given text echoes pervious texts. Many forms of intertextuality are outside my present concerns. I am not interested, for example, in stylistic quotation, in those case in which a text quotes, in a more or less explicit way, a stylistic feature, a way of narrating typical of another author—either as a form of parody or in order to pay homage to a great and acknowledged master. . . . For example, the heroine, in the West, tied by bandits to the railroad tracks: the alternating shots show on one side the approaching train and on the other the furious cavalcade of rescuers trying to arrive ahead of the locomotive. In the end, the girl (contrary to all the expectations suggested by the topos evoked) is crushed

by the train. Here we are faced with a comic ploy which exploits the presupposition (correct) that the public will recognize the original topos, will apply to the quotation the normal system of expectations (I mean the expectations that is piece of encyclopedic information is supposed to elicit), and will then enjoy the way in which its expectations are frustrated. . . . We have texts that are quoted from other texts, and the knowledge of the preceding ones—taken for granted—is supposed to be necessary to the enjoyment of the new one.[19]

The elaboration of "intratextual signification" in *The Most Dangerous Game* that Kuntzel describes makes the same referential demands as the "intertextual dialogue" Eco explains, but with a difference: the information that illuminates these symbols—literally enables them to be symbolic—is *external* to the main text only in the sense that opening titles are peritexts, *external* to the narrative itself; the *intra*textual forms in *The Most Dangerous Game* title sequence symbolically anticipate the story that follows. The relations of all paratexts to their main texts reveals the distinction between *intra-* and *inter*textuality lies with their point of reference: a reliance on *internally* versus *externally* recognized information. Both rely on what the audience knows in advance of the particular encounter—the distinction is whether this information is gleaned from the text being considered, or must be known entirely independently of that encounter. In assuming the audience will recognize the *narrative* situation evoked by the imagery in *The Most Dangerous Game* title sequence Kuntzel analyzes, the expected recognition becomes a *material* organizer of meaning in the sequence; realism (via the dynamic range of naturalism::stylization) orchestrates applications of established expertise to render interpretation "natural." David Bordwell presents an *en passant* survey of exactly this *narrative function* used by "credit sequences" in *The Classical Hollywood Cinema*:

Classical narration usually begins before the action does. True, the credits sequence can be seen as a realm of graphic play, an opening which is relatively 'open' to non-narrational elements. (Certainly it is in the credits sequence that abstract cinema has had its more significant influence on the classical style.) Yet the classical Hollywood film typically uses the credits sequence to initiate the film's narration. Even the forty to ninety seconds cannot be wasted. . . . Some credits [in the silent period] used 'art titles' whose designs depicted significant narrative elements. . . . The sound cinema

canonized this stylized 'narrativization' of the credits sequence, assigning it a range of functions. The credits can anticipate a motif appearing in the story proper.[20]

Bordwell's concerns are with the higher-level audience interpretations of story expressed via the "exposition" conveyed within/through the titles, not with a description of their lower-level anticipations (or recapitulations) of the narrative. His theory is engaged with what happens *after* the credits are recognized as being expository—with the *results* of the audience linking title sequence to *fabula*: "narrativization" has no precise description beyond his cursory identification of the narrative connection produced by the credits in silent films such as *The Narrow Trail* (1917) where the background image of a stagecoach evokes the setting[21]—the "exposition" informs the viewers it is a "western," a recognition that draws from the audience's past experiences with the genre and similar story settings. In later films such as *The Most Dangerous Game*, this symbolic exchange (its discourse) is an indirect revelation of narrative progression—the series of transfers Kuntzel describes all focus on the woman whose appearance in the title/narrative is the animating force of the title (the female hand that knocks at the door). Her role will be as a trophy to be exchanged among men—but it can only be recognized in retrospect. Bordwell does not develop an analysis of the range or varieties of *narrative function* he briefly mentions as appearing in titles throughout the history of Hollywood cinema. He suggests their distinction from the *crediting function* provided by the typography, but their role in the recognition of the "title sequence" as such never arises. These divisions tend to be ignored precisely because their recognition is autonomous, an immediate and direct reference to itself; making these connections within the same text is seemingly insignificant, a natural feature of how interpretations proceed, but for the pseudo-independence of titles and main text, it necessarily directs attention to those linkages whose organization is necessary to produce the *fabula* from its component sequences (episodes and events).

Intratextuality is ignored in analysis simply because it is an invisible, inherent part of lexical construction. Only in special situations do these internal relationships built around reiteration and variation of the motifs within a narrative even become a point of theoretical concern: they are typically the text itself. Semiotic organization masks the more basic realism in the range of naturalism::stylization, allowing them to be both symbols *and* depiction. These low-level identifications render the world on screen as a material fact that enables

the pseudo-independence of the title sequence. The problem posed by *intra*textuality is apparent in how the connections that are the central focus of Kuntzel's analysis are not necessarily apparent in the title sequence itself, but depend on an audience's conscious choice. Understanding title sequences as narrative anticipation or recapitulation depends on their placement at the start or conclusion of the narrative, but simultaneously describes the ambivalent relationship of the motifs in this expository text to the main text—their peripheral role in the motion picture ("peritext" has the base basis as "peripheral") is not just a matter of placement or production, but of interpretation. Symbolic forms are neutered by their realist presentation. The 'autonomy' of title sequences is a historical product that mediates mutually incompatible approaches to depiction as a construct: realist ideology claims the range of naturalism::stylization in depictions *are* what they appear to be; the transition to a higher-level symbolic interpretation is an inherent challenge to this realism by necessarily unmasking the lexical code in assigning meanings beyond those of mere appearance. The potentials for critical interpretations arise in the redirection of attention away from denotation in depiction or narrative to consider explicitly non-narrative, lexical meanings.

Notes

1. Stanitzek, G. "Reading the Title Sequence (*Vorspann, Génèrique*)," *Cinema Journal*, vol. 48, no. 4 (2009), p. 45.
2. Armitage, M. "Movie Titles," *Print*, vol. 5, no. 2 (February 1, 1947), pp. 43–46.
3. Kirkham, P. "Maurice Binder's Bond Film Titles," *Sight & Sound*, December 1995, pp. 10–12.
4. Gunning, T. "The Whole Town's Gawking: Early Cinema and the Visual Experience of Modernity," *Yale Journal of Criticism*, vol. 7, no. 2 (Fall 1994), p. 190.
5. Britton, A. "The Philosophy of the Pigeonhole: Wisconsin Formalism and 'the Classical Style,'" *CineAction!* no. 15 (Winter 1988/9), p. 59.
6. Altman, R. "General Introduction: Cinema as Event," *Sound Theory, Sound Practice* (New York: Routledge, 1992), pp. 2–4.
7. Foucault, M. *The Archaeology of Knowledge* (New York: Pantheon, 1972).
8. Sternberg, M. *Expositional Modes and Temporal Ordering in Fiction* (Bloomington: Indiana University Press, 1978), p. 8.
9. Stewart, G. "Crediting the Liminal: Text, Paratext, Metatext," *Limina/le soglie del Film: Film's Thresholds*, ed. Veronica Innocenti and Valentina Re (Udine: Forum, 2004), p. 51.
10. Bordwell, D. *Narration in the Fiction Film* (Madison: The University of Wisconsin Press, 1985), p. 53.
11. Bordwell, D. *Narration in the Fiction Film* (Madison: The University of Wisconsin Press, 1985), p. 53.

12. Bordwell, D. *Narration in the Fiction Film* (Madison: The University of Wisconsin Press, 1985), p. 66, 160.
13. Bordwell, D., Staiger, J. and Thompson, K. *The Classical Hollywood Cinema* (New York: Columbia University Press, 1985).
14. Bordwell, D. *Narration in the Fiction Film* (Madison: The University of Wisconsin Press, 1985), pp. 50–53.
15. Stanitzek, G. "Reading the Title Sequence (*Vorspann, Génèrique*)," *Cinema Journal* vol. 48, no. 4 (2009), p. 45.
16. Kuntzel, T. "The Film-Work, 2," *Camera Obscura*, vol. 2, no. 2 and 5 (Spring 1980), p. 24.
17. Kuntzel, T. "The Film-Work, 2," *Camera Obscura*, vol. 2, no. 2 and 5 (Spring 1980), p. 19.
18. Rushton, R. *The Reality of Film: Theories of Filmic Reality* (Manchester: University of Manchester Press, 2011), pp. 10–19.
19. Eco, U. *The Limits of Interpretation* (Bloomington: University of Indiana Press, 1994), pp. 87–89.
20. Bordwell, D., Staiger, J. and Thompson, K. *The Classical Hollywood Cinema* (New York: Columbia University Press, 1985), p. 25.
21. Bordwell, D., Staiger, J. and Thompson, K. *The Classical Hollywood Cinema* (New York: Columbia University Press, 1985), pp. 25–27.

3 Expositional Modes

The identification of titles *as* peritexts simultaneously attenuates their relationship to narrative and creates the understanding of these sections as pseudo-independent units of exposition. Intratextual relationships between titles and the main text depend on audience engagement to create their proximate connection, revealing four distinct historically determined semiotic modes derived from [1] the formal connection between titles and narrative (direct::indirect) and [2] the audience interpretation of the relationship (introduction::restatement) that ensures their differentiation from the realist narrative. Semiotic modes linking peritext::text create exposition specific to cinematic forms, a unique reflection of the enunciative role played throughout the titles' historical development. Distinctions between peritext::text—via the formal elements contained within the title sequence—are *not* self-evident; the conclusion "narrative integration" is one potential, but its identification does not preclude *another* potential conclusion, "pseudo-independence," although they are typically conceived as mutually exclusive. This semiosis corresponds to what theorist Meir Sternberg termed "modes of existence" that define the structural principles[1] (abstractions) employed by audiences to decode and organize the various components of exposition: for motion pictures, these elements form the sequence from lower-level elements of editing, framing, compositing, synchronization, and text, as well as relationships of *crediting* and *narrative functions*. Understanding the events on screen as being a *sequence* demonstrates their relational connection—*intratextuality*—to what comes before and what follows. A change of enunciation marks a semiotic shift. The *sequence* is the interface between individual *statements* and their organization into more complex units, the *syuzhet*, which the audience interprets to create the higher levels of abstraction that explain what happens on screen, the *fabula*.

The truth table matrix in Figure 3.1 describes the four semiotic modes engaging the peritext::text dynamic: the **Allegory, Comment, Summary**

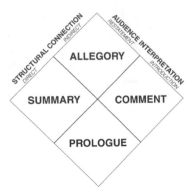

Figure 3.1 Title sequences employ four expositional modes to organize their narrative function. These different types depend on both a *structural connection* of paratext::text, and an *audience interpretation*. The various combinations possible for these paired potentials are displayed in this truth table matrix

and **Prologue** modes all characterize and reflect audience interpretation of *narrative function*, apparent in the relative understanding of the title sequence as anticipating or recapitulating the *fabula* depending on their relative position—a function of locative placement at the beginning, in the middle, or at the end, rather than an element of their design. Recognizing the 'title sequence' is a historical convention guiding audience interpretation. Internal divisions within the otherwise continuous events of the motion picture unspooling are signified by changes in exposition; recognizing the start/conclusion of a title sequence identifies such a transition. The distinction peritext::text is a construct; the realist ideology these works contain is masked by the historical processes that govern how audience interpretations parse the continuous flow of on-screen events into distinct statements and sequences, a fluid integration of title sequence and dramatic narrative is always a potential. Once established, the modal engagements that guide this semiotics remain constant, even as the *crediting function* declines in importance and the *narrative function* increases, matching the complexity of connections between titles and *fabula*.

American Feature Film Title Design Periods

Early (Experimental) Period	(beginning until ~1915)
Silent Period	(until ~1927)
Studio Period	(until ~1955)
Designer Period	(until ~1977)
Logo Period	(until ~1995)
Contemporary Designer Period	(1995 to present)

While the dates for the periodization of feature film titles produced in Hollywood are approximate and the innovations introduced or dominant in one period continue into later periods, the changes this periodization describes are obvious on examination: the dynamics of *crediting* and *narrative functions* that are foundational for peritext::text (the identification of title sequences as pseudo-independent units) align with novel innovations and differences in their design, giving these periods an empirical dimension. The semiotics of *crediting* and *narrative functions* initially emerges in Hollywood films during the codification of titles, intertitles, and other on-screen texts during the Silent Period.[2] The various roles and uses for text as "labels" in the Early (Experimental) Period[3] only suggest their later development. Terry Ramsaye noted in his 1926 book *A Million and One Nights: A History of the Motion Picture* that "As one follows the evolution of the screen art the increasing importance of the relation of the word becomes apparent. Only the primitive pictures required no titles. Pictures remained primitive until they got titles."[4] In his history, title cards arrive along with the shift to narrative feature film production. For Silent Period title sequences such as *Stella Maris* (1918) or *Male and Female* (1919), [Figure 3.2] the credits, intertitles, and live action scenes flow together as a continuous progression, as historian Brad Chisholm explained in his formalist analysis of "Identifications" (credits) between 1903 and 1927:

By the 1920s a standard procedure for introducing characters had been established in Hollywood. A long to medium shot of a person or group of persons is followed by an intertitle of identification, which is itself followed by a closer shot that isolated the named character. In many cases, the actor's name is listed in this identifying intertitle, thereby enabling the artifice of the opening to spill into the narrative.[5]

Chisholm is not describing a pseudo-independent title sequence; this conception of the motion picture is closer to an animated picture book. Fusing *narrative* and *crediting functions* provides a precedent for later integrations of narrative scenes within the title sequence itself. By the Studio Period in the 1930s, the title sequence had assumed a particular, familiar structure: dominated by the *crediting function*, its narrative engagement became schematic and generally limited.[6] These limitations do not begin to change until the 1950s, as the Designer Period begins; the three phases of the Designer Period describe formal shifts in the title sequence that allow the *narrative function* to

Figure 3.2 The opening title cards and intertitles for (TOP) *Stella Maris* (1918) and (BOTTOM) *Male and Female* (1919)

become central to the semiosis. The transition between the Early, Middle, and Late Phases corresponds to the decline in importance first for the *crediting function*, then for the title sequence itself.[7] The Early Phase, pioneered by Saul Bass, adapts Modernist approaches to graphic design.[8] These titles are specifically "signed" by the star-designer following the precedent established for print publications by Alvin Lustig and Paul Rand, and which William Golden opposed.[9] The addition of a "designer credit" to the main title sequence brought title design back into prominence not enjoyed since the Silent Period.

The expanded role of title sequence exposition during the Middle Phase was connected to changes in *how* the film begins—the challenges to the *crediting function* raised by a closer integration of narrative and marketing concerns into the title sequence.[10] These shifts correspond to a new emphasis on the *narrative function* that begin minimize the pseudo-independence of the title sequence in the Late Phase, culminating in the Logo Period, where the credits are either entirely absent, or severely curtailed in design, quantity, and prominence. The models of *Citizen Kane* (1940), *Touch of Evil* (1958), and *Star Wars* (1977) provide precedents for the Logo Period dominance of the *narrative function*. This elimination of the title sequence allows the *fabula* to begin immediately.

The twined elements that organize these four semiotic modes describe *narrative function* as an intratextual, narrative exposition that parallels the dominant *crediting function*: Structural Connection::Audience Interpretation, and their subordinate pairs, direct::indirect and restatement::introduction. The theoretical separation of these two functions is an artificial distinction, a resolution of their innate ambivalence that allows a recognition of *how* they support the range of naturalism::stylization in the realist construction of cinema. The audience fluently recognizes the separation between actor and role, reality and fantasy, external information and internal narration. Viewers are always aware of the difference between the actor and the role they perform, even if some actors do become closely identified with particular characters, such as the isomorphic relationship between Bela Lugosi and his role as "Dracula," Leonard Nimoy and "Spock," Carrie Fisher and "Princess Leia," or even Mike Myers and "Austin Powers." Lexical expertise allows viewers to navigate these differences easily, enabling the overlap of *crediting* and *narrative functions* in title sequences such as *Touch of Evil*. The intercut montage of narrative/title cards in the Prologue mode designs for both *Prince of Darkness* (1987) and the TV program *Inspector Morse* (1987), or the "replacement" of montage with kinetic

title/masks in Pablo Ferro's design for *Bullitt* (1968)[11] are examples where the *narrative function* replaces the *crediting function* of these titles. In these designs, the title sequence disappears from consideration as there is no necessarily obvious or separate role for "credits." Their integration overshadows the *crediting function* to such an extent that their pseudo-independent status is moot: the title cards are an element of montage making these "credit sequences" into the *literal* beginning of the film narration. The pseudo-independence of the *Bullitt* opening encapsulates the mystery the narrative seeks to resolve. These sequences cannot be disregarded as anterior or extraneous to the *fabula*, nor set aside as a stylistic "excess" that can be ignored in analyzing the exposition.

This intratextual dimension becomes obvious only in those rare title sequences that do not appear at the start or conclusion of the narrative, occurring instead in the middle of the motion picture, thus dividing the narrative into two sections: the lone title cards' literal role for *Fantasia* (1940) as an "intermission" that comes after *The Rite of Spring* is marked by closing the "theatrical curtains" on-screen and the screen fading to black before the fade-in on the title card; after the card's fade-out, the curtains re-open and the concert continues. This separation is precisely the point of the title's placement. Even though this title sequence has a total run time of approximately thirty seconds, its impact in terms of the narrative progression is decisive. For the duration of this title, the motion picture has stopped. Deems Taylor, the narrator in *Fantasia*, explains this break: "And now we'll have a fifteen-minute intermission." The musicians stand up and exit the "stage"; the title card placement inherently acknowledges this distinction by separating "first part" and "second part." That the title card only last thirty seconds does not mean the projectionist cannot stop the film for Taylor's suggested fifteen minutes. When the musicians return, their "tuning up" repeats the very beginning of the film.

Understanding this title card as an "intermission" is explicitly a part of *how* this title sequence has been integrated into the symphonic performance of *Fantasia* as a whole; it occupies the traditional position of the intermission in live symphony performances. Its unusual location in the middle of the film illuminates the role of audience engagement in title sequences placed more traditionally: it is *exactly* that the title sequence interrupts the progression that makes it an "intermission." The title sequence for *Fantasia*, due to its brevity, allows a precise articulation of this break anticipated by the actions preceding it: the musicians stop playing, Taylor announces the intermission, the on-screen curtains close, and then it fades to black. The formal

cessation comes only as part of an extended series of stoppages, each of which appears in reverse order when *Fantasia* "resumes" following the credits. Simply cutting to the title card might signify "finality" rather than "intermission"—causing the audience to rise from their seats and exit the theater to go home—an interpretation appropriate to the role of credits as a *conclusion*, as with the end of *The Holy Mountain*. The exposition created by the "intermission" in *Fantasia* is not coincident with the duration of the title card. It begins after the conclusion to *The Rite of Spring* and includes a variety of shots that more properly resemble the narrative action. This ambivalence is typical of the complexity surrounding the title sequence apart from its *crediting function*.

The Metro-Goldwyn-Mayer logo [Figure 3.3] that designer Saul Bass recasts as a duotone image in black and green at the start of *North by North West* (1959) demonstrates not only the clout[12] that Bass had acquired in 1950s Hollywood—his redesign of a studio logo to match his titles was unprecedented, even in the Studio Period—but it also reveals an emergent, overarching concern with the integrity of the title sequence as a pseudo-independent unit *starting* the film itself. The title sequence mediates the beginning or ending of the film—anticipating or recapitulating its contents, the pseudo-independent opening separates the narrative section of the film from the other material—typically even the studio logo—that precede it. End credits function similarly as a statement of finality, that "The End" has arrived and the audience can leave without missing anything. The occasional practice of adding "Easter Egg" scenes after the conclusion of the credits do not change this relationship: their function as *special* extras only makes sense when the end credits/scroll signify "The End."

Engaging with the symbolic particulars of the narrative are not limited to designs by Bass; in shifting concern from the legibility of typography to the visual experience of watching the title sequence, this change enabled the intensification of the title sequence as a fully autonomous opening, an approach common during the 1960s, and evident throughout film-series such "James Bond." Walt Disney's introduction to "The Title Makers," a 1961 *Adventureland* segment on his TV show *Walt Disney Presents*, explained this 'new' emphasis on the title sequence emerged with the return to crediting the title designer on-screen during the main title sequence:

> Now time was you know when you could open a motion picture merely by flashing its title on the screen and listing the names of

Redesigned Metro-Goldwyn-Mayer logo with Leo from *North by North West* (1959)

Slats (1916-1928)

Jackie (1928-1956; black and white)

Coffee (1932-1935; Technicolor tests)

Tanner (1934-1956; Technicolor)

George (1956-1958)

Leo (1957-today)

Figure 3.3 The Metro-Goldwyn-Mayer logo redesign in duotone by Saul Bass for *North by North West* (1959) with the standard MGM logos and the dates of their use for comparison

the people who helped put it together, but not anymore. We've reached the point where almost everybody wants to make a bid for the title as the "most ingenious" of the title makers. It has become a real challenge to devise a sequence that is fresh and interesting and entertaining. Also according to theory, it should also help to get the audience into the proper frame of mind.[13]

A short filmed sequence to "help to get the audience into the proper frame of mind" could take *any* form; however, the concern with this approach is new, contrasting sharply with Merle Armitage's comments only fifteen years earlier. The change Disney acknowledges defines the Early, Middle, and Late Phases of the Designer Period. These differences in *narrative function* are immediately apparent in a shift toward spectacle in the Middle Phase, followed by the "opening sequence" becoming a means to prioritize narrative information quite apart from concerns with credits in the Late Phase.[14]

Presenting backstory through an on-screen text is commonplace in cinema, starting with the use of intertitles (i.e., specifically *expository* intertitles[15]) in the Silent Period to summarize and provide commentary on story or discourse about the events in the drama.[16] These associations of title sequence and *fabula* are generally reversible— the same design can function as either anticipation or recapitulation of the drama—giving the *narrative function* a scope beyond just the proximate relationship of peritext::text to potentially include epitexts as well; the semiotics of paratexts are subordinate to and productive of higher-level expositions of *syuzhet* and *fabula*. The 'title sequence' demonstrates the importance of audience interpretation as creating the interface between different levels that depend on identifying not only the title's *crediting function* (which defines the title sequence as such), but recognizing how the *narrative function* links these varied sequences to produce both *syuzhet* and *fabula*, linking the range of naturalism::stylization in the titles to the realism of the fictive drama, a change that leads to the subordination of credits to narrative.

The Allegory Mode

Allegorical interpretations of the intratextual connection between title sequences and the main text they accompany are simultaneously either so simple and immediate that they don't appear to be allegorical, or they develop as a subtle and apparently indirect connection. The resulting range of potentials reveals the complexities of allegorical relationships themselves. Media historian Solange Landau's

proposal of the "Ästhetische Intro" (Aesthetic Intro) for TV show titles acknowledges how the Allegorical mode presents an "interpretation" of the series' themes.[17] Her designation identifies one implementation of the Allegorical mode, focusing on only its particular development for Television; this variant is part of a wider range of indirect restatements of the main narrative via its themes. The role of realism in these designs is optional, allowing the full range of naturalism::stylization in their imagery. At their simplest, Allegory mode designs have an immediately apparent connection to the narrative, one where the imagery of the title sequence displays and aligns with the film's *title* itself. *Rumba* (1935) [Figure 3.4] is precisely such an example of this proximate association: a collection of shadow-figure women move on-screen in Spanish-style dress, their rhythmic movements suggesting they are dancing a rumba. Connections of this type are so instantly recognizable that their placement within the range of allegorical associations seems unnecessary, yet it is precisely this spontaneous connection that makes the less obvious connections of other allegorical examples coherent. Allegory, like metaphor, depends on the audience recognizing and interpreting the indirect connections that lie between what is actually being shown and their understanding of the significance of that design. Past experience decrypts the allegory. While it seems "obvious" the women are dancing a rumba in *Rumba*, the motions of their shadows are framed in such a way that this identification of *what* they doing is set-up and directed by both the music played (a rumba) and the film's title appearing after the studio logo. Their motions, when viewed silently, are ambivalent about *what* they

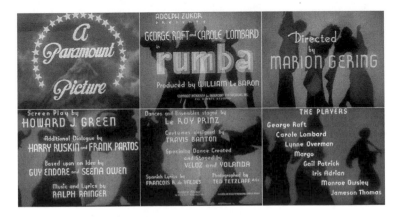

Figure 3.4 All the title cards in *Rumba* (1935)

are doing actually means: they are really just walking around in front of some bright stage lights so they cast shadows on a wall.

The immediacy of the allegorical connection masks how its symbolic aspects depend on specific recognitions to invent meaning; thus, a stylization of the imagery, whether realist photography or abstract graphics. For those designs where recognizing the symbolic link to the narrative is readily apparent, as in the works of Saul Bass who promoted the Allegory mode,[18] these less-immediate connections are of greater interest than the superficially proximate literalness of designs such as *Rumba*. Bass discussed his innovations in an interview with film historian Pamela Haskin:

> My initial thoughts about what a title could do was to set mood and to prime the underlying core of the film's story; to express the story in some metaphorical way. I saw the title as a way of conditioning the audience, so that when the film actually began, viewers would already have an emotional resonance with it. . . . My actual entry into film began when Otto asked me to design a title for *The Man with the Golden Arm*. This opportunity grew out of my having designed the original graphic symbol for the film.[19]

The 'symbolic dimension' of the twisted arm that concludes *The Man with the Golden Arm* (1955) is the most famous part of this sequence, and Bass suggests it is the only part of the design that has symbolic content; however, the design itself contradicts his reductive explanation [Figure 3.5]. The "metaphorical" expression is explicitly a function of not just the final, twisted arm appearing at the end of the sequence, but the white lines/needles appearing throughout it and which are the dominant element within the design. His proposition that *only* this final image, the twisted, graphic arm created from the white lines via an animorph[20] symbolically encapsulates the narrative is questionable, as are his claims that his work "constituted a reinvention of the film title."[21] The separation between the allegory in *Rumba* and *The Man with the Golden Arm* is not as great as Bass suggests. Although his designs reduce the narrative to dominant symbols that become the conceptual focus of the graphics, in *The Man with the Golden Arm* this "reduction" produced an arm and needles. This arm can be easily recognized as the same type of literalization operative in the title for *Rumba*: it is a rendering of the "golden arm" on-screen in the same way that the dancing women perform a "rumba."

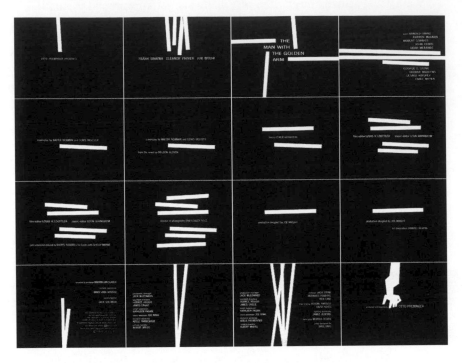

Figure 3.5 All the title cards in *The Man with the Golden Arm* (1955)

The allegorical meanings of *The Man with the Golden Arm* have two distinct levels in the exposition: [1] where the imagery of the twisted arm has a recognizable connection to the film's title, a feature it shares with *Rumba* and many other earlier designs; [2] via the narrative anticipation that only becomes apparent in retrospect. To identify the white lines as representing "needles," and not dismiss them as decorative graphics, requires the audience to *already* know the story is about heroin addiction. Bass-as-innovator lies with his visually reductive styling and his work as a self-promoter,[22] rather than his transformation of the organization and structure of title sequences themselves; the "reinvention" of title sequences produced by *The Man with the Golden Arm* is a product of its highly Modernist design, an issue of style rather than meaning. The Allegory mode had been in use since at least the 1930s, long before Bass produced this title sequence.

Graphically, *The Man with the Golden Arm* breaks with the tradition of making the text fill the screen—fundamentally a question of legibility—a design decision dictated by the difficulties of projecting

films in large theaters where the typography needed to be large enough to be visible at the back of the theater. Merle Armitage, an impresario and gallerist better known for his work as an avant-garde book designer,[23] produced several title sequences for MGM such as *The Hucksters*, *Living in a Big Way*, or *Green Dolphin Street* (all 1947). He explained these formal constraints imposed on title designers in an article published in *Print* magazine:

> A book page is generally taller than it is wide, and a book designer becomes accustomed to working with that shape in various dimensions. But the motion picture camera "frame" is wider than it is high, and that makes a considerable difference in the approach to the problem. Even one of the most successful, experiences, and competent men in motion pictures first overlooked the fact that unless the lettering is expanded to the full possible size of the screen frame it will not *carry* to the comparatively remote sections or balconies in large motion picture theaters, and in some of our first attempts in arranging type on the surface of film were interesting, but at a distance unreadable. The necessity to use type in its largest dimension, or to cover the entire available space with lettering, puts the designer in somewhat the position of the singer who must continuously sing at full voice. When all the factors are considered, there seems but a very limited range at the disposal of anyone who elects to keep motion picture titles simple, dignified, and readable.[24]

Legibility as an operative constraint served to strictly limit the options available for the designs that Armitage produced to centrally placed arrangements of simple typefaces with minimally graphic backgrounds (neutral, with subtle patterns that allowed the typography a maximum of contrast) [Figure 3.6]. The elimination of even the 'neutral' background of grey-on-grey pattern Armitage employs in Bass' design for *The Man with the Golden Arm*—a black background fills the screen—increased the contrast of his typography, allowing more freedom to employ smaller typefaces for both the main title card and the other credits, thus enabling a greater focus on the graphic elements as equally significant to the text. This de-emphasis on typographic composition is not unique to Bass; it is a common element of those text::image composites such as the calligram and rebus appearing in title sequences throughout their history.[25] The shift from a primarily text-oriented design to one that is graphic or imagistic is a precondition for creating the symbols Bass tells Haskin are the central focus of his designs.

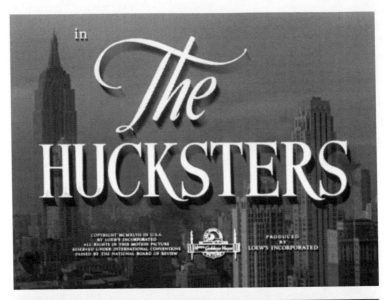

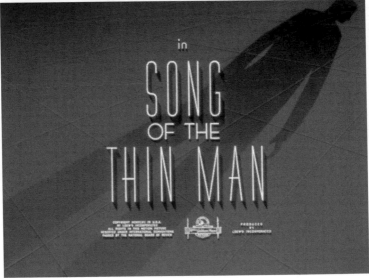

Figure 3.6 Traditional title card design in *The Hucksters* (1947) and Modernist design in *Song of the Thin Man* (1947) designed by Merle Armitage for MGM

Symbolic meaning defines allegory. Associating the title sequence with the main text through thematic imagery dominates title designs of the 1950s and 1960s; the Allegory mode is associated with the high prestige openings that Walt Disney describes. The indirect connection to narrative and the ambivalent statement of its themes rewards those viewers who recognize and understand the allegorical "code." The suggestive and allusive dimensions of the avant-garde, with its focus on creating ambiguity, provides models for these designs. Concern with projected images as a physical material—an approach that will become increasingly common in avant-garde "structural films" of the later 1960s that P. Adams Sitney famously described as using a "fixed camera position, the flicker effect, loop printing and rephotography"[26]—appears in designer Robert Brownjohn's two title sequences for the James Bond series from the early 1960s, *From Russia With Love* (1963) and *Goldfinger* (1964). He explained these designs in his article "Sex and Typography," describing how thematic concerns determined both his imagery and its presentation:

> On this type of film the only themes to work with are, it seems to me, sex or violence. I chose sex. . . . In considering the problems of the integration of type and image I had often wondered if film titles did not provide an opportunity for a different solution from the usual technique of superimposing type in the laboratory. . . . I painted a girl with gold make-up, had a gold leather bikini made for her, and with a 100 amp. back-projection unit projected moving pictures over her and filmed this in color. The girl became, in effect, a three-dimensional gold screen, with running figures, explosions, and fight sequences moving across her body. The actual images I projected were scenes from all three James Bond films—*Dr. No*, *From Russia with Love*, and *Goldfinger*—and they formed a sort of moving collage.[27]

Brownjohn's description of "sex" as the thematic focus the *Goldfinger* title sequence is immediately apparent: the female body is a *literal* 'screen of desire' and 'field of action' for shots taken from *Dr. No* (1962), *From Russia With Love*, and *Goldfinger*. The thematic symbolism of vision—sexuality dominates any potential *narrative function* in both his designs, and continues in those of Maurice Binder. The 'thematic' focus—*sex*—Brownjohn describes is typical of how the Allegory mode indirectly addresses the narrative as a symbolic arrangement of iconic images, their cause-effect (*syuzhet*) relationships elided, explicitly separating the title sequence presentation from

the *fabula* in an assertion of that sequence as pseudo-independent enunciation. The voyeurism apparent in Brownjohn's organization of body-as-screen in *Goldfinger* [Figure 3.7] is a summative presentation of the traditional gendered hierarchy of vision and social power: in patriarchy, the gaze is masculine, a dominating force that understands the female body as a *thing* that symbolically represents heterosexual desire in the Bond films.[28]

The use of Allegory mode in Brownjohn's design is obvious in how the 'cut scenes' from the first three James Bond films (*Goldfinger* is the third in the series) are mixed together so they neither imply a story, nor introduce characters. The sequence begins and ends with a woman's gold-painted hand, the image of "Auric Goldfinger" (played by Gert Fröbe) projected on it—literal *golden fingers*—however, only the credits for Sean Connery who is "James Bond" and Honor Blackman as "Pussy Galore" have their names matched to their images; no other title cards are calligrams. Aside from the occasional alignment of images to the lyrics—such as the opening and concluding shots of "Goldfinger" with the lyric naming him that also serves to visualize the film's title—the narrative connections of peritext::text remain ambiguous, allowing Brownjohn's design to be understood as a traditional literalization of the film's name. The main text that follows is

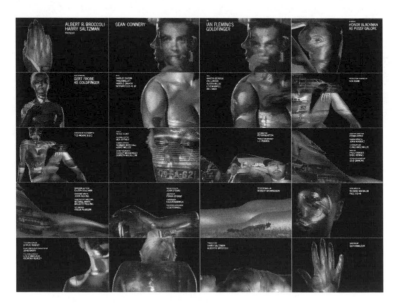

Figure 3.7 All the title cards in *Goldfinger* (1964)

neither necessary for the peritext's comprehension, nor is its *fabula* implied in the titles. The fragmentation of 'cut scenes' projected on the golden, female body are transformed by this projection to such an extent that their origins and capacity to reveal *fabula* are attenuated by their new role as a self-contained peritext. The *Goldfinger* title sequence does not invoke *syuzhet*. Instead, this sequence presents a series of suggestive, sexually provocative units to decorate each title card. His association of body-screen-image is a literal presentation of the female body as the surface over which male fantasies of power and dominance play, an exemplar of what Laura Mulvey called "the gaze" in her article "Visual Pleasure and Narrative Cinema," a precise example of traditional erotic spectacle:

Women displayed as a sexual object is the leit-motif of erotic spectacle: from pin-ups to strip-tease, from Ziegfeld to Busy Berkeley, she holds the look, plays to and signifies male desire.[29]

Mulvey's comments could have been written specifically about how the *on-displayness* of the female body in *Goldfinger* becomes a literal 'explicit' support for the 'sex' that is central to Brownjohn's' design: an explosion spreading across the model's back in the non-title card image that comes before the producer credit. The self-evidently *artificial* space of heterosexual male fantasy signals the distinction between titles and narrative whose scenes are partially shown in projected form. The themes of vision—sexuality introduced to these titles by Brownjohn will be inflected and developed into a rhetoric of seduction by Maurice Binder's transformations of the schema on view in *Goldfinger*. The allegory in *The Spy Who Loved Me* (1977) [Figure 3.8] uses synchronization with the theme song to make the sexual themes and imagery Binder inherited from Brownjohn into a shifting domain of power and dominance: *whose* desire is on display is ambivalent.[30] These sequences deflect the patriarchal order Mulvey critiques through a subversive re-presentation of its own established codes,[31] their *seduction* countering the suggestion these titles *only* present the female body as a threat, sex object, or victim of violence.[32] This female 'role play' is a set of reversals, the apparently voyeuristic imagery challenged by the lyrics sung by Carly Simon. The synchronization of lyrics-imagery develops the transformations of power implicit in seduction.

In contrast to Binder's challenge to the patriarchal gaze, Karin Fong's homage[33] to these earlier designs for *This Means War* (2012) renders the female body in an embrace of the traditional positioning

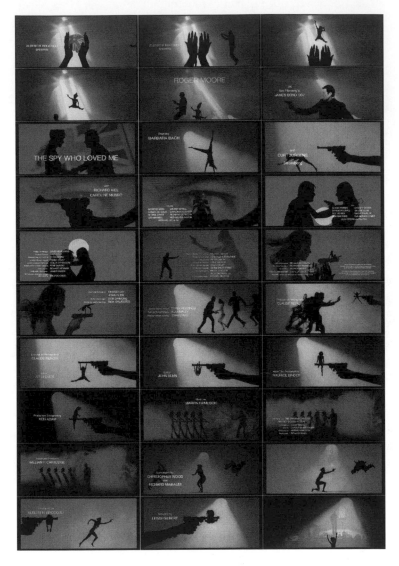

Figure 3.8 All the title cards in *The Spy Who Loved Me* (1977)

of 'female' as the battleground for/of heterosexual, masculine desire [Figure 3.9]: a fully nude female body is covered with projected images of maps while moving through a variety of suggestive poses censored by the framing of the shot. This literal presentation of the female body as a landscape—a disempowering image that is not only

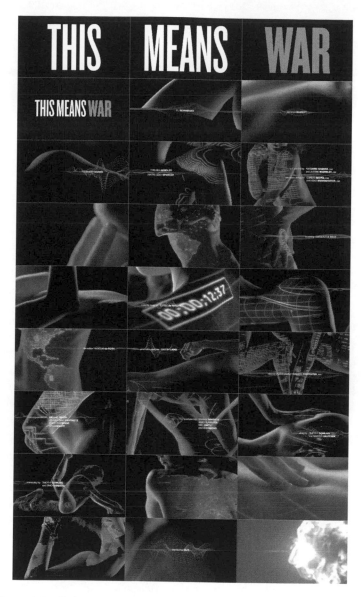

Figure 3.9 All the title cards in *This Means War* (2012)

a 'sex object' for masculine attention, but 'property' to be seized and held—allegorically prefigures the romantic conflict of the narrative where two male spies (played by Chris Pine and Tom Hardy) fight with each other when they discover they are both dating the same

female spy ("Lauren" played by Reese Witherspoon). The conflict is between the men; she is their trophy; *her role in dating them is ignored*. The title cards at the beginning of the title sequence stating the film's name also reveal this conflict simultaneously—"This"—"Means"—"War"—appears one word at a time, synchronized with the repeated lyric "Love" from theme song *Good Love* by Kram, offering a traditional connection between imagery and title without the need to recognize or consider any "intertextual dialogue."

Territorializing the female body recreates the positioning of women as trophies to be claimed by the male protagonists, implicitly reinforced by the linkage to normative gender roles of patriarchy that Mulvey critiques: masculine (audience) and feminine (image). The sequence is an autonomous playing out of female on-displayness that embraces the visualized, gendered hierarchy Mulvey's theory anticipates *for* the images shown. That these positionings anticipate the narrative precisely only becomes apparent to audiences that *already* know the events of story-to-come. However, the intertextual schema of "sex and typography" that Brownjohn developed for the earlier James Bond films is more obvious and apparent in Fong's design than its narrative linkages—its quotational references to the earlier design for *Goldfinger* overshadows the intratextual connections offered by the Allegory mode simply because the allegoric linkages require knowledge of the specific and immanent text-to-be-engaged, while the recognition of "James Bond" in this design merely requires a knowledge of a famous and well-known title sequence produced nearly fifty years earlier. This exposition requires past knowledge of the future *fabula* (narrative futurity) to make the symbolic cohere: there are more opportunities to know the two designs by Brownjohn or the many designs by Binder that develop this schema than there are to know the narrative of *This Means War*.

The Allegory mode introduces the main text ambivalently: without prior knowledge or past experience to identify the narrative's presentation symbolically in the title sequence, there is only a limited capacity for the audience to make the appropriate associations to render the allegory immanent. The simple connections that literalize the film's title, while entirely different than the *fabula*, are a typical part of the selection and design of title sequences in Hollywood productions. They do not require, nor do they prompt, much analysis or consideration, precisely because their relationship to the film title (name), once made, forecloses on further development. Understanding the relationship of title sequence to film's title thus becomes a simple exercise in recognition—the literalization of the commonplace expression *as* the

imagery of the design. No further analysis or consideration is required for it to 'make sense.'

Lexical Expertise

Identification of a title sequence as employing a more complex alle-gory concerned with the *meaning* of the film (a higher-level organi-zation for their emergent meaning) depends on the identification of lower-level signs within that sequence, communicated through rebus mode title cards and synchronized with the music to articulate them as discrete *statements*. Lexical fluency demonstrates an embrace of the assumptions in the encoding system. Unlike the formalism of lexical form, the symbolic structures of naturalism::stylization that enable allegory require a conscious decision by their audience; nar-rative references depend on existing knowledge of their connections to become meaningful indices of the *fabula*, as semiotician Umberto Eco explains:

> Signs are natural events that act as symptoms or indices, and they entertain with that which they designate a relation based in the mechanism of inference (if such a symptom, then such a sickness; if smoke, then fire). Words stand in a different relation with the thing they designate (or with the passions of the soul they signify or, in Stoic terms, with the proposition—*lekton*— they convey), and this relation is based on mere equivalence and biconditionality.[34]

His distinction between *words* and *signs* allows a recognition of the separation between specifically lexical interpretations and those emer-gent in the ascription of meaning to what are specifically experiential phenomena. The *recognification* of visuals as signs is an autonomous phenomenon whose emergent understanding is specifically elusive when *not* engaging with the formalism of lexical form. Interpreted meanings of this type require their audience to recognize they are demonstrative of other factors, what Eco calls their inferential *cause*, within the ambiguity of their presentation. This attenuation of mean-ing renders the Allegory mode an evasive construction, contingent on potential audience identifications/recognitions deploying exist-ing knowledge in the immanent title sequence. Identifying cinematic peritext is a product of instabilities between the internally consistent structure of the title sequence, and its association/subsumption within the larger, higher-level engagement with the whole text. Shift-ing between low-level identifications of découpage and independent

symbolic meaning (the title cards), middle-level engagement with the title sequence itself, the higher-level integration of opening sequence to other, narrative sequences, and finally to the high-level comprehension of the *fabula* happens autonomously, primarily without conscious consideration or the need for significant analysis: these changes of 'level' are the interpretive process in motion pictures.

Allegory modes are *always* concerned with expressing the *fabula* indirectly, in a way that is not necessarily apparent to its uninformed viewers. Understanding a design such as *This Means War* or *Walk on the Wild Side* through the Allegory mode as an anticipation of the *fabula* depends on a recognition that must be 'discovered' to render their content apparent. As in Fong's design for *This Means War*, the title sequence for *Walk on the Wild Side* (1962) presents the conflicts of the narrative as the symbolic content of the design [Figure 3.10].[35] This live action title sequence shows a black cat walking through an array of cement pipes and chain link

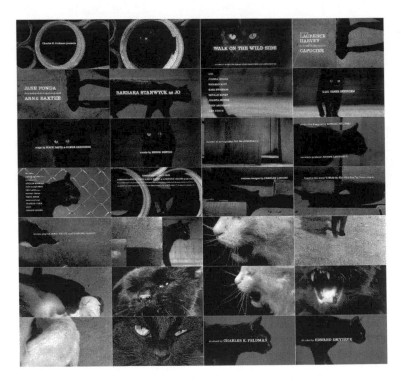

Figure 3.10 All the title cards in *Walk on the Wild Side* (1962)

fencing, climaxing with a short fight with another, white cat. This same black cat only appears at the very conclusion of the narrative, along with a newspaper headline about "Jo" (Barbara Stanwyck) and her accomplices being sentenced to many years in prison. The titles play on the film's name: "walk on the wild side" is an everyday expression describing a short excursion that results in adventurous and ethically ambiguous behavior away from the "straight and narrow." It encapsulates a safe, bourgeois "adventurism"—excitement without threat. The literal progression of the title sequence follows exactly this understanding of the expression—the cement pipes are both straight and narrow, the progression of shots from walking to cat fight mirror the shift from a confined, everyday to the exciting conflict found just outside it; these recognitions of how the sequence illustrates the *meaning* of the title have nothing directly to do with the main text or the *fabula*. The more complex allegorical content only emerges from the recognition of higher-level semiotics, originating with a structural contrast between image and typography established via rhetorical juxtapositions dependent on intertextual knowledge—such as *metonymy* and *synecdoche*—rather than via the mutually reinforcing, but independent illustrational links of the calligram mode.[36] The complex varieties of the Allegory mode depend on lexical expertise: expository links are commonly made via rebus mode title cards where the text-image composite creates an indirect connection, this association reflecting the encultured knowledge of the text::image play in children's books that contain word-image puzzles.[37] Text and image are entangled, producing an ambivalent meaning dependent on past experience, a shift from the immediacy of illustrating the film's title in designs such as *Rumba* or *The Man with the Golden Arm*.

The close association of Saul Bass with the Allegorical mode in the 1950s and 1960s captures his repeated use of allegory as a complex, secondary level in the distinction of peritext::text that produces a closer association between these pseudo-independent statements, but only for those viewers who recognize the connections. In his design for *Walk on the Wild Side*, the duplicity of meaning is both [1] the understanding of the sequence as an illustration of the film's title, an interpretation accessible to most of its audience, and [2] as an allegorical presentation of the conflict between "Jo" (Barbara Stanwyck) and "Kitty" (Jane Fonda) for viewers who already know the *fabula*. The title card stating "Barbara Stanwyck as Jo" is a rebus: white text superimposed over the body of the black cat assigns her the role of a prowling cat. For this recognition to connect the opening to the

story requires knowledge that the narrative will take place in a New Orleans bordello ("cat house") and concerns what happens to "Kitty" as she gets into trouble with "Jo"—a series of associations reliant on past experience and knowledge of the story-yet-to-come (an intratextual engagement that anticipates the story).

The rhythmic montage follows the languid (and slightly slow) motion of the cat as it stalks between and through cement pipes and past industrial fencing. There is no real "space" for this action except the abstracted volume composed from stark contrasts between black-white-grey fields shown on-screen: the cat's initial appearance out of the darkness in a pipe at the start of the sequence establishes the tone for the montage that follows. It is this "discovery" of what hides in the darkness that renders the sequence as a visualization of what the title means. In literally following the cat *walking*, the link of action shown to film title is ensured. The cat struts across the screen in slow motion to the music, rendered large by the framing, in a reverie on its capacity for sudden violence—the cat fight is filmed with slightly fast motion, the cat's threatening calls masking the acceleration of the footage; yet the allegorical comprehension of these actions changes their significance. The 'black cat' as a symbol in art is well known: it appears prominently in Edouard Manet's *Olympia*, at the feet of model and fellow painter Victorine Meurent, a sign suggesting promiscuity and demonic association, for black cats have long been known as a witch's familiar.[38] The black cat and its graphic connection to "Jo" in these titles invites an allegorical reading of her as demonic, witchy, informing viewers of the conflicts to come.

The problem that allegory presents is precisely this dependence on existing knowledge that is then simply reconfigured, offering a duplicitous second meaning distinct from the immediate one. The novelist Jorge Luis Borges critiques it as an aesthetic form in "From Allegories to Novels," his comments on allegory provide an explanation of the interpretive complexity that he sees as its primary definition:

> "The allegory is not a direct mode of spiritual manifestation, but rather a kind of writing or cryptography." Croce does not admit any difference between the content and the form. The latter is the former and the former is the latter. The allegory seems monstrous to him because it aspires to encipher two contents into one form: the immediate or literal one (Dante, guided by Virgil, comes to Beatrice) and the figurative one (man finally comes to faith, guided by reason). He believes this way of writing fosters tedious enigmas. . . . With one form of communication declared

to be insufficient, there is room for others; allegory may be one of them, like architecture or music. It is made up of words, but it is not a language of language, or a sign of other signs. For example, Beatrice is not a sign of the word *faith*; she is a sign of active virtue and the secret illuminations that this word indicates—a more precise sign, a richer and happier sign than the monosyllable *faith*.[39]

The necessity of already having the "key" to decode the allegory necessarily means its duplicity is also its interpretive interest: the Allegory mode is one where the rhetoric of synecdoche and metonymy become organizational principles. The "reward" audiences receive for their correct decoding is an affirmation of the established order they already know. The problems that allegory poses for literature are compounded by the already-ambivalent nature of imagery and motion pictures. That the Allegory mode is precisely oriented toward the main text—the *fabula* provides the "key" to understanding these symbolic structures—resolves the "tedious enigma" decisively through its recapitulation of the proximate (but not immanent) narrative. Allegory depends on recognizing a 'signal' provided by the rebus—for example, the text "Barbara Stanwyck as Jo" superimposed over the walking cat—that there is a parallel being drawn between the progression of title sequence and the characters in the narrative. Without this recognition, the Allegory mode does not become coherent; the literalness of cat walking, the name of Jane Fonda's character ("Kitty"), and metaphoric description of bordello as "cat house" act to affirm the allegory, additional links that bring attention to the assignment of "Jo" to the black cat. Allegories tend to be tautological, justified by the coherence of the interpretations they produce.

As exposition, the Allegory mode repeats the same problematics contained by the peritext::text relationship for cinema: the marking of difference depends on the semiotics it enables, rather than being a formative and material separation between one and the other. Only through the judicious and informed transfer between these semantic units does their distinction emerge, posing the paradox of their emergence for interpretation since its arbitrary and capricious nature threatens to dissolve one into the other; however, this rarely happens.

Exposition organizes ideology: thematic motifs, narration, and differentiated sections within the narrative, not just between opening and *fabula*. Assuming viewers are 'passive' is a fallacy; the hypothetical "average reader" is intimately involved in the maintenance of this construct. Audiences *do* recognize the difference between titles

and narrative, often precisely, even when they flow into each other, as with *The Player* or *Touch of Evil* whose opening long takes contain significant narrative development. The invisibility of all these modes derives from and justifies the pseudo-independence of the title sequence, but it also enables the "naturalization" of any meanings presented *in* the exposition. Allegory is adept at misdirection, denying the suggestions it produces—its diffuseness allows these expository texts to make specific statements about the *fabula* while simultaneously *not* making any statements at all.

Allegory always says one thing while indirectly making a second, alterior statement for those audiences with the lexical expertise to recognize and understand the transpositions that reveal the "other" meaning. These shifts are fundamentally about intertextual knowledge employed to decrypt designs and imagery whose meaning is not contained in their own structure or intratextual development, deriving instead from a relationship to some other text. This encrypted meaning emerges as a fragmentary statement, dispersed, dividing its audience into those who "know" and those who "do not." The Allegory mode, in spite of its logical and descriptive difficulties, is easily recognized and understood because of the role that past experience and established expertise have in shaping all interpretations. It is an exaggeration of the referential and indexical nature of all signification; audiences who acknowledge the allegory reconceive the title sequence as a space of rhetorical inflection where lower-level interpretations become signifiers in a higher-level abstraction. In offering the potential for independent meanings beyond the objective contents, allegory opens the titles to the extent these ambivalences are not reducible to commonplace observations or lexical description.

Notes

1. Sternberg, M. *Expositional Modes and Temporal Ordering in Fiction* (Bloomington: Indiana University Press, 1978), pp. 10–12.
2. Gaudreault, A. and Barnard, T. "Titles, Subtitles and Intertitles: Factors of Autonomy, Factors of Concatenation," *Film History*, vol. 25, no. 1–2 (2013), p. 83.
3. Mahlknecht, J. *Writing on the Edge* (Heidelberg: Universitatsverlag Winter, 2016), pp. 17–34.
4. Ramsaye, T. *A Million and One Nights: A History of the Motion Picture*, Two Volumes (New York: Simon and Schuster, 1926), pp. 267–268.
5. Chisholm, B. "Reading Intertitles," *Journal of Popular Film and Television*, vol. 15, no. 3 (1988), p. 138.
6. Chisholm, B. "Reading Intertitles," *Journal of Popular Film and Television*, vol. 15, no. 3 (1988), pp. 137–142.

7. Betancourt, M. *The History of Motion Graphics: From Avant-Garde to Industry in the United States* (Rockport: Wildside Press, 2013).
8. Spigel, L. "Back to the Drawing Board: Graphic Design and the Visual Environment of Television at Midcentury," *Cinema Journal*, vol. 55, no. 4 (Summer 2016), pp. 28–54.
9. Golden, W. "Type Is to Read," *The Visual Craft of William Golden*, ed. Cipe Pineles Golden, Kurt Weihs and Robert Stunsky (New York: George Braziller, 1962), pp. 13–35.
10. Rosen, B. "The Man with the Golden Arm," *The Corporate Search for Visual Identity* (New York: Van Norstrand, 1970), pp. 101–106.
11. Betancourt, M. *Semiotics and Title Sequences: Text-Image Composites in Motion Graphics* (New York: Routledge, 2017), pp. 92–100.
12. Horak, J. *Saul Bass: Anatomy of Film Design* (Lexington: University Press of Kentucky, 2014), pp. 233–234.
13. "Adventureland: The Title Makers," *Walt Disney Presents*, broadcast on ABC, June 11, 1961.
14. Betancourt, M. *The History of Motion Graphics: From Avant-Garde to Industry in the United States* (Holicong: Wildside Press, 2013), pp. 210–222.
15. The two general categories of "intertitle" were established early in the Studio Period. By 1920 the difference between *expository intertitles* that address, summarize and describe the diegetic events (of which the title sequence remains the most familiar), and *dialogue intertitles* that convey information contained within the diegesis were standard conventions of narrative exposition.
16. Chisholm, B. "Reading Intertitles," *Journal of Popular Film and Television*, vol. 15, no. 3 (1988), pp. 140–142.
17. Landau, S. "Das Intro als eigenständige Erzählform. Eine Typologie," *Journal of Serial Narration on Television*, vol. 1, no. 1 (Spring 2013), pp. 33–36.
18. Bass, S. "Film Titles—a New Field for the Graphic Designer," *Graphis*, no. 89 (1960), pp. 208–215.
19. Haskin, P. and Bass, S. "'Saul, Can You Make Me a Title?': Interview With Saul Bass," *Film Quarterly*, vol. 50, no. 1 (Autumn 1996), pp. 12–13.
20. Quist, A. "Developing Expressive Ani-Morphs," *Animation: An Interdisciplinary Journal*, vol. 12, no. 1 (2017), pp. 7–27.
21. Haskin, P. and Bass, S. "'Saul, Can You Make Me a Title?': Interview With Saul Bass," *Film Quarterly*, vol. 50, no. 1 (Autumn 1996), p. 12.
22. Horak, J. *Saul Bass: Anatomy of Film Design* (Lexington: University Press of Kentucky, 2014), pp. 13–21.
23. Dawson, M. "Edward Wesson and Merle Armitage," *LA's Early Moderns: Art, Architecture, Photography*, ed. Victoria Dailey, Natalie Shivers and Michael Dawson (Los Angeles: Balcony Press, 2003), pp. 253–257.
24. Armitage, M. "Movie Titles," *Print*, vol. 5, no. 2 (February 1, 1947), p. 45.
25. Betancourt, M. *Semiotics and Title Sequences: Text-Image Composites in Motion Graphics* (New York: Routledge, 2017), pp. 7–21.
26. P. Adams Sitney, *Visionary Film: The American Avant-Garde 1943–1978*, Second Edition (New York: Oxford University Press, 1979), p. 370.
27. Brownjohn, R. "Sex and Typography," *Typographica*, vol. 10 (December 1964), pp. 49–58.

28. Racioppi, L. and Tremonte, C. "Geopolitics, Gender, and Genre: The Work of Pre-Title/Title Sequences in James Bond Films," *Journal of Film and Video*, vol. 66, no. 2 (Summer 2014), pp. 22–23.

29. Mulvey, L. "Visual Pleasure and Narrative Cinema," *Film Theory and Criticism: Introductory Readings*, ed. Leo Braudy and Marshall Cohen (New York: Oxford UP, 1999), p. 837.

30. Betancourt, M. *Synchronization and Title Sequences: Audio-Visual Semiosis in Motion Graphics* (New York: Routledge Focus, 2017), pp. 106–115.

31. Solow, L. "Maurice Binder: Bringing the Titles to Life," *Cinema Odyssey*, vol. 1, no. 1 (1981), pp. 21–23.

32. Woollacott, J. "The James Bond Films: Conditions of Production," *The James Bond Phenomenon: A Critical Reader*, ed. Christoph Lindner (Manchester: Manchester University Press, 2003), pp. 99–117.

33. "Stirred, Not Shaken: Karin Fong Projects Bond for Action Rom-Com," *Forget the Film, Watch the Titles*, www.watchthetitles.com/articles/00244-This_Means_War retrieved May 5, 2014.

34. Eco, U. *The Limits of Interpretation* (Bloomington: Indiana University Press, 1994), p. 113.

35. "Saul Bass: Man With a Golden Arm," *Time*, March 16, 1962, p. 46.

36. Betancourt, M. *Semiotics and Title Sequences: Text-Image Composites in Motion Graphics* (New York: Routledge, 2017), p. 77.

37. Betancourt, M. *Semiotics and Title Sequences: Text-Image Composites in Motion Graphics* (New York: Routledge, 2017), pp. 75–106.

38. Lipton, E. *Alias Olympia* (New York: Cornell University Press, 1999).

39. Borges, J. "From Allegory to Novel," *Other Inquisitions* (Austin: University of Texas Press, 1975), p. 155.

4 The Comment Mode

Each distinct expositional mode links the title sequence to the rest of the *fabula* via audience engagement using established conventions of *narrative function*. Those title designs employing the Comment mode always introduce their story indirectly—what can be expected in it, what the themes are, who the various actors/characters are—only becoming coherent in context with the narrative. Their use of cut scenes always shows the characters "in action," but the elements of *fabula* they contain do not reveal their significance because they are isolated, lacking the narrative context required for revelations of causality. To understand any instance of the Comment mode as developing *fabula* demands prior knowledge *about* that story: the range of naturalism::stylization in these designs implies their audiences are already aware of the narrative's events—anticipating what will happen—and this knowledge reveals the narrative linkage for those viewers who have the information. These associations of peritext::text are an emergent reconciliation of what appears during the title sequence with the cause-effect structures of the narrative (*fabula*): the audience's ability to decode these engagements often depends on prior knowledge about that *fabula*, thus rendering these connections ambivalent without the information that makes their anticipation or recapitulation of the proximate narrative readily comprehensible. To understand what happens in the Comment mode requires that the viewer have existing knowledge of narrative *futurity*—the events yet-to-be depicted: in the indirect associations of Comment and Allegory modes, futurity derives from expertise with interpreting similar texts; thus the *intra*textual and *inter*textual coincide as distinct aspects of the same expositional interpretation.

The role of past knowledge in the Comment mode demonstrates the self-similarity of narrative connections in both sub-types of paratext: the repetition of other, absent narrative text in the intratextual

linkages of the Comment mode work to repeat some aspect of the same text, internally, ensuring the recognition-knowledge of its connection can emerge from a consideration of the peritext::text dynamic via their proximate association. The overlap of peritext and epitext is suggested by Umberto Eco's consideration of "serial form." This difference reveals the social function of intertextuality that is its more common focus of analysis, as he notes:

> These imperceptible quotation marks [in intertextual works], more than an aesthetic device, are a social artifice; they select the happy few (and the mass media usually hope to produce millions of the happy few). To the naive spectator of the first level the film has already given almost too much; that secret pleasure is reserved, for that time, for the critical spectator of the second level.[1]

The "intertextual dialogue" Eco describes depends on recognition, an identification of connection to past knowledge; in contrast, "intratextual signification" requires a critical interpretation, itself dependent on a rigorous engagement and interrogation of the imagery and content contained by the work as it develops. Both relations engage in a repetition and development of thematic material—internal and external—linking the otherwise distinct, and very different placements of the peritext and epitext: the audience's existing knowledge of the main text and the conventional relationship of these marginal productions to it ("social artifice") always informs their construction-interpretation of paratextual meaning. Historian Lisa Kernan's observations about the role of anticipated narratives in the interpretation of film trailers links title sequences to the narrative topoi that Eco invokes in his discussion of intertextual dialogue. The comprehension of this emergent "intratextual signification" is at the same time an assertion of difference between those forms shown during the paratext and the later organization of *fabula*. Kieran explains how the development of *fabula* in film trailers corresponds to its appearance in the main text:

> Aristotle characterized the process by which assumptions about an audience become structured into a rhetorical argument in his description of the *enthymeme*, a component of what he termed "epideictic rhetoric" (wherein rhetorical arguments are constructed for the purpose of praise or blame). Usually thought of as an abbreviated syllogism, an enthymeme omits one of the logical steps within a syllogism, allowing it to remain as an implicit

assumption within the logic of the remaining terms. . . . These rhetorical structures are generally spelled out in trailer titles or voice-over narration, and their logic is backed up by selections of particular images in the promotion of a given film, through a "discontinuity editing" that makes connections between scenes, demonstrating the enthymeme's assumptions.[2]

The implicit distinctions of narrative interpretation-presentation that separate the paratext from the elaboration of *fabula* in the main text reveal the overlap between film trailers (epitext) and title sequences (peritext). These elliptical demonstrations of *fabula* elide the cause-effect coherence of narrative events (*syuzhet*). Their intratextual signification depends on the audience supplying the necessary information to make the connections to *fabula*. It is a matter of narrative *futurity*: those shots, scenes, and events shown during the title sequence become coherent only in the audience's connective interpretation, which may only come later: absent this link that relies on past experience, what Kernan calls "enthymeme," deciphering the narrative encounter becomes impossible.

Title sequences for films made during the Studio Period such as *The Big Broadcast of 1937* (1936) avoid the apparent paradox Kernan's discussion proposes through their deployment of already known, conventional semiotic structures that are not concerned with the elaboration of *fabula*. The encultured ways of understanding the relationship of text::image within the title cards themselves creates redundancies that identify each fragmentary shot via superimposed text, repeating optical transition (each image "folds" into view), and their accompanying voice-over that states the actor's name to designate each title card as an individual unit while making its interpretation quite determinate. Each credit stands apart from the ones before and after it. The *narrative function* dominates this design, but remains constrained by the implicit, mediating role of the *crediting function*: while the eleven calligrams in *The Big Broadcast of 1937* are labels, and their text identifies the 'portrait' they accompany [Figure 4.1], this title sequence is not limited to just introducing those actors or musical performers who receive on-screen credit with their name, but it also introduces the setting—a radio station [see Figure 1.4 on page 8]. Simultaneously, understanding titles are a pseudo-independent unit that minimizes their narrative integration as an introduction to the story, these ellipses between titles and narrative never become apparent while watching the sequence, a demonstration of the Comment mode's discursive organization.

Figure 4.1 Calligram title cards from *The Big Broadcast of 1937* (1936)

For audiences encountering these works, the exteriority of knowledge Eco describes as evoked by the *inter*textual becomes the "unity" created in the *intra*textual repetitions and juxtapositions of distinct parts: first in the familiar lexical structure of individual title cards, then at the organizational level of the title sequence, and at a higher level, in the relationship between actors appearing in those titles and their roles in the narrative itself. The exposition about the setting complements these statements about the performers and their roles. *The Big Broadcast of 1937* title sequence uses the Comment mode to establish narrative *parameters* such as *who* the actors are, which *characters* they play, and *where* the story takes place. These repetitions both "internally" in the peritext, and "externally" as linkage to the main text is precisely what enables the audience to recognize any "unity" or "organic" connection, especially when they are not immediately apparent: where the Allegory mode is an ambiguous, *symbolic presentation* of narrative concerns, the Comment mode is a statement *about* the narrative whose relationship or connection to the *fabula* only reveals itself in retrospect since its linkage requires prior knowledge of the story itself—the designation "exposition" masks this emergent identification by making its link a matter of conventional association. Both modes are intratextual, but in radically divergent ways. Validating the information conveyed by exposition requires the audience to have existing knowledge of the story *before* encountering that story. Past experience is essential, as in other lexical interpretations.

Comment mode statements about *fabula* are introductions dependent on audience anticipation. For the original 1930s audience who already know "what to expect" of live broadcast in a radio studio, the expository progression of *The Big Broadcast of 1937* title sequence develops discursively. After the studio logo, but before the first title card, a child dressed as a theater usher silences the audience, saying "Quiet! Quiet! Quiet! We're on the Air!" This opening shot is followed by the main title card, its individual words appearing on-screen synchronized to the silhouette profile of the announcer saying "The Big Broadcast of 1937!" into a microphone, the lip- and text-sync aligning the events and imagery of the title sequence with a literal dramatization of the film's title. This hierarchy of reading::seeing::hearing organizes all the credits in this sequence—all the calligrams presenting each actor and musical performer will also be read in sync with their appearance. And although the narrative takes place in a radio station, this opening is independent of it—a comment that the *fabula* is about a radio station and its stars—rather than the actual beginning of the story. The cut at the end of the titles to the women singing a commercial comes as an abrupt shift in music and visual tone, clearly demarcating the change from title sequence into the beginning of the narrative.

The difference between paratexts arises from their distinct status: the trailer is an epitext, while the title sequence is always peritextual, a peripheral element of the main text, integral and immanently linked to its organization and development. Lexical construction in the Comment mode is always discursive—exposition about the *fabula*—in the same ways that film trailers are also *about* the (absent) main text. In constructing their understanding of these works, audiences apply their internalized ideological conceptions to them, affirming that ordering through the coherent match of peritext::text. As a result, the title sequence proceeds not as an enticement to watch (as with the trailer or promo), but as a preliminary and/or potentially tangential presentation explaining that immanent narrative, affirming how the "average reader" engages it.

Narrative Futurity

The Comment mode develops its expositions within a range that has both simple and complex variants, distinguished by their ease of recognition: the simple variants are concerned with introducing the characters, their relationships, and occasionally elements of the story (the setting, for example). In contrast, the complex exposition engages

in making statements about the narrative through "intertextual dialogue," transforming these quotations into exposition on the meaning or significance of the *fabula*. The Comment mode is a discursive presentation about the subject matter of the narrative, but devoid of its events. It is the opposite of what Garrett Stewart described as "all *syuzhet* with no *fabula* yet constructed"[3] in discussing title sequences whose organization focused on a *symbolic* presentation of narrative contents (i.e., the Allegory mode); the Comment mode constructs *fabula* without *syuzhet* (narrative events). The presentation of story without narrative incident means that the Comment mode's information about the narrative remains undecipherable, an aspect of these Studio Period designs implicit in David Bordwell's discussion of narration in *The Classical Hollywood Cinema*. These instances of the simple variety do *not* depend on *inter*textuality for their meaning to emerge; exposition conveyed in the "credit sequence" anticipates events in the main text:

> The credits can anticipate a motif to appear in the story proper. In *Woman of the World* (1925), the protagonists' scandalous tattoo is presented as an abstract design under the credits; in *The Black Hand* (1950), a stiletto forms the background for the titles. Credits' imagery can also establish the space of the upcoming action, as do the snowy fir trees in *The Michigan Kid* (1928) or the city view in *Casbah* (1948).[4]

These title sequences are Comment mode expositions *about* the characters, the events, or the setting (in that order). The apparent "appropriateness" of imagery (thematic anticipation) is also its superficial banality. These depictions appear obvious when considered in terms of their narrative *futurity* precisely because they reveal *fabula* without providing the cause-effect necessary for *syuzhet*. This separation of one from the other does not diminish the role of the *narrative function* in these sequences—instead it demonstrates the dominance of the *crediting function*. The indirectness of these connections is at the same time a giving-priority to the credits (and thus the title sequence as whole) that ensures its composition and identification as being pseudo-independent. The peritextual status is not in doubt. These designs achieve an apparently autonomous opening presentation, that by the 1930s, had become an essential technique to establish the "stars" at the Hollywood studios. Both *She Done Him Wrong* (1933) and *The Wolf Man* (1941) [Figure 1.2 on page 7] are examples of these simple comments that link the star's name with their image.

All these credits use calligrams for their title cards. Each *statement* about the actor–character relationships proceeds through an organization of shorter elements, whether single shots or brief sequences. In their more elaborate form, "discontinuity montages" introduce the lead actors and their characters, their organization as title cards masking their otherwise fragmentary nature—each shot stands in semi-isolation, rendered as a singular statement by its synchronization with music.

The same dynamics of narrative futurity anticipate the events of the *fabula* without revealing them in the Logo Period design for *Real Genius* (1985), by Wayne Fitzgerald. This simple variant of the Comment mode demonstrates this type of exposition's enduring presence in title sequences. It employs a montage of weaponry to demonstrate the military applications of scientific discovery [Figure 4.2]—the resulting exposition about the relationship between technology and war describes the focus of the *fabula* without engaging in a presentation of *syuzhet*. The superimposed credits are separate from the montage showing weaponry progressing from the stones of the Paleolithic to nuclear explosions, an elliptical reversal of Albert Einstein's comment about World War IV being fought with sticks and stones.[5] It is sufficiently indirect that audiences may not initially link the imagery of the titles to what happens in the story, its connection only emerging in retrospect. Unlike either Designer Period design by Saul Bass for *The Man with the Golden Arm* or *Walk on the Wild Side*, this design cannot be interpreted allegorically; it describes the implicit concerns of the narrative—the invention of a new, high-technology laser weapon—as a part of human history, but does so in a fashion that is not symbolic (indirect) but literal, using montage to directly construct a semi-chronological progression. The crediting texts are superimposed, separate—the opening text::image relations are clearly an instance of the figure–ground mode where the text (figure) occupies one "field" of consideration, and the background another. Text::image remain parallel, facilitating the development of the montage "behind" the credits as a separate progression unconnected to the title card texts. The distinction offered by figure–ground mode[6] text::image combinations is the most common approach to the design of individual title cards in the Comment; their separation facilitates the distinction between *crediting* and *narrative functions*.

The comment the *Real Genius* title sequence offers, that weapons and technology have always been closely aligned, does not alter the narrative, and for audiences unaware of the *fabula*, it is an opening

Figure 4.2 All the title cards in *Real Genius* (1985)

whose visual choices might seem arbitrary or irrelevant to the events as they develop, demonstrating the essential mediating feature that future knowledge of what the *fabula* entails. *Narrative futurity* is a requirement for comprehending the comment it offers. This dependence on an established awareness unites the indirect modes of association because their presentations are based in an identification of narrative functions *not* based in the *syuzhet* or *fabula* appearing in the main text. This marginalization of the title sequence is also responsible for its pseudo-independence—enabling the peritext::text distinction—demonstrated through its typical neglect in considerations of the narrative.

The *particular* historical images' sources are not important to the progression of this montage: it is not a matter of their historical nature, but their depictive contents that are productive of the signification in the *Real Genius* title sequence. The collage-aspects of this collection of imagery, while inherently indexical to their originary sources (thus instances of intertextuality), they are not productive of what Eco termed "intertextual dialogue." It is not important to the meaning of the sequence that the audience recognize any particular source; the apparent chronology of this progression renders their indexicality as secondary to their accumulative effect—this montage produces its meaning via the technology-as-weapon motif that only becomes apparent as the sequence progresses. The imagery functions independently of the credit-texts, allowing the audience's attention to shift from what the individual credits state to a consideration of how the imagery develops its war and military-tech iconography. The directness of this montage sequence belies its ambivalence in relation to the *fabula*: the story of *Real Genius* is a comedy about a child prodigy, "Mitch Taylor" (played by Gabe Jarret) and his college roommate, "Chris Knight" (Val Kilmer) developing a high-power laser. That this device is a weapon does not emerge until fairly late in the film, rendering the military focus of the opening titles both initially puzzling and easily forgotten as the narrative progresses. Its anticipation of the story, while a revelation of the *fabula's* primary concern, is also sufficiently indirect that their link is not obvious to audiences watching the credits. This simultaneous ambivalence and literalness demonstrates the same types of narrative comprehension emergent in the film trailer: it tantalizes without necessarily revealing the actual event sequences of cause-effect. The effects of this displacement of narrative masks the ideological aspects of *fabula*—the meanings offered by the linkage of peritext::text are hidden by the indirectness of this association, a parallel construction that converges on the meaning

84 *The Comment Mode*

of *fabula* without directly engaging the dramatic events that signify. This disappearance of ideology enables its progression as an inherent assumption, beyond question or consideration.

The *narrative function* in the Comment mode is thus also a demonstration of these title designs' pseudo-independence: they are formulated as a *separate* organization of narrational motifs, a capricious progression, parallel to the main text. When there are aspects of cause-effect presented during these openings/closings, it is necessarily separated from the structure and organization of main text—while at the same time reflecting its premises (or themes). The development of the Late Phase design by Michael Palin for *Monty Python and the Holy Grail* (1975) [Figure 4.3] parallels the *nature* of the comedy to be expected from the film that follows: the narrative futurity of this opening reveals nothing and everything about the conventions it will challenge and overturn. This exposition parodies the idea of "serious" film, in this case associated with Swedish art cinema exported to the United Kingdom/United States and shown with subtitles, thus revealing the duplicity of the film's title "Monty Python and the Holy Grail"

Figure 4.3 Selected title cards from *Monty Python and the Holy Grail* (1975)

and enabling the recognition that the "Holy Grail" for TV actors is to become film stars: that the film the audience is currently watching is itself a "Holy Grail."

Palin's design is composed exclusively from text and dramatic (stock) music; no composited imagery appears during its three-and-a-half-minute duration. The established expectations for *how* the story of King Arthur and his Knights of the Round Table will proceed is revealed during this title as a rupturing of cinematic conventions matched by the opening shots of the narrative: "King Arthur" (Graham Chapman) miming riding a horse, the hoof-sounds made by banging two halves of a cocoanut together, a reference to the use of Foley sounds to augment on-screen reality that becomes a literal part of the story (and a recurring joke in the film). This opening is matched by the digression of the subtitles during the opening credits from Swedish into faux-Swedish, then narrative, and finally as a series of increasingly disruptive interventions to the credits themselves that ultimately render them (almost) unintelligible. The limitations of this design— text only—does not preclude complexities of enunciation: unlike the clear distinction of figure–ground mode title cards employed in *Real Genius*, the reflexive (self-referential) role of first the subtitles, then the title cards themselves signal a secondary level of signification that emerges from their morphology and structure as a whole. The initial progression in the credits precisely matches the comic narrative's progression from 'fiction' ultimately into 'reality' with the actors being arrested by the police as the conclusion of the film; the titles' narrative function directly reveals the main text's progression, but does so in a way that is not apparent except on reflection—the interruptions and subversion of the credit's role by the subtitles that counter, then replace them is ultimately "stopped" by breaks in the sequence (policing actions)—the indirectness of the intratextual relationship in the simple variant precludes any clarity in its narrative association, making the recognition of its narrative association an ambivalent interpretation. This equivocation undermines any potential to be a "spoiler" that reveals important dimensions of plot or character.

TV title sequences using 'cut scenes' are the most familiar examples of the simple variant. These show openers create portraits of the actor/ characters in the program putting them in the same category of derivative production as film trailers—and potentially containing the same revelations of cause-effect, called "spoilers." Those designs employing cut scenes are what media historian Solange Landau identified as the "Mosaik-Intro" (Mosaic Intro) composed from shots extracted from the episodes that (typically) follow these openings.[7] Credit sequences for TV shows have employed this approach throughout their history, borrowing its organization from the Hollywood feature

film productions such as *She Done Him Wrong, The Big Broadcast of 1937*, or *The Wolf Man* [Figures 1.3 and 1.4, pages 7 and 8]. The single shots that provide illustration of the characters in TV designs such as *S.W.A.T.* (1975) that introduce each character "in action" increasingly focused on the presentation of narrative information to introduce the relationships between characters during the 1980s; the association between title sequence and narrative, apparent only in the "stars" who portray the characters *in* that story are presented as montage, revealing their contents through the combination and juxtaposition of shorter sequences within the higher-level 'title sequence.'

The organization of cut scenes in title sequences for TV shows are remarkably consistent. The design for the television program *Magnum, P.I.* (1980–1988) provides a model for their later development [Figure 4.4]. This sequence is focused specifically on the relationships between the four primary lead actors/characters: this structure remains constant across all three distinct title sequence variations in the first season, and continues for the seven subsequent seasonal "refreshes." Even though these revisions involve replacing the earlier season's shots with ones from the new season, and season 1 includes a radical redesign that re-cut the entire sequence to match the change from the initial Ian Freebairn-Smith theme to the more familiar Mike Post theme, all these designs have the same narrative focus. They present four character portraits (one for each of the main stars) that revealed the relationships between the supporting cast and "Thomas Magnum" (Tom Selleck). In revealing information about *who* the characters are within the fictional world, these 'cut scene' designs superficially appear to link the Comment mode directly to the narrative; however, this connection is a product of the pseudo-independence of these arrangements—their interpreted meaning as commentary *about* the story reveals them to be an introduction to the events of the narrative (via the characters in it) concerned with *fabula* but eliding the diachronic element of cause-effect (*syuzhet*). This presentation aligns with Sternberg's definition of "exposition" as the opening or beginning to the *fabula*:

> This definition, however, though it firmly establishes the exposition as *terminus a quo* and though it flexibly covers the innumerable possibilities of combining and ordering a given number of motifs, may still be regarded as seriously incomplete unless we can determine exactly up to what point in the *fabula* the motifs are expositional.[8]

Figure 4.4 All the title cards in *Magnum*, *P.I.* (Mike Post variant, season 1, 1980)

For motion pictures, this demarcation is readily demonstrated as the terminus of the title sequence; the conventional role of theme music acts to consolidate this "opening" as a unit, signifying its extent within the production even when there are not corresponding on-screen credits that unequivocally signify its conclusion—this distinction is definitive, separating cinema from the written texts Sternberg considers. Even the most minimal instances of the Comment mode, those whose title cards are introductions of actors or of the setting for the narrative, all depend on the same audience recognition of internal reiteration (intratextuality) for their intelligibility. That these are links made between sections of the same production does not diminish their reliance on the same critical and engaged faculties as "intertextual dialogue" or the recognition of quotations contained within a text; their distinction lies instead with the apparently uniform potential access—any viewer can potentially make the same connections between peritext::text that renders these title sequences' narrative functions obvious. That ease of potential recognition may be a reason for the title sequence's general critical neglect: the connections created by intratextuality are so immediate and seemingly obvious as to not require theorization or analysis.

Unlike the film trailer or other epitexts, which are commonly composed as a collection of images and shots derived from the main text (and thus inherently tied to the elaboration of *syuzhet*), the pseudo-independence of the Comment mode in title designs allows a freedom to engage narrative without necessarily revealing *syuzhet*. The ambivalent linkage in Fitzgerald's *Real Genius* is no less uncertain than that of Palin's design, or the various, and even simpler Studio Period designs such as *Woman of the World, She Done Him Wrong*, or *The Big Broadcast of 1937*. The construction of anticipatory openings on TV employing cut scenes to explain the character relationships provides a similar discursive linkage between the *crediting function* and the *narrative function* through their identification of the actors/roles as specific social positions within the narrative. These intratextual relationships render the *narrative function* coherent, even in a design as discursive as *Monty Python and the Holy Grail*, they remain constant throughout all the instances of the simple variant of the Comment mode; cut scenes retain this associative organization even when they are not placed at the start of the motion picture. In focusing on the characters and their social roles, these Comment modes develop the internal constancy of the narrative world-on-screen, establishing in advance of its presentation the interpersonal dynamics that make the drama engaging for its audience. This essential information frees

the progression of narrative to explore these dynamics as a given, rather than having to re-present (or even re-explain) them in each particular installment. Shifting this audience instruction to the title sequence gives the *narrative function* a central role in the morphology and structure of the titles, but leaves it subservient to the *crediting function's* action as a series of introductory labels.

Intertextuality and Quotation

The complex variants of the Comment mode are readily identified by their reliance on intertextual knowledge. These designs are immediately comprehensible to those audiences who recognize the *external* referents, while for those who do not make the recognition, their meaning remains unknowable since it does not employ the *intra*textual reiterations of the simple variant to establish its meaning. Unlike the self-contained organization of the cut scene, when the title sequence engages with the events of the *fabula*, the results are more ambiguous, offering a variety of other potential relationships, but masking any ideological significance via their quotational and referential constraints on interpretation.

Umberto Eco's proposition of intertextuality is more than just the opposite of intratextuality. It belongs to the same order of relationships that are productive of lexical meaning, emergent from the audience's internalized network of accumulated semiotic knowledge gleaned from past 'successful' interpretations.[9] As Eco noted, these identifications of the already known can appear as parody, quotation, or repetition (homage) depending on how the audience understands this intertextual component. Intertextuality describes the elements that audiences recognize employing a predetermined framework—the recognitions drawing from a state of information already known—quotations always require a recognition of their status as *quotational* for the meaning derived from their reiteration in another work to emerge:

> Such phenomena of "intertextual dialogue" were once typical of experimental art and presupposed a very sophisticated Model Reader. The fact that similar devices have now become more common in the media world leads us to see that the media are carrying on—an presupposing—the possession of pieces of information already conveyed by other media. . . . Any difference between knowledge of the world (understood naively as a knowledge derived from an extratextual experience) and intertextual knowledge has practically vanished.[10]

The complex Comment mode produces its meaning through the "intertextual dialogue" established explicitly between the design and its quotational references. The significance of these sequences arises not through an internal relationship of peritext::text, but via what intertextuality enables: the ability of one text to reflect back on itself through its transformations of other, earlier works. These external-to-text relationships can potentially direct the audience's attention outwards, away from the proximate narrative, but they offer more complex statements about the significance *of* the *fabula*, as in the quotational collages used in the Late Phase title sequence designed by Terry Gilliam for *Life of Brian* (1979) [Figure 4.5] that depends on precise intertextual recognitions for its meaning to emerge; these complex designs do not require past knowledge of the *fabula* to express their significance—intertextual knowledge substitutes for the *intra*textual linkage employed in the simple Comment mode.

The relative rarity of the complex variant *before* the 1970s demonstrates the shifts that Umberto Eco, writing in 1994, describes. The role of quotation and relations *between* media texts as a commonplace part of media has not diminished with time. Quite the contrary, it has become a standard part of how these media are created, understood, and engaged. The emergence of these formative approaches to both media production and reception demonstrates the transition from a Modernist aesthetic based on uniqueness to a Contemporary one where the avant-garde innovative challenges to both the traditional and the Modern are now familiar, a reflection of the answer to Paul Virilio's question of avant-garde aesthetics[11]—*in advance of what?*—resolved as the shift from rarified, and alienated art to popular media, such as *Life of Brian*. The role of intertextuality is "serial" in nature, a product of repetition and variation:

> The series consoles us (the consumers) because it rewards our ability to foresee: we are happy because we discover our own ability to guess what will happen. We are satisfied because we find again what we had expected. We do not attribute this happy result to the obviousness of the narrative structure but to our own presumed capacities to make forecasts.[12]

In Eco's theory of serial form, the repetitions enable the audience to recognize the topoi in use, allowing them to anticipate—and thus interpret meaning and events in advance of their presentation. These forms are defined through the different shifts recognized by audiences as transformations of established schemas into a novel example.[13] These recognitions of established form arising from past experience

Figure 4.5 All the title cards in *Life of Brian* (1979)

create the expectations implicit in Bordwell's' discussion of how narrative motifs appear in the title sequence; the role of viewer expectations in recognizing and understanding these elements is productive of the specific pleasure in their identification and analysis.[14] For title

sequences, these shifts distinguish the simple and complex Comment modes, this same play of anticipation and recapitulation first functions within the same text as the simple mode, across the boundary between peritext and main text (*intra*textuality), then as quotation between different texts (*inter*textuality).

Gilliam's collage animations are heavily influenced by the earlier collage animations of experimental film maker Stan VanDerBeek, but differ from his films in several key ways: where VanDerBeek tends to use photographic material arranged and presented in a disjunctive fashion, Gilliam's work tends toward a seamless integration of diverse materials, resulting in animations that assert their continuous and apparently *un*collaged nature that serves to disguise the always-quotational nature of collage. This stylistic uniformity gives the materials employed in his animations a consistent character, one that simultaneously suppresses (or at least suspends) their "intertextual dialogue"; this suspension is apparent in *Life of Brian* as well. However, unlike his animations for the *Monty Python's Flying Circus* TV show where the animations drew from a broad mixture of sources, including nineteenth-century photo-postcards, illustrations, and hand-drawn characters, in *Life of Brian*, there is a singular, dominant source for the materials: Gustave Doré's illustrated version of Dante's *Inferno* [Figure 4.6], first published in 1861.[15] This external quotation is essential to the emergent comment about the *fabula*: it depends on exactly this intertextual recognition of the imagery used as collage material for the "background" animation to become apparent. At the same time, for the unaware audience who does not make the connection, the visible features of these collage animations showing classical architecture provides the "archaeological" quality these titles have, successfully evoking the early Roman Empire. The images used in the titles transform the original context of the visuals into the contents of the title cards. Recognizing this source material creates an excess of meaning that when juxtaposed with the events of *Life of Brian* reveals its comment—"We're going to hell for this!"—in the original meaning of these collage-elements depicting a journey through Hell, a tour of the punishments given out for sins committed during life. It is an intertextual reference parallel and extraneous to the narrative, a series of quotations that draws attention to its parody, not of Christ, but of his followers, the Christians; therein lies the commentary on the *fabula* presented without recourse to the narrative events (*syuzhet*).

The indirect connections to the narrative these quotations create are reflective of the same rhetorical play active in *Real Genius*, but their recognition-understanding requires the audience to identify an

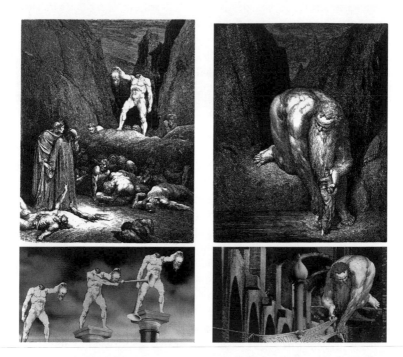

Figure 4.6 (TOP) Selected illustrations by Gustave Doré for Dante's
Inferno paired with (BOTTOM) their quotation in *Life of Brian*
(1979)

additional relationship (intertextual) to another, absent media-text—
Doré's illustrated Dante's *Inferno* created in the nineteenth century.
Intertextuality, rather than being tangential and disruptive, is essential
to the emergent commentary about the *fabula*.

However indirect, any links between peritext::text will become
apparent during the progression of the main narrative. In Contempo-
rary Period designs such as Karin Fong's *This Means War*, the addi-
tional quotational element is an excess, extraneous to the allegorical
meaning it constructs [Figure 3.9, page 65]—the homage to earlier
title sequences made for the James Bond films by Robert Brownjohn
and Maurice Binder disrupts the recognition of the symbolic mean-
ing. This homage dominates the encounter with the sequence, forcing
attention away from the Allegory mode's connection to the imma-
nent narrative and *fabula*, interrupting and challenging its develop-
ment and meaning with an *external* connection that does *not* inform

the understanding of the narrative that follows. As with other kinds of lexical interpretation, the statements made in the Comment mode are emergent; the role of past experience constrains the immanent encounter: intertextuality is always already a foundation required for meaning to emerge. At its most basic, the identification of the "stars" in the narrative interfaces between the established knowledge—beyond the confines of the narrative—and the particular encounter in the *fabula* itself. The addition of their 'role played' to each star's title card presentation (whether a calligram or not), as in the Silent Period designs *Stella Maris* and *Male and Female* where the title act like a "picture book" [see Figure 3.2, page 50] or in Studio Period designs for *She Done Him Wrong* and *The Wolf Man* [Figure 1.3, page 7] make this mediation of internal::external obvious. The Comment mode of association transforms this intertextuality in the title sequence into a "lexical" statement about the *fabula*, thus producing its peritext::text dynamic.

By directing attention away from the immanent text to recognitions emerging from past experience and established knowledge, the Comment mode produces associative connections that render its meaning coherent. The pleasures of intertextuality arise from these relations of immanence::memory; thus, recognition of intertextuality is essential for understanding them, an example of what semiotician Umberto Eco termed "serial form" in his discussion of how intertextuality functions in those works where its identification and recognition is the primary aspect of recognition-meaning:

> In the most typical and apparently "degenerated" cases of seriality, the independent variables are not all together the more visible, but the more microscopic, as in a homeopathic solution where the potion is all the more potent because by further "successions" the original particles of the medicinal product have almost disappeared. . . . What is more interesting is when the quotation is explicit and recognizable, as happens in post modern literature and art, which blatantly and ironically play on the intertextuality . . . aware of the quotation, the spectator is brought to elaborate ironically on the nature of such a device and to acknowledge the fact that one has been invited to play upon one's encyclopedic knowledge. . . . We are thus facing a "neo-Baroque aesthetics" that is instantiated not by the "cultivated" products, but even, and above all, by those that are the most degenerated.[16]

Past experience is central to interpreting these "serial forms." This intertextual element requires the audience to recognize that each

episode quotes from earlier versions of itself—a self-referential series of links familiar from language: each word gains its meaning from all the myriad uses it has had, their recognition and transformation in the immanent context being precisely the instantiation of its current meaning. "Quotations" of this type are not necessarily apparent *as* quotational, since repetition is fundamental to interpretation itself: meaning is a special kind of intertextuality emergent in language. For the Comment mode in title sequences, this relationship between immanent and emergent is productive of complexity *through* the quotational aspects of intertextuality, a state of information where the identification of intertextual links is generative of new signification.

Wayne Fitzgerald's Late Phase title design for *The Nude Bomb* (1980) [Figure 4.7], the first adaptation of Buck Henry's TV spy parody *Get Smart* that ran on NBC from 1965 to 1969, concluding its run on CBS in 1969–1970, depends on the audience recognitions of its intertextual relationship to Maurice Binder's designs for the James Bond films. It is a title sequence that adapts its approach from television show openers,[17] highlighting Don Adams who stars as "Maxwell Smart, Agent 86 for CONTROL," but unlike TV designs, the meaning of what appears is a

Figure 4.7 All the title cards in *The Nude Bomb* (1980)

specific parody of the sexual theme of the Bond title sequences, desublimated so its sexuality figures prominently in the *events* shown during Fitzgerald's sequence. These intertextual elements are integral, necessary recognitions to not only "get the joke," but to understand the events shown in these credits themselves. The intertextual element is the central part of this design's interpretation: it literally begins the design with the three white circles that begin the sequence, and in which "Max Smart" confronts his other selves before they all turn in unison to look at the camera, a direct address that signals the self-consciousness of the sequence as a whole as well as its *desublimated* commentary on Maurice Binder's Middle Phase designs.[18] Understanding Fitzgerald's sequence as parody requires the viewer to supply the contextual and referential understanding of *how* the design for *The Nude Bomb* simultaneously functions as a variation on the James Bond sequences; the quotational references are essential to the sequences' decoding.

The subject of this design—the already known designs for the James Bond films—becomes the material referent for the serial deviations and revelations. It is precisely those recognitions of similarity and difference that give rise to their understanding as variations that reveal the underlying sexual fantasy of masculine prowess and heterosexual desirability that are the focus of this design: the "helluva explosion" that appears during the sequence cannot be literal (nothing about the set changes). Its metaphoric—orgasmic—thrust, that "Max Smart" has satisfied three women at once plays out as a series of shifts in expectation around the introduction of each woman in turn that also recapitulates the subtext of Binder's designs.[19] These quotations involve both audience expectation (that the second woman approaches Smart with the gun, as if to shoot him, only to put it back in his holster instead) and their intertextual dialogue with the earlier designs' meaning. The exposition offered by this Comment mode opening is a precise statement about the nature of the parody to come, its object of address, but it also establishes the roles of quotation, past experience, and the active engagement required from the audience to understand the comedy.

In Kyle Cooper's Contemporary Period design for *Mission: Impossible* (1996), the intertextual, historical sources are not an essential part of its decoding. Instead, recognizing the links to the titles for the 1966–1973 CBS TV show [Figure 4.8] is an example of what Umberto Eco described as the "post-modern aesthetic solution" where audiences making the connection (recognizing the quotation) have an enhanced understanding of the work—one that

Figure 4.8 Selected shots from both *Mission: Impossible* title sequences: (LEFT) the original show opener (1964); (RIGHT) the feature film title sequence (1996)

expands its basic meaning in ways the reconfigure the understanding of both quotation and original source:

> The problem is not one of recognizing that the serial text works variations indefinitely on a basic scheme (and in this sense it can be judged from the point of view of the "modern" aesthetics). The real problem is that what is of interest is not so much the single variation as "variability" as a formal principle, the fact that one can make variations to infinity. Variability to infinity has all the characteristics of repetition, and very little of innovation. But it is the "infinity" of the process that gives a new sense to the device of variation. What must be enjoyed—suggests the postmodern aesthetics—is the fact that a series of possible variations is potentially infinite.[20]

Eco's conception of "variability" is exactly what appears in the design for *Mission: Impossible*. The recognition of the earlier TV

title sequence composed from cut scenes is reproduced in this feature film title sequence. While some of the imagery employed has been drawn from the opening sequences of the *fabula*—the "op" that goes wrong—mixed with shots from the entire story that follows, including its climax; however, what dominates this title sequence is not the anticipatory aspects offered by the narrative futurity of this design, but in its relationship to the *original* show opener. The transformation of particular images, as well as the "white line" reproduced by the streaming text, unites both designs. It is precisely the way that the new design revisits and transforms the original TV show's cut scene opening that creates the "intertextual dialogue," which suggests the feature film as an updated, current variant of the original program, even though the development of the *fabula* makes the distinctions between TV show and feature, rather than their continuity, the focus of concern.

*Inter*textuality and *intra*textuality in the Comment mode equally provide and support the assertion of the fictive world as an independent, self-consistent reality, separated and contained by the range of naturalism::stylization in the pseudo-independent title sequence. While intertextuality expands the range of potential meanings in the complex examples of the Comment mode by directing audience attention in specific, lexical ways, it also is an intratextual return, reflecting on the internally consistent 'reality' of the *fabula*. Thus the *déjà vu* quality that all "intertextual dialogue" has parallels the necessity of past knowledge in any semiotic interpretation: the audience must already know and understand the terms being manipulated for their novel configurations to signify; for motion pictures, this innate role of words is engaged through the use of quotation and repetition in the creation of exposition. The capacity of the audience to "get caught up in" the fictional world is asserted by the peritextual limit emergent from the statements produced by this exposition *about* that "world-on-screen."[21] The resulting affirmations of that artificial world are necessarily ideological—they serve to distance fictionality from reality—in the process making the relationship between the world and the world-on-screen one that is autonomously answered by the crediting function: that what is shown is simply fantasy, unrelated or connected to actual life (except as the distraction from it). For the complex varieties, these statements necessarily direct attention away from the proximate relationship of peritext::text toward some other, absent and potentially unknown referent—but in doing so, their interpretation returns to the immediate linkage of credits to *fabula*. These directives away from the current text into reverie return

in the Comment mode because their indirect links necessarily depend on the audience's interpretations to emerge at all. This separation is precisely the role that the *crediting function* always has, but in the case of the Comment mode, it is also the effect of the self-referential concerns that define this type of exposition that makes these political/ ideological considerations apparently irrelevant to its understanding.

Notes

1. Eco, U. *The Limits of Interpretation* (Bloomington: Indiana University Press, 1994), p. 94.
2. Kernan, L. *Coming Attractions: Reading American Movie Trailers* (Austin: University of Texas Press, 2004), pp. 40–41.
3. Stewart, G. "Crediting the Liminal: Text, Paratext, Metatext," *Limina/le soglie del film: Film's Thresholds*, ed. Veronica Innocenti and Valentina Re (Udine: Forum, 2004), p. 51.
4. Bordwell, D., Staiger, J. and Thompson, K. *The Classical Hollywood Cinema* (New York: Columbia University Press, 1985), p. 26.
5. Einstein, A. "Interview With Alfred Werner," *Liberal Judaism*, vol. 16 (April–May 1949), Einstein Archive 30–1104, quoted in *The New Quotable Einstein*, ed. A. Calaprice (Princeton: Princeton University Press, 2005), p. 173.
6. Betancourt, M. *Semiotics and Title Sequences: Text-Image Composites in Motion Graphics* (New York: Routledge, 2017), pp. 31–33.
7. Landau, S. "Das Intro als eigenständige Erzählform. Eine Typologie," *Journal of Serial Narration on Television*, vol. 1, no. 1 (Spring 2013), pp. 33–36.
8. Sternberg, M. *Expositional Modes and Temporal Ordering in Fiction* (Bloomington: Indiana University Press, 1978), p. 14.
9. Betancourt, M. *The Critique of Digital Capitalism* (Brooklyn: Punctum Books, 2016), pp. 117–152.
10. Eco, U. *The Limits of Interpretation* (Bloomington: University of Indiana Press, 1994), p. 90.
11. Virilio, P. *Art and Fear* (New York: Continuum, 2003).
12. Eco, U. *The Limits of Interpretation* (Bloomington: University of Indiana Press, 1994), p. 86.
13. Eco, U. *The Limits of Interpretation* (Bloomington: University of Indiana Press, 1994), pp. 84–87.
14. Eco, U. *The Limits of Interpretation* (Bloomington: University of Indiana Press, 1994), p. 95.
15. "Publisher's Note," *The Doré Illustrations for Dante's Divine Comedy* (New York: Dover Publications, 1976), p. v.
16. Eco, U. *The Limits of Interpretation* (Bloomington: University of Indiana Press, 1994), p. 97.
17. Tuchman, M. "Wayne Fitzgerald Interviewed," *Film Comment*, vol. 18, no. 2 (May–June 1982), pp. 66–69.
18. McGregor, D. "Maurice Binder: Part 1," *Starlog*, no. 74 (September 1983), pp. 20–23, 60; and McGregor, D. "Maurice Binder: Part 2," *Starlog*, no. 75 (October 1983), pp. 56–61.

19. Betancourt, M. *Synchronization and Title Sequences* (New York: Routledge, 2017), pp. 104–113.
20. Eco, U. *The Limits of Interpretation* (Bloomington: University of Indiana Press, 1994), p. 96.
21. Cavell, S. *The World Viewed: Reflections on the Ontology of Film*, Enlarged Edition (New Haven: Harvard University Press, 1979).

5 The Summary Mode

The role of *narrative function* in title sequences is complex. Audience interpretation and engagement determine how exposition creates the peritext::text connection, mediated to large degree by lexical expertise, past experience, and prior knowledge of the *fabula*. There are two ways to understand the direct connection between title sequence and narrative: as an immediate part of the story, an integral unit within the progression of *syuzhet* itself (Prologue mode); or as a pseudo-independent unit, a separate and parallel restatement of the narrative (Summary mode) that does not *introduce* the *fabula*, but repeat it. Both types depend on the same realist ideology that transforms their presentations into a self-evident "fact."[1] *Narrative function* dominates the audience's understanding in Summary mode expositions, but is balanced by the *crediting function* to define them as a self-contained sequence separate from the main text—a *paranarrative*[2]—either a series of 'cut scenes' arranged as montage (the simple variant), or as a sequence whose order and progression requires prior knowledge to make its *fabula* coherent (the complex variant). The contingent interpretation the term paranarrative identifies is the audience's invention of an absent causal link that creates a *fabula* from the unfolding cinematic events progressing on screen.[3]

The peritext::text distinction that identifies the Summary mode 'title sequence' organizes how the audience understands these expositions and their *narrative function*. Exposition in the Summary mode retains key events from the *fabula* and results in the presentation of a cause-effect sequence that encapsulates the narrative for the audience, but which cannot be interpreted as "backstory." This abbreviated or schematic *syuzhet* is comparable to what develops in the main text, challenging it for primacy. For the audience, this presentation always reveals key parts of the narrative, an intratextual statement about what has or will happen in the story, re-presenting the course

of the plot's development;[4] however, their pseudo-independence is never in question.

Peritexts and epitexts are united by their use of abbreviated narrative development to present the *fabula*, linking them to the Summary mode. These repetitions are increasingly common in title sequences and trailers during the Middle Phase of the Designer Period. Audience understanding of simple and complex Summary is inflected by its placement—at the beginning, middle, or end of the motion picture—but this location does not alter the nature of the *syuzhet* encapsulating events. This locative differential creates a superficial misconception of these designs as "spoilers" (anticipation) or "nostalgia" (recapitulation), an understanding that Jonathan Gray explained in *Show Sold Separately*, his study of epitexts. These expositions present the narrative elaboration of the main text in advance of the audience's encounter with the *fabula*:

> Spoilers include any information about what will happen in an ongoing narrative that is provided before the narrative itself gets there. To tell someone who will die on next weeks show, what a film's key plot twist is, or what to expect next is to "spoil" the person and/or text.[5]

How this information is conveyed by the exposition unites film trailers and title sequences employing the Summary mode. A "spoiler" reveals narrative information inappropriately early, anticipating events that are not immediately obvious. It is always a potential concern for any paratext employing cut scenes or other derivative elements from *fabula*. The *narrative function* dominates the interpretation of these designs by implying cause-effect without necessarily showing it precisely. The recognition and interpretation of these narrative shards depends on the audience's lexical expertise and fluency with the narrative codes that may be only schematically present. These simple expositions are comparatively rare as opening expositions, even though they are common in film trailers.

The Designer Period title sequence for *The Mephisto Waltz* (1971) designed by Phill Norman [Figure 5.1] is a typical instance of the simple variant. This expositional montage presents the narrative composed through cut scenes to reveal the essential points in the cause-effect progression of the *fabula*. However, this opening is not a "spoiler" in the sense that Gray describes: recognizing that it presents the entire story "inside" the optically printed masks of hands superimposed over flames only becomes possible in retrospect, once the film

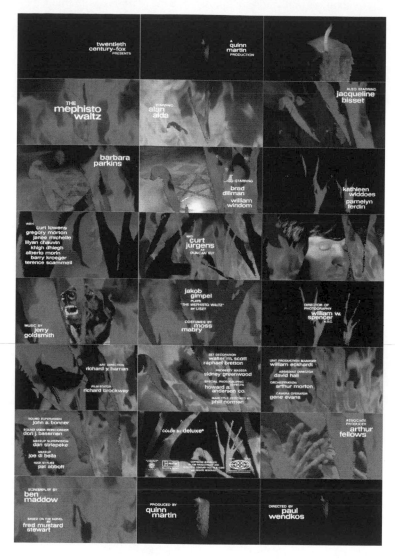

Figure 5.1 All the title cards in *The Mephisto Waltz* (1971)

is over, because while the events *do* offer a condensation of *fabula*, they have been rearranged to proceed in *reverse* order. Stylization prevents the titles from being an immediately apparent 'spoiler' in a higher-level interpretation. The naturalism::stylization develops an

ambivalent *syuzhet* whose relationship to the narrative is attenuated by its abstract progression. The long take showing "Roxanne Delancey" (played by Barbara Parkins) performing the Satanic ritual that allows "Duncan Ely" (Curd Jürgens) to trade places with "Myles Clarkson" (Alan Alda), swapping his old body for Clarkson's younger one, is typical of the narrative reiteration created by the chosen cut scenes in *The Mephisto Waltz*. The construction of this narrative about an aging pianist who uses witchcraft to steal the body of a younger man so he can continue his career is challenged by the ellipses/disconnections between shots. The encapsulated narrative shown in the Summary is the same as what appears in the main narrative. There is no obvious resolution to this problem since the titles remain a pseudo-independent unity, self-contained and organized separately as paranarrative. It is the same issue that all title sequences employing cut scenes have: the shots *do* appear in the main text, but their context/significance often remains unknown.

The recognition of ambivalence in *The Mephisto Waltz* is nuanced: the titles can be understood as either [1] a reiteration of what happens, or [2] a statement that the events of the *fabula* have all happened before and will happen again. Which potential the audience chooses depends on how they engage the exposition, naturalizing this presentation of supernatural, demonic events as a mundane ordering of the world. However apparently direct the Summary mode's *narrative function* seems to be depends on a conclusion about its relationship to the main text. The stylization of the events in Phill Norman's design makes multiple interpretations possible because the disconnected, evocative shots composited together are not a montage, even though they are synchronized rhythmically. Compositing multiple layers of imagery with optical masks isolates and abstract the causality shown by the cut scenes, or the narrative might emerge from a more traditional montage sequence without the additional juxtaposition of flames and hand-masks. Stylization attenuates *narrative function*: the compositing of the flames, hands, and text is sufficiently transformative to render their causality ambivalent. Any "spoiler" in this opening requires past experience, either the audience's prior knowledge of the *fabula*, or through intertextual knowledge that Liszt's *Mephisto Waltz* adapts scenes about a musician who has made a deal with the Devil from Nicholas Lenau's version of the *Faust* story.[6] The theme music provides an subtext for those audience members who recognize the allusion to *Faust* that informs Franz Liszt's *Mephisto Waltz, No.1* (*Der Tanz in der Dorfschenke*) S.514, or who recognize the piano and violin duet's title *is* also the title of the film—these external,

intertextual recognitions direct consideration away from the *narrative function* to the traditional, literal presentation of the film's name, a connection that does not require further analysis.

The Summary mode develops as overlaps between epitexts and peritexts since audiences understand title sequences dominated by *narrative function* as parallel or even external to the main text they credit. Without narrative restatement accentuating their pseudo-independence, Summary mode exposition is irrelevant to viewer engagement with the title sequence. These titles, like the trailers historian Lisa Kernan describes in her book *Coming Attractions*, contain a secondary exposition of the same *syuzhet* and *fabula* that appears in the main text:

> Through the rhetoric of story, trailers both impart and withhold story knowledge, performing a balancing act that both provides enough information and holds back enough information to maximize interest in seeing the film (i.e. not "give away the product").[7]

Her "rhetoric of story" is fundamentally realist—narratives match audience expectations of how things are perceived in daily life and experience. The audience's expectations that what they encounter in the world-on-screen corresponds to their understanding of the real world they inhabit. This understanding of "realism" is a presentation where what happens on-screen corresponds to what could happen for the audience it they watched the same events in real life.[8] This view becomes an essential element in the decoding and interpretation of the schematic narratives presented in a Summary mode paratext. Roland Barthes' observations in *S/Z* about the role of naturalism::stylization in realist works are instructive:

> Thus, realism (badly named, at any rate often badly interpreted) consists not in copying the real but in copying a (depicted) copy of the real: this famous *reality*, as though suffering from a fearfulness which keeps it from being touched directly, is *set farther away*, postponed or at least captured through the pictorial matrix in which it has been steeped before being put into words: code upon code, known as realism.[9]

The elements of fictional structure are foundational assumptions for narrative interpretations: the cause-effect sequence (*syuzhet*), the story (*fabula*), characterization, and the creation of a consistent fictional 'reality' on-screen presenting a self-consistent 'reality.' As Barthes

noted, the identification of any particular representation—linguistic, visual, audible, etc.—as being "realist" is a conventional identification, encultured. The particular problematics of photographic/cinematic realism are less important in their detail than in their existence—the contingency and conventional nature of their organization as a set of codes applied to the production of motion pictures. Materials organized by the range of naturalism::stylization (via lighting, photography, mise-en-scene, etc.) retain this basis even when recontextualized in another, derivative sequence such as the 'cut scene' employed in a title sequence. Assuming cinematic realism in the reductive elaborations of events is inherent to their narrative construction. Barthes identifies the ideology of realism in those claims about the denotative image as an imprint or proof of the real, that the image is what it appears to be in a motion picture, rather than the contingent and already encoded product of découpage—editing, lighting, framing, compositing, and photographic processes—because 'realism' organizes this articulation to make itself invisible.

The dynamic between naturalism::stylization in the composited imagery of *The Mephisto Waltz* title sequence converges with observations theater historian Nicholas A. Vardac made about the relationship of fantasy to realism in nineteenth-century melodrama, and its role in the invention of narrative cinema. The conventional links between stylized and naturalistic presentations in melodramatic theater became a foundational part of the emergence of narrative cinema in the first decades of the twentieth century. Greater narrative and dramatic abstraction (stylization) was accompanied by an equally great appeal to the audience's everyday experiences (naturalism) to render stylization and fantasy as plausible, mundane "reality." These developments illuminate the role of established expectations for realism:

> The growth of this "slice-of-life" naturalistic theatre exercised an influence upon the popular theater and upon that stream of romanticized pictorial productions flowing through the work of Charles Kean. Romanticism and realism were simultaneous tastes of the entire cycle of theatrical expression emanating from Garrick: the more romantic a dramatic conception, the more realistic tended to become its production.[10]

The emergent paranarrative forms created by the Summary mode depend on audience recognitions for their transformation not just of stylization into narrative, but their adding missing or elliptical details

to the exposition to allow the implied or incomplete *syuzhet* to create the *fabula*. The resulting narratives depend on lexical expertise. This active role is immediately apparent in the paranarrative created by *The Mephisto Waltz* title sequence. Although the composited event-shots encapsulate the entire progression of the story—its narrative futurity—their causality is compromised by the stylization and selection process. The causal links are not present in this montage. Instead, stylized optical printing juxtaposes the cut scenes with both imagery of hands (as the mask) and high contrast, hellish red flames (as the background field for the compositing), creating a stylized statement that is only partially *syuzhet*. Naturalism is normally assumed for cut scenes and other live action materials,[11] but when they are mixed together by the compositing process, it becomes an ordering interpretation that must be consciously imposed.

Vardac's "slice-of-life" only applies unambiguously to the composited cut scenes themselves. These depictions of moments from the main narrative in *The Mephisto Waltz* title sequence offer clear statements of *syuzhet*. The opening is organized by the iconography of red flames, masks/hands and the synchronized, staccato music of Liszt's waltz, written for his *Faust* symphony. The music as *event*—apparent from its intertextuality—gives an additional level of signification to this opening. The satanic character of the narrative imagery is highlighted by the theme music, the first and immediate focus of attention during the title sequences' progression from flames to cut scenes composited with the shots of fire inside hand-masks. Without knowledge of narrative events, it is only in retrospect that its summative dimension becomes obvious.

The ordering "realism" created by audience expectations is doubled by Norman's design: the naturalism of the cut scenes is counterpointed by the stylization of the compositing. This naturalism::stylization dynamic orchestrates their synchronization to Liszt's *Mephisto Waltz* (the most famous part of his *Faust* symphony)[12] to make the meaning of events shown an immediate focus for what appears in this title: a 'twined realism' of superficial, "mere appearances" of the visible world, *and* the revelation of their significance, intellectual, a "deeper reality" normally hidden. The repetition of the *fabula* in the peritext::text dynamic coincides with the narrative's implication that these events have happened many times before—the rule of variation, *e pluribus unum*—that the story concerns only *one* time the pianist has stolen a younger man's body, something he has done before and will do again. The doubling of narrative in the opening becomes a rhetorical presentation of these earlier thefts. The recognition of them

in the more naturalistic events of the main text allows the audience to know how the story ends without changing the interest in the *particular* story being told.

In being schematic, the Summary mode relies on the established codes of cinematic realism to allow audiences to invent causal connections between isolated shots (*syuzhet*) transforming them into a conventionally pre-established *fabula*. Schematic narratives are tautological: without the recognitions of narrative (*fabula*) evoked by the series of images and guided by past experience, audiences cannot justify their organization as *syuzhet* beyond the lower-level *statements* offered by the montage sequence and its synchronization. This difficulty of advancement from lower to higher levels is clear in the ambivalences of *The Mephisto Waltz*. Audiences can only recognize the relationship to narrative events if they already know what they will be—*futurity* is essential to the identification of this credit sequence as elaborating on the *fabula*-yet-to-come. Understanding the Summary mode as *fabula* demonstrates the essential, central role of audience interpretation as the organizers of isolated elements. The role of established lexia—the narrative schema invoked—makes the Summary mode the most directly and specifically semiotic type of exposition.

The distinction between the Summary mode's use of cut scenes and those of the Prologue or Comment modes lies precisely with *how* the audience understands their relationship to narrative. The organization of the Prologue mode as a series of events happening *before* the beginning, as with the lone rider approaching town in the Studio Period design for *Shane* (1953), or the elaboration of who each character *is* in the TV title sequence for *Grimm* (2012–2017) are distinct, alterior interpretations than the recognition of narrative in *The Mephisto Waltz*. If the audience understands the events shown as containing a narrative progression, as being a condensation of cause and effect to offer a schematic version of a story, it cannot also be about who the characters are. Each of these engagements require the same lexical decisions about the relationships between elements as in the other modes, but with a very different conclusion about the role of *syuzhet* and *fabula* in the morphology and structure of the title sequence.

Complex Summary

The complex variants of Summary mode create highly schematic paranarrative, stylized to the point of seeming allegorical (or symbolic), making the organizational role of naturalism::stylization in their realist construction obvious. Using iconic imagery to represent

the narrative gives these complex Summaries a superficial similarity to the Allegory mode: the distinction between these modes lies with how the Summary mode aligns with a direct presentation of the plot's events (*syuzhet*) rather than an indirect, thematic presentation.

The animated "map" by illustrator and graphic designer Bob Gill previews the narrative for *The 7th Voyage of Sinbad* (1958) [Figure 5.2]. This example of Summary exposition from the Early Phase of the Designer Period simultaneously renders the background/title sequence as a hand-drawn diagram of events in the *fabula* that is also a rendering of the actual film titles using limited-cel animation. This map is a metonymic rebus whose visualization of the story is readily apparent. The complexity of this exposition encapsulates the "sights" from the film/narrative's progression as the marginalia common to ancient maps proclaiming "here be monsters." The isomorphic relationship between "voyage" and "map" is immediate and instantly understood. The real motion across the title/map invokes the convention of narrative cinema where animated motion over the map is always a visual metaphor for the voyage the map suggests, an entanglement of presentation in the fact of the map, and in the metaphor of mapping events that are also the future events to come in the story: in *The 7th Voyage of Sinbad*, the monsters shown on the map are real,

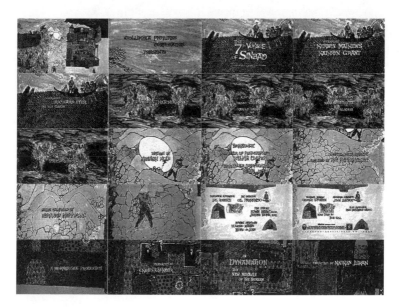

Figure 5.2 All the title cards in *The 7th Voyage of Sinbad* (1958)

given life by Ray Harryhausen. The duplicity of interpretations is typical for the Hollywood title sequence: multiple engagements result in a singular interpretation, converging on film title itself, while the paranarrative reveals *syuzhet* in anticipation of its naturalistic elaboration in the main text.

The distinction between the Allegory mode, which tends toward abstraction, is clear from *The 7th Voyage of Sinbad*. The events informing these designs match the progression of the story's events, but without their *literal* appearance. The Summary mode tends to align with the story, without the need for intertextual dialogue for its comprehension, a direct engagement with narrative that is discursively complex. Even though the "sights" of the narrative are contained by the map, their presentation is more a "teaser" than a dramatization—the still images traversed in the kinestasis are not the same as Harryhausen's stop-motion that is the film's primary attraction. Just as in the lower-level entanglement of text::image in the rebus, the Summary mode exposition depends on the audience recognizing the rhetorical relationship between the exposition and its deciphering 'key.' Because of the centrality of narrative events to the comprehension of the Summary mode, it is more common to encounter the complex variant as a main-on-end, a review of narrative events whose intratextuality makes their relationship to narrative immediately apparent, than as an ambivalent beginning.

A similar paranarrative appears in the main-on-end design for *Land of the Lost* (2010) by Jeremy Dimmock and Brent Watts [Figure 5.3]. The same literalization of actual film title as the progression of movements into/though a graphic landscape—the same use of kinestasis as in *The 7th Voyage of Sinbad*—is also a reiteration of its "map" of narrative events as the exposition. The diversity of "lands" the characters pass through during their visit to the "land of the lost" recapitulate the narrative. The minimal animation within these shots does not diminish their role as kinestasis, corresponding to transitions between one rebus-background and the next, a repetition of *how* the characters entered into the "land of the lost." The convergence of these otherwise very different designs from the Studio Period and the Contemporary Period demonstrates the uniform priorities imposed by the traditional organization of title sequences in Hollywood productions. These formative conceptions of titles and their relationship to the main text apparent in Summary mode designs tautologically enable their interpretation.

The same reiteration of *fabula* appears in the Contemporary Period title sequence by Manija Emran for *The Huntsman: Winter's War* (2016). The collisions between symbolic figures in this main-on-end

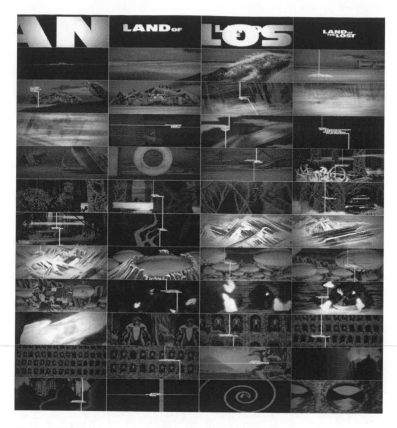

Figure 5.3 All the title cards in *Land of the Lost* (2010)

design represent the main characters in the film [Figure 5.4]. The audience easily makes the connection between title sequence and narrative because this design recapitulates the "war," ending when only the victor remains. For the audience watching this design it directly restates the *fabula* in an abstracted visual form. Unlike the Summary mode main-on-end designed by Steve Volta for *The Avengers*, which also employed similar icons to represent the primary "heroes" of the narrative, Emran's design stages these symbols in collision, shattering each other. What separates both designs from the Allegory mode they resemble is precisely their narrative engagement, readily apparent in *The Huntsman: Winter's War* where the victor at the conclusion of this conflict mirrors the victor in the *fabula*. This title sequence is not a cypher requiring the discovery of a key for its decoding. Placed

Figure 5.4 All the title cards in *The Huntsman: Winter's War* (2016)

as a main-on-end, after the *fabula* concludes, audiences can readily recognize its intratextuality because they know the narrative progression, enabling its unambiguous recognition in the title sequence, thus resolving the problematic aspects of anticipation apparent in earlier Designer Period designs such as *The Mephisto Waltz*.

Reiteration renders the summary presentation readily apparent, eliding its obviously constructed nature for readily comprehensible intratextual quotations. Its dramatization of the narrative's progression is explicit, if ambivalent about the particular details of the events. The 'unity' of the title design and the narrative hides the constructed nature of these associations. The directness of the connection between peritext::text lies with how the events of the narrative are recognizable in the paranarrative; reiterations and repetitions that make the links of the complex variants immediately comprehensible and apparently so "natural" as to not require theoretical analysis.

Narrative Restatement

Summary mode expositions are fully dominated by the narrative function, but are not fully integrated with the narrative: the pseudo-independence of 'title sequence' from narrative enables their stylized encapsulation and representation of *fabula* without the audience necessarily recognizing the intratextual repetition that inherently results. That the audience does not necessary recognize any Summary encapsulation during the title sequence is reflective of the information needed to anticipate the connection, not the organization of the opening; for those viewers who recognize the *narrative function* dominating these opening credits, the *fabula* and its presentation are the central concern for their engagement with the Summary mode. *Syuzhet* appears in these expositions via evocative shots or scenes chosen for their potential as a visualization of "plot points" in the main text; unlike Landau's description of the cut scenes appearing on TV in Comment mode expositions, the images chosen and arranged create a direct restatement of the narrative itself, an encapsulation of events that are *fabula*. The "invisibility" of narrative content reveals the ambivalence of designs that require prior knowledge (futurity) for their recognition.

Narrative restatement in the Summary mode poses a unique challenge to the division of peritext::text in how this exposition is a rendering equivalent of narrative and title sequence. The resulting narration presents a story without a coherent, autonomously evident diegesis—it elides key elements of this construction, leaving their

invention to the audience. Semiotician Christian Metz' observations about diegesis in *Film Language* makes the role for viewers in Summary mode expositions clear:

> The term [diegesis] was introduced into the framework of cinema by Étienne Souriau. It designates the film's represented instance (which Mikel Dufrenne contrasts to expressed, properly aesthetic, instance)—that is to say, the sum of a film's denotation: the narration itself, but also the fictional space and time dimensions implied in and by the narrative, and consequently the characters, the landscapes, the events, and other narrative elements, in so far as they are considered in their denoted aspect.[13]

The highly schematic nature of these isolated cut scene shots renders their denotative, naturalistic contents ambivalently: how is the shot of a snarling, barking dog to be understood in the opening to *The Mephisto Waltz*? It is not merely a dog, but a "hell hound," an identification *not* present in the shot of the dog, but an interpreted conclusion offered by its composited juxtaposition with the red flames themselves evoking "Hell." One contingent meaning reinforces the other. But this recognition is not *denotation*: it is invented, challenging the assumption of a self-evident narrative space whose realist demonstration and denoted contents are autonomously emergent. The viewer is integral to constructing paranarrative, their recognitions and identifications inventing the denoted causality and identifying the imagery—and thus any narrative—making their encultured ideology an implicit, and invisible, part of the fictive presentation.

The centrality of audience recognition in Summary mode paranarrative cannot be underestimated. The audience must identify the visible events as having a narrative dimension for cause-effect relationships to emerge. Realism is central to these constructions of *fabula* since the narrative interpretation depends on the audience recognizing the features of 'reality' in the various stylized shots and sequences. Their construction of causal relationships comparable to those more complete sequences in the main text rely on the directness of their realism. The link between apparent realism and narrative content—in *The Mephisto Waltz*, the elimination of continuity replaced by the juxtaposed imagery made possible with optical printing, or the 3D animation of *The Huntsman: Winter's War*—makes naturalism evocative of an immanent causality that instructs viewers to engage the imagery/events they show as productive of narrative. Apparently autonomous jumps from naturalism to denotation to narrative are the

conventional engagement with the naturalism::stylization of imagery in motion pictures, a learned engagement that renders the apparently denotative contents are *syuzhet*, and thus generative of *fabula*.[14]

The conventional understanding of *credits* and *fabula* always asserts a hierarchy where the peripheral elements (paratexts) are specifically subservient, an appendage to the events of the narrative. Although the same decision process might be employed in both Summary and Comment modes to select and isolate the cut scenes shown in the title sequence, the audience interpretation of that use is entirely different, reflecting the differential relationship of these modes to the narration their audiences invent to organize and link the disparate materials on view. Narration is not denotation; it is an invention to justify the particular interpretations and assignments of roles and meaning to the lower-level sequences. Paranarrative doubling of *fabula* simultaneously relies on the evident distinction between title sequence and narrative, while implying their interdependence. Only the conventional hierarchy maintains lexical order. The reduction to only those essential "plot points," equally apparent in any Summary mode exposition, from the encapsulation in *The Mephisto Waltz* or ambivalence of *The 7th Voyage of Sinbad*, to the abstraction of *The Huntsman: Winter's War*, demonstrates that the *other* moments left out were actually unnecessary, challenging the main text's dominant position. Narrative restatement is thus ambivalent: at once a separate construction, in condensing the story, it suggests the irrelevance of the parts removed.

The greater the ellipsis in the construction, the more essential the audience interpretation is in that relationship. Without this initial identification of the dramatic and naturalistic progression of event-elements as organized according to an ambiguous or even absent causality, their identity as *syuzhet* never emerges, and the iteration of *fabula* thus becomes problematic. The schematic nature of Summary exposition shifts understanding onto the audience who must invent the logical connections between the disparate parts shown—establishing their causality—without necessarily being shown all the elements of that narrative sequence: the "filling-in" of details in these constructions depends on the viewer's lexical expertise. There is no singular meaning proposed by Summary exposition precisely because so much of its causal and narrative significance must be *invented* by the viewers. What is missing in Metz' description of 'diegesis' is the role of audience interpretation in facilitating and energizing narration: the viewer's understanding renders what is ambivalent as denotation, establishing the understanding of what they will encounter in advance. The spectatorial agency required in engaging these partial or

fragmentary narrative expositions align with the observations Richard Maltby made in his examination of the "romantic interlude" in *Casablanca*:

> This reader's competence is responsive: imaginatively active, perhaps, but not proactive; it accommodates the reader to the world of the text. . . . Unlike the critic, who inhabits an alternative sphere of analytic liberty in which the fissures of the text are exposed and its sutures unsewn, Eco's "average reader" is a good bourgeois, never seeking to occupy a position from which it might disrupt the text.[15]

These idealized, typical viewers who use their lexical expertise to follow and embrace the narrative are precisely those "complicit" viewers whose shifting understanding of crediting/narrative functions, engagement with statements[16] at different levels of enunciation, and recognition of the intratextuality of sequences renders the Summary mode coherent. Paranarrative relies on lexical expertise, but is itself an ambiguous collection of enunciations. This "average reader" who engages the text in a standardized fashion, guided by encultured, lexical codes of decipherment is revealed by how the analysis of peritexts creates narrative modes equally integrated and separated from the main text. It is these viewers' engagement that produces narrative and provides the dominant assumptions challenged by "critical readers" who disrupt the text and do not "merely" follow the "rhetoric of story."

Only in adopting a conventional resolution, lexically informed, do these aspects of Summary exposition render a fictional space and time productive of *fabula*. The competence and easy engagement by these idealized audiences creates the 'completeness' of the main text and the paranarrative equally. The Summary mode makes exposition of causality in the selective choices inherent to any progression of cut scenes necessarily self-referential and reflexive. This distinction in engagement between Summary exposition and main text reiterates the separation of pseudo-independent sequences.

The instability around the relationship of the narrative events is obvious in Designer Period expositions, such as that of *The Mephisto Waltz* and *The 7th Voyage of Sinbad* where the contents of both main text and title sequence converge. Their ambivalence is accentuated by the role of past knowledge; lexical expertise (the distinction between what Maltby terms "innocent" and "sophisticated" viewers[17]) demonstrates the recognition of Summary mode exposition as developing

fabula, but this development is framed by the artificiality of that construction. The paranarrative is not a substitution for the primary narrative, but a supplement to it, and at the same time, a challenge to its dominance. The progression contained by the Summary mode requires a more constructive engagement for its *fabula* to cohere: this distinction between the "innocent" and "sophisticated" viewer mirrors the lexical distinctions between simple and complex variants in each expositional mode. It makes the centrality of spectatorial agency obvious in the invention of narration, diegesis, and the denoted contents of sequences.

Audience understanding of title sequence exposition depends on viewers' conscious decisions about how to interpret the ambiguities (antimonies) of plot and narrative progression in relation to the contents of the title sequence. The schematic nature of any narration in the Summary mode draws attention to these instabilities and the resulting artificial resolution imposed by the viewers, since the denoted elements of character, setting, and causality commonly assumed in narrative are ambivalences. Stylization augments this multiplicity of potential interpretations by complicating the interpretation. The dynamic that emerges between naturalism::stylization attenuates the causal linkages between statements made within the title sequence. The polysemous variety these designs offer opens the range of interpretations beyond the obvious exposition of *fabula* to other, non-narrative understandings. This expanded field appears as a range of potential meanings, thus challenging the view of Summary mode exposition as being simply a "spoiler": only some viewers interpret paranarrative as revelations of future story; the uncertainty about the narration created by the indirect and repressed connections of cause-effect opens audience engagements beyond the singular statements offered by *narrative function*. These other meanings are no less expository—the rhetorical play between traditional fantasies of "here be monsters" and the mapping of the voyage promised in the title in *The 7th Voyage of Sinbad* does not preclude narrative contents even as these other meanings challenge them as being an explicit, unambiguous statement of *fabula-to-come*.

Singular interpretation opens into a range of potentials, all equally grounded in the materials of the design, but whose multiple and mutually exclusive understandings challenge the singularity of *fabula*. This variety undermines the authority of the main text by introducing narrative orderings developing the ambivalence of audience engagement: the Summary mode offers "something for everyone" at the expense of developing a readily coherent narrative. Because key

details are missing from these expositions, the audience must invent them—supplying the missing parts from their own past experience—effectively creating the narrative from partial cues and (often absent) statements of cause-effect. The presentation of diverse elements, only some of them causal, is precisely constructive of the ambivalence in these designs. This reliance on viewers' complicit engagement in the material presentation challenges the traditional conception of audiences as "passive"; however, their "activity" is not the distanced, critical gaze of aesthetic judgment, but the rapt attention of the seduced, whose own engagement has been used as a lure to insure a stronger and more complete enthrallment within the fictional realm.

The apparently autonomous organization of paranarrative in the title sequence and the superficially "natural" separation of peritext::text masks the ideological/cultural dimensions of their interpretation by rendering the semiotics superficially insignificant to the higher-level productions of *fabula*. The composition of title designs from a range of lower-level associations of text::image, statements of synchronization, and narrative expository modes makes these units within a motion picture exemplars of its semiosis. Marginalizing the title sequence as simply a "threshold" whose stylization and abstraction is of only limited relevance for the critical engagement with the main text loses the role that peritexts play in the development of the main narrative. However, the affirmation of naturalism::stylization in realist form mediates an ideology where the depiction on-screen is conceived as merely denotative. Understanding the motion picture as an isomorphic description of reality shifts focus to the fictive events, not the conventions governing their naturalism::stylization, hiding the presence of paranarrative from critical consideration. The title sequence is an essential mediator in this assertion of a "passive" engagement. It is an instruction about *how* to understand the motion picture. This role for the titles establishes the appropriate types for the audience to interpret: these openings discourage oppositional challenges to established lexical codes.

Notes

1. Ryan, M. *Avatars of Story (Electronic Mediations)* (Minneapolis: University of Minnesota Press, 2006), pp. 186–187.
2. Martens, G. and Biebuyck, B. "Channeling Figurativity Through Narrative: The Paranarrative in Fiction and Non-Fiction," *Literature and Language*, vol. 22, no. 3 (2013), pp. 249–262.
3. Biebuyck, B. "Figurativeness Figuring as a Condenser Between Event and Action How Tropes Generate Additional Dimensions of Narrativity,"

Amsterdam International Electronic Journal for Cultural Narrantology, no. 4 (Autumn 2007), http://cf.hum.uva.nl/narratology/a07_biebuyck. htm retrieved July 26, 2017.

4. Allison, D. "Novelty Title Sequences and Self-Reflexivity in Classical Hollywood Cinema," *Screening the Past*, November 27, 2006, www. screeningthepast.com/2014/12/novelty-title-sequences-and-self-reflex ivity-in-classical-hollywood-cinema retrieved May 26, 2015.

5. Gray, J. *Show Sold Separately: Promos, Spoilers and Other Media Paratexts* (New York: NYU Press, 2010), p. 147.

6. Ewen, D. *The Complete Book of Classical Music* (Englewood Cliffs: Prentice-Hall, 1965), p. 519.

7. Kernan, L. *Coming Attractions: Reading American Movie Trailers* (Austin: University of Texas Press, 2004), p. 80.

8. Rushton, R. *The Reality of Film: Theories of Filmic Reality* (Manchester: University of Manchester Press, 2011), pp. 44–47.

9. Barthes, R. *S/Z* (New York: Hill & Wang, 1974), p. 55.

10. Vardac, A. Nicholas. *Stage to Screen* (Cambridge: Harvard University Press, 1949), pp. 68–69.

11. Lotman, J. *Semiotics of Cinema* (Ann Arbor: University of Michigan Press, 1981).

12. Hamilton, K. *The Cambridge Companion to Liszt* (Cambridge and New York: Cambridge University Press, 2005), pp. 79–80.

13. Metz, C. *Film Language* (New York: Oxford University Press, 1974), p. 98.

14. Burch, N. "How We Got Into Pictures," *Afterimage*, no. 8/9 (Spring 1981), pp. 24–30.

15. Maltby, R. "A Brief Romantic Interlude: Dick and Jane Go to 3 1/2 Seconds of the Classical Hollywood Cinema," *Post-Theory: Reconstructing Film Studies*, ed. David Bordwell and Noel Carroll (Madison: University of Wisconsin Press, 1996), p. 435.

16. Foucault, M. *The Archaeology of Knowledge* (New York: Pantheon, 1972).

17. Maltby, R. "A Brief Romantic Interlude: Dick and Jane Go to 3 1/2 Seconds of the Classical Hollywood Cinema," *Post-Theory: Reconstructing Film Studies*, ed. David Bordwell and Noel Carroll (Madison: University of Wisconsin Press, 1996), pp. 438–439.

6 The Prologue Mode

The traditional Hollywood demand for title sequences that are legible throughout the entire theater, common until the Designer Period in the 1950s, restricts the potentials for *narrative function*. How title designs handle the text::image dynamic, always an issue for text::image composites, becomes increasingly prominent as the *crediting function* becomes less important. The development of the Prologue mode demonstrates how these traditions were in flux the in the Designer Period. Both Saul Bass' Modernist design for *The Man with the Golden Arm* (1955) at the start of the Early Phase, and the orchestration of credits and narrative typical of the Middle Phase in Wayne Fitzgerald's title sequence for *Touch of Evil* (1958) challenged the established standards in Hollywood, but offered distinct resolutions to the opposition between *crediting* and *narrative functions*.[1] These changes are apparent in the design of the titles themselves, changes that impact the exposition modes allowed in opening sequences, and which lead to a transformation of the design, meaning, and structure of end titles. The avant-garde graphic design of Saul Bass's Allegory mode title *The Man with the Golden Arm* allows the typography to dominate in spite of its smaller on-screen size, an arrangement and hierarchy of type and graphics on-screen that rejects the graphic morphology and structure of earlier title sequences. In contrast to this repudiation of Hollywood's standards for type placement and appearance, Fitzgerald's design for *Touch of Evil* accommodates the traditional size and prominence of the credits by locating voids in the screen composition ("type hole") allowing the addition of large, superimposed title cards as a counterpoint to the narrative action. Fitzgerald's transformation of tradition resolves the opposition of live action photography and type on-screen. These differences reflect the very different production of each design: Bass, working as an outside "star" designer and credited on-screen in the titles, in contrast to Fitzgerald, working without

on-screen credit, a staff designer at Pacific Title & Art Studio[2]—the former ignoring the traditions of title design in Hollywood, the latter literally a part of the singular company[3] most closely associated with establishing them.

The Prologue mode is dominated by the *narrative function* in ways that fundamentally distinguish it from the other expositional modes: the complexity of these designs derives from their integration of *crediting* and *narrative functions* that can eliminate the "title sequence" as such. However, no matter how few opening credits there are in the Prologue mode, there is *always* a studio or distributor logo that comes first, before the narrative action, signifying the start. Even when the story seems to begin instantly, this opening does not preclude a complex title sequence *after* the narrative ends. Their role in the narrative defines their identification; the identification of the film's opening sequence as a pseudo-independent unit is a prerequisite for it to function as a prologue to the narrative that follows. They can develop in long takes with elaborate staging and mise-en-scene such as in *Touch of Evil* (1958) or *The Player* (1990), or almost none as in the Studio Period design *White Zombie* (1931), as well as for cut scene montages in television programs such as *The Prisoner* (1967), *The Incredible Hulk* (1978), or *Grimm* (starting in season 2, 2012). "Prologues" must always come at the beginning or else they are "epilogues." Prologue mode expositions establish narrative 'facts'—when placed at the start of the narrative, it presents *causes* whose effects are the development of the *fabula*; when placed at the end, as an epilogue, it presents *effects* whose causes are the conclusion to the *fabula*.

In the Prologue mode opening for *Touch of Evil* [see Figure 1.8, on page 23] neither the superimposed credits nor dramatic action obstructs the visibility of the other, in the process providing a model for later title sequences dominated by their *narrative function* without violating the existing design standards and practices. The separation of titles from story via the presence of theme music and on-screen credits—the minimal features required to identify the *crediting function*, even if only in a single title card or production logo—are the necessary and sufficient conditions for the titles to be understood as being *outside* the narrative, as a title sequence, or *peritext* even though the *fabula* has already begun. The design for the Logo Period title sequence *Prince of Darkness* (1987) [Figure 6.1] produced at Pacific Title & Art Studio assimilates both *crediting* and *narrative functions*. The title cards are spacers presenting simple white type over black, implicitly understood in this montage as 'gaps' between parallel actions: they encapsulate these "in medias res" shots as a

Figure 6.1 Title cards intercut with shots in *Prince of Darkness* (1987)

prologue. The titles are ellipses between sub-sequences, a formal choice that substitutes for the more common cross-cutting. These title cards are not interruptions of *narrative function*: they provide a spacing out of events. These title cards become themselves an exposition of cause-effect (*syuzhet*) suggesting "meanwhile" and "later" without stating those words.

This same elliptical structure plays out more dramatically in the opening for the first episode of the TV program *Inspector Morse* (1987) [see Figure 1.5, page 11]. By employing the credits in an identical expository role, the cutting between title cards/opening scenes are 'gaps' that unite disparate shots/sequences. The interruptive effects of the crediting serve as syntactical breaks in continuity to signal changes of space-time. In both cases the extent of the "credit sequence" is marked by the duration of the theme music. For *Inspector Morse*, the progression of theme music keeps the audience oriented to the preliminary nature of this sequence as a prologue, signaling the conclusion as a change in tone. In contrast to *Inspector Morse*, the opening theme music in *Prince of Darkness* is so long that when the audience does eventually realize the background music *is*

theme music (i.e., the background to the opening titles), this recognition comes as a sudden shift in tone, a momentary disruption to the narrative as the credits conclude that draws attention to the artifice of theme music defining the title sequence.

Exposition in the Prologue mode more commonly proceeds through a minimization of the quantity and role for title cards at the beginning of the motion picture. This limitation on credits demonstrates the belief that the "drawing attention" to the constructed nature of cinema apparent in designs such as *Prince of Darkness* undermines the integrity of the *fabula*. This is a process of reduction that begins with the use of introductory pre-credits scenes that David Bordwell describes in films of the 1950s, as the transition between Studio and Designer Periods was underway:

> Here the film opens truly *in medias res*, with the credits presented only after an initial scene or two of story action. This practice began in the 1950s, possibly as a borrowing from television's technique of the 'teaser.' The effect of a pre-credits action was to eliminate the credits as a distinct unit, sprinkling them through a short action sequence that conveyed minimal story information (e.g. the establishment of a locale or the connecting of two scenes by a trip.) The postponement of the credits tacitly grants the narrational significance of whatever scenes open the film.[4]

The short action sequences he describes appear as the Prologue mode exposition in the Middle Phase opening for *Touch of Evil*, where the credits are superimposed over the live action in the long take that sets the mystery in motion. Legibility for credits was a traditional priority in title sequences. However, these elements are not necessarily connected to any particular expositional mode; the pre-credits opening "action scene" is equally familiar as preceding the Allegory mode sequences for the various James Bond films, coming before the films' elaborate, and spectacular titles. However, the progression Bordwell suggests is toward a reduction in the presence and role of credits at the start of the film, apparent in the dominance of *narrative function* during the title-card-only openings common to the Logo Period[5] following the 1977 success of *Star Wars*, and continuing into the present with designs that use visual effects to literally embed the credits within the "space" of the narrative action, in a diverse range of designs including *Batman Begins* (2005), *Easy A* (2010), *Sucker Punch* (2011), or *Deadpool* (2016).

The immediacy of the drama in the opening to Galo Make Canote's fully integrated logo for the Contemporary Period design *Sucker Punch* [Figure 6.2] happens through a reduction to a logo-only title card and an elision of the credit sequence entirely. Anything that reveals the cinematic artifice is detrimental to its elaboration; the world-on-screen demands precisely this immersion of credits into narrative. However, the justification for eliminating this 'opening threshold' is reflective of particular assumptions about the audience's engagement with the *fabula*, as film historian Casper Tybjerg notes

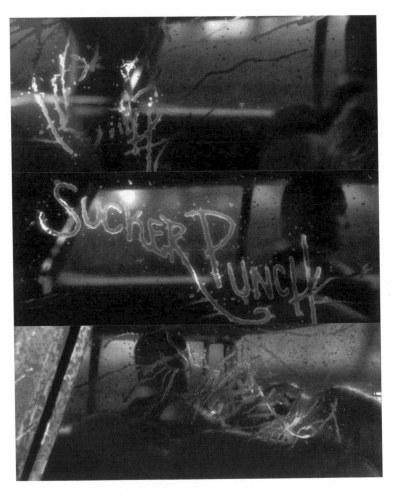

Figure 6.2 The title-card-only opening for *Sucker Punch* (2011)

in his introduction to *Limina/le soglie del film*, a collection of papers from the Italian conference on film paratexts in 2003:

[The conference description states] "the fictional world takes shape while verbal information is provided which reveal its artificiality, therefore putting at risk the fictional contract." This passage carries the assumption that there is some sort of inevitable tension between a fictional world and information about its creation, its status as an artifact; in other words, that the fictional world is an illusion and that credits and the like call attention to this, threatening to destroy the illusion. This assumption is a wide-spread one.[6]

Challenges to the presence of the titles—most notably in the atypical and highly abbreviated title sequence for *Citizen Kane*, and Welles' well-known arguments with Universal[7] about titles for another of his films, *Touch of Evil*—reflect the same assumption that credits interfere with the integrity of the narrative that justifies the reductive title designs for both *Star Wars* and *Sucker Punch*. This opposition to the identifications and other labels offered in the title sequence is more specifically a rejection of the *crediting function*, based in the assumption Tybjerg notes: the addition of peritext before "entering" the fictional realm is a challenge to the *fabula*—as if the audience could be unaware they are watching a motion picture! It fundamentally conceives of the audience as passive, that they do not actively engage, evaluate, and anticipate what they encounter on-screen and in the narrative; that the narrative identifications that make it coherent are not formed by the audience's web of expectations derived from past experience and requiring lexical expertise.

The distinction in placement between 'prologue' (start) and 'epilogue' (end) is incidental to the *narrative function's* interpretation as "in medias res" exposition; Galo Make Canote's design for *Sucker Punch* (2011) is a notable, extreme example of the same integration apparent in *Prince of Darkness*. This dominance of the *narrative function* common to the Prologue mode is of particular interest in *Sucker Punch*, not only because the main title card is literally embedded within the diegetic space on-screen, but for how the main-on-end credits [Figure 6.3] are handled as an epilogue that recapitulates the main themes of the drama. Aside from the photoreal animated title card that morphs into visibility from streams of water flowing over a car window, the start of the motion picture has an almost complete

Figure 6.3 Selected stills from the main-on-end sequence for *Sucker Punch* (2011)

absence of credits; in contrast, the conclusion has a complex, double main-on-end design. The two sections of this epilogue are joined by a fully rendered 3D title card logo as the transition between them. The first part is composed from title cards and a nearly vacant animated background of colored lighting effects; the second set of credits are an elaborate, literal song-and-dance routine providing a visible spectacle to accompany the extensive list of production credits.

Both main-on-end sections reiterate the motifs of performance and theatricality that appear throughout the narrative; the song-and-dance routine renders these motifs a literal part of the "scroll"—this epilogue integrates this main-on-end into the theatrical artifice of the narrative in a direct fashion. It provides a clear and immediate linkage

between the concluding peritext and the main text matching the shifts and repetitions of the *fabula*. While the *internal* organization of this main-on-end as a doubled sequence is unusual, it is simultaneously a typical instance of the Prologue mode when placed at the conclusion of the story as an epilogue.

More typical epilogue sequences provide information about what happened "next." This information is typically communicated simply through a series of texts, as in the Logo Period design *9 to 5* (1980), or at the end of each 'variation' in the Contemporary Period sequences for *Run Lola Run* (1998), where each character's fate is revealed on-screen. The use of intertitles accompanied by a still extracted from the narrative action commonly link the exposition to a particular character. A more complex intercutting of dramatic scenes appears in the Contemporary Period main-on-end design by David Z. Obadiah for *Paul* (2011) [Figure 6.4]. The same elliptical intercutting of credits with live action used in the opening titles to *Prince of Darkness* become a concluding epilogue. The alternation of elaborately designed main-on-end with a variety of live action scenes featuring the main characters' lives

Figure 6.4 Selected stills from the main-on-end sequence for *Paul* (2011)

"one year later." Cutting between live action and credits acts to replicate the montage employed during the narrative. This entire epilogue/montage proceeds while Olivia Newton-John sings the *Xanadu* (1980) theme song—reused as the concluding theme for *Paul*—thus separating peritext::text and simultaneously suggesting to the audience recognizing this quotation that the conclusion is a "a fantasy come true" for the two main characters. The narrative role of the Prologue mode in a main-on-end epilogue is no different than that of the introductory prologue—placement distinguishes *what* they communicate about the *fabula*, not their means of communicating it.

Realist Integration

The direct integration (and dominance) of the *narrative function* over the title sequence in the Prologue mode originates with a tendency to view the titles as disruptive to the fiction, to conceive of the audience as passively acted *upon* by the range of naturalism::stylization. The dominance of the traditional view of a passive audience justifies the rejection of the title sequence. The conception of the realist narrative as "fragile," easily challenged by the credits at the start of the motion picture, fails to acknowledge either the role of the audience in creating and maintaining this realist illusion, or the dynamic of peritext::text emergent in the titles' morphology and structure. Philosopher Juliane Rebentisch comments on this role in her study *Aesthetics of Installation Art*. The assumption of passive audiences surrendering their agency to narrative is frequently used to justify the "invisible" realism of commercial media:

> Like traditional dramatic theatre, conventional narrative cinema implies the idea that the time of the audience should converge, by virtue of empathic identification, with the time of the dramatic events—that the time of aesthetic experience should come to coincide with the film screening as the viewer focuses on the action represented (and less on its representation).[8]

"Realism" thus conceived requires the absolute opposition of *narrative* and *crediting functions*; the distinction between *actual* audience engagement and the *ideal* Rebentisch describes returns to the consideration of their dynamic and comingled relations in actual title sequences. In cases such as the Late Phase design for *The Holy Mountain*, the *crediting function* does not "impede" the action of the narrative—quite the opposite—it dominates it. The Brechtian rupture

offered at the end of the film is undermined by the credit scroll's *return* to exposition; precisely this assertion of fictionality prevents the fictional realm's capacity to "spill over" into reality. As both Rebentisch and Tybjerg suggest, the mere *presence* of credits serves to draw the audience *back* into the "time of aesthetic experience."

Rebentisch's analysis of the typical relations of audience to fictive world does not address title sequences, but does account for the Prologue mode's tendency to integrate and accommodate narrative exposition. "Eliminating the credits" can be recognized as the assumption that the title sequence disrupts narrative. Historically, this development is a general tendency toward the direct association of peritext::text equally apparent in designs such as the Designer Period *Touch of Evil*, Studio Period *White Zombie*, or even the Logo Period *Prince of Darkness*. The simplest variant of the Prologue mode fully integrates opening of credits and narrative, requiring the audience to ignore the separation posed by the *crediting function* to comprehend their development, thus rendering the distinction between the title sequence and the start of the *fabula* moot. In the severely curtailed opening titles of the Prologue mode, a main-on-end title sequence often appears at the conclusion of the motion picture, either as an epilogue, or using one of the other expository modes to recapitulate the main text; it is the same desire for a 'perfect' fictionality that appears to be 'reality' itself. For Prologue mode expositions, their position in relation to the rest of the narrative is predetermined, emerging from the cause-effect relations apparent in *syuzhet*—as with a forward or preamble in a book, all motion picture prologues are ostensibly concerned with "backstory"; the epilogue's presentation of "afterwards" is equally prescriptive of placement after the terminus of the narrative. The exposition's role in the development and elaboration of the drama means their position is set: openings *always* come first; they must begin the narrative to be *prologues* at all.

Because Prologues always directly introduce the *fabula*, this mode immediately reveals the paradoxes of paratext in cinema by prioritizing narrative links between the pseudo-independent paratext and the main text. Needing to resolve the assumed opposition of *crediting* and *narrative functions* historically limited the development of a close dramatic integration between the opening credits and narrative events. In the simple variants of the Prologue mode, these conflicts are not immediately apparent, but for the complex instances integrating the events of the story and the titles into contiguous whole—as when the narrative runs throughout the titles—paradoxes emerge precisely because the distinction between peritext::text is not marked.

In the Silent Period designs for *Stella Maris* (1918) and *Male and Female* (1919) [Figure 3.2, on page 50] the progression into narrative proceeds directly. The title cards introducing actors also provide character sketches about who they are, accompanied by short sequences that demonstrate their personality. This association of actors with their names is a common approach used throughout the history of title sequences, employed since the 1910s as a way to both identify actors and introduce their characters; these demonstrations, if they were independent of the *fabula*, would be examples of the Comment mode. Expository information conveyed by the Prologue mode is easily recognized because it provides essential narrative information at the start of the motion picture—most directly and obviously by using a scrolling intertitle. *Narrative function* is central to their interpretation, as film historians André Gaudreault and Timothy Barnard note in their article "Titles, Subtitles, and Intertitles: Factors of Autonomy, Factors of Concatenation":

> To be an *inter*title, a title card must not only be sandwiched between two image segments, but must bridge what came before (which it completes) and what comes after (which it announces). It must become an element of, I'll say the word, *editing*. For it is the very question of editing—that of passing from one scene to the next, of matching two "image packets"—that is explicitly brought into play by interposing title cards.[9]

Credits and *fabula* are not easily distinguished: in the Prologue mode, the relationship of text::image is part of a continuous flow of narrative, live action, and titles. The on-screen texts in silent films become part of how these opening sequences are edited—their formal role in both *Stella Maris* and *Male and Female* is an instance of David Bordwell's *syuzhet*—events that are constructive of narrative cause-effect. In *Male and Female*, the understanding of the child looking through each door's keyhole and becoming excited when he reaches Barbara Stanwyck, only to be caught peeping by the butler at the end of the scene is specifically a "micro-narrative sequence" that informs the viewers about each character in turn, but at the same time, it is not a pseudo-independent cut scene, but an exposition of *fabula*. These introductory events establish the characters and their relationships, but do so within a specifically narrative structure: the movement from exposition into narrative is direct. The shift from 'credits' to 'drama' is marked by the conclusion of theme music rather than visually on-screen. In the Logo Period opening to *Ghostbusters* (1984), the

build-up in pre-credits sequence flows directly into the opening dramatic scene of "Dr. Peter Venkman" (Bill Murray) conducting a parapsychology experiment on two students using an oversized deck of Zener cards. The title-card-only opening designed by Robert Greenberg appears on-screen for only twelve seconds, but the theme music lasts forty-five seconds, its duration identifying the "title sequence" even though the credits are only briefly on-screen.

Creating a direct continuity between the opening narrative shots and the development of *fabula* requires a clear presentation of cause-effect (*syuzhet*) during the title sequence. Even before it disappeared in the Logo Period, the Middle Phase of the Designer Period was experimenting with complex narrative integration that challenged the peritext's pseudo-independence. In Pablo Ferro's design for *Bullitt* (1968) [Figure 6.5] the opening montage becomes the title sequence—the replacement of standard cutting (montage) by optical compositing of shots-within kinetic typography/masks produces a revelational affect characteristic of rebus mode title cards.[10] The sense in watching this Prologue mode exposition is that it is specifically a search

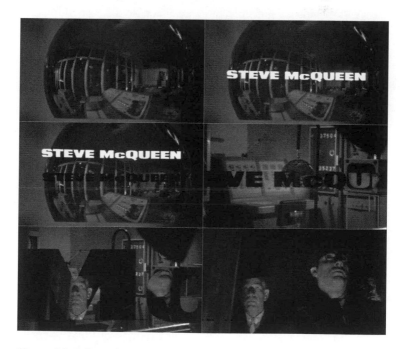

Figure 6.5 Selected title cards from *Bullitt* (1968) showing the motion of kinetic masks

within the space of this vacant, rather mundane, office. The compositing is handled in a similar way for each actor's name, producing a continuous flow that elides traditional editing. The "image packets" are instead connecting 'spaces' revealed through the progression of expanding masks. As the white text slides off-screen, exiting the shot, the kinetic typography in white leaves an optically printed "window" into a second image that provides the "cut" to the next shot as the mask expands to fill the screen. In place of editing, this optically printed composite suggests movement *into* or *beneath* these images. Each shot-transition suggests movement forward ('going deeper'): while the white typography slides off screen, the holes behind it grow larger, expanding—the titles dramatize their anticipatory role, a discovering of causally (*syuzhet*). As the sequence progresses, the audience is put in the position of detective or criminal: the office initially appears in the convex reflection of a lamp, countered in the next composited shot by a rogues gallery of rough looking men standing in the dark, their faces lit from below, seen en mass via a tracking shot. The sequence is dominated by *narrative function*. These men watching from outside the windows assault this office, breaking the glass and rushing in, guns blazing—an attack on a single individual who escapes by using a smoke grenade. Violence, smoke and mirrors, misdirection—the narrative question *what is happening?* dominates audience engagement with these shots as the credits recede from consideration. Answering the questions posed by this three-and-a-half-minute opening title/sequence organizes the *fabula*; it is essential narrative exposition for the drama that follows—the unknown causality expected of a mystery story.

The prologue to ITV program *The Prisoner* (1967) [Figure 6.6] remains constant for the majority of the seventeen episodes in the series. The rhythmic montage comes immediately at the start of every episode (including the first). The opening exposition is dominated by *narrative function*. It presents how "Number Six" (played by Patrick McGoohan, who also produced the series) was captured and imprisoned in "The Village," suggesting *why* without ever explicitly stating it. The titles for the premiere episode "Arrival" have a longer version of this narrative montage containing approximately 150 distinct shots in a two-minute duration. There is a greater emphasis in this initial montage on how he was captured and brought to the surrealistic prison for former spies than appears in the titles used for the rest of the series. No "real" names are ever provided for any of the characters, nor is his former job as a spy directly stated in any of the episodes in the series, even though it is clear from the dialogue and nature of

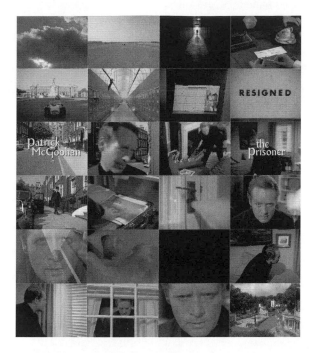

Figure 6.6 Selected stills from the opening montage in *The Prisoner* (1967)

various plotlines that his role as a secret agent is simply assumed; *The Prisoner* is the series McGoohan did during the final season of his very popular role as a spy in *Danger Man* (1960–1968), giving the series a strongly intertextual dimension. The montage is dominated by its *narrative function* to such an extent that without this opening the coherence of the individual stories is in question: this opening explains how "Number Six" became a prisoner; all the episodes conclude with an assertion that he has not escaped. The face of "Number Six" rises out from an aerial shot of "The Village," only to be stopped by prison bars slamming shut with a clang. The background to the end credits evokes a Surrealist, visionary space resembling the work of painter Konrad Klapheck, synchronizing the assembly of the same Columbia bicycle that appears as the background to the name badges worn in the village (an actual Columbia bicycle is in "Number Two's" office) to the theme music, an appropriate dramatization of the claustrophobia and paranoia in the series, reiterating subtle motifs from the mise-en-scene.

The development of the titles for the rest of the series after the premiere reveals the conflicts inherent to the Prologue mode: there are two distinct 'sequences,' the first an abbreviated version of the montage in "Arrival" is dominated by the *narrative function*, an opening that sets-up for the second half of title sequence that is dominated by the *crediting function*. The shortened montage appears in "The Chimes of Big Ben," the second episode, and is used in the rest of the series (except for three episodes that do not have any opening titles, including "Fall Out," which has a main-on-end sequence). The dislocation arises from how the theme music is used to mislead the audience about whether the credits have ended—or not. This initial montage is marked by the theme music by Ron Grainger; when it ends, there is interstitial music of a different character, suggesting the titles have concluded, creating a sense of dislocation for viewers that undermines their sense of certainty about how to interpret the sequence. The duplicity of the "conclusion" to the titles, a shift between a sequence dominated by the *narrative function* and a secondary one dominated by the credits corresponds to a shift between the story of *how* "Number Six" arrived in "The Village" and *what* audiences can expect from the story of his imprisonment there: there is no escape from the title sequence (or "The Village"). The lull in this opening is a "teaser"—when "Number Six" looks out his window, he discovers he is no longer in London, but is actually imprisoned in a "resort," whose exteriors were filmed at Portmeirion, a tourist resort modeled on an Italianate village located in Gwynedd, North Wales, a discovery marked by the return of the theme music, now accompanied by both a second montage from shots taken from "Arrival," showing him running around a vacant village while a voice-over dialogue with "Number Two" plays:

Number Six: Where am I?
Number Two: In The Village.
Number Six: What do you want?
Number Two: Information.
Number Six: Whose side are you on?
Number Two: That would be telling.
Number Two: We want information . . . *information* . . . *information!*
Number Six: You won't get it!
Number Two: By hook or by crook, we will.
Number Six: Who are you?
Number Two: The new Number Two.
Number Six: Who is Number One?

Number Two:	You are Number Six.
Number Six (shouting):	*I am not a number, I am a free man!*
Number Two:	Laughs

The voice of "Number Two" changes periodically, and there are some slight variations in the dialogue and its performance, a reflection of the series changing the actor in the role. These subtle shifts happen throughout the series, notable for its paranoia and surrealistic organization and the uncertainty this voice-over emphasizes. The final version of these titles alters the answer to "Who is Number One?" shifting the emphasis from in "You are Number Six," to "You are, Number Six," without changing what "Number Two" says.[11] In title sequences using the Prologue mode, concerns with the *crediting function* detracts from their narrative integration and the progression of *fabula*. The highly naturalistic realism of these titles grounds the more stylized and Surrealist elements of the narrative whose conclusion resembles a psychodrama from experimental film more than commercial television. The consistent and uniform naturalism allows audiences to focus on the action represented in the drama, rather than being concerned with its stylization: any deviation from this realist presentation draws attention to its form.

A similarly direct integration of the type Rebentisch implies in her analysis appears in the opening sequence for the Contemporary Period main title for *The Guardians of the Galaxy, Vol. 2* (2017). Created by director James Gunn, this opening sequence integrates narrative events in the background with type placements designed by Erin Sarofsky—but both are "upstaged" by the animated character "Baby Groot" dancing.[12] This opening intertextually links the main-on-end title sequence in the first film with its sequel. Title cards are always incidental to the *fabula*, but in this case, the narrative events are also rendered secondary to the tangential actions of the animation. While the duration of this title sequence corresponds to the length of the music—it ends when the speakers playing the theme music are crushed by Drax (played by "Dave Bautista")—the "upstaged" background scene continues without interruption. The conflict between crediting and narrative functions specifically emerges as the formative distinctions between title cards, shots, and sequences disappear.

The long takes in both *Touch of Evil* (1958) [Figure 1.8, page 23] and *The Player* (1990) [Figure 6.7] demonstrate the integration of narrative *syuzhet* with the title sequence. The events shown during these opening long takes are directly contiguous with the start of the narrative—the narrative continues after the credits end without interruption; in the case of *Touch of Evil*, the long take itself continues for

Figure 6.7 All the title cards in *The Player* (1990)

one minute longer than its role as a background for typography. These openings deny the separation of peritext::text by their direct elaboration of the story before any credits appear (but immediately after the production company logo). These problems are apparent to varying degrees in *all* Prologue mode designs.

Just as credits are incidental for the Prologue mode, so is the long take. The history of the long take in title sequences does not imply the realist, dramatic, and narrative meanings ascribed to it by film theorists André Bazin, Siegfried Kracauer, or Stanley Cavell in their arguments for realism; a long take appearing in *any* title sequence is *not* a signifier of *narrative function*. Instead, its role is standardized as a way to enliven the title design—long takes are in common use throughout the entire history of title sequences in Hollywood films, even when they just provide background imagery to the composited text. The Studio Period design for *Rumba* (1935) [Figure 3.4, page 56] has a (nearly) continuous camera run or long take distorted with a prismatic lens attachment, but it is *not* an instance of Prologue mode exposition. What is important to acknowledge about the function of long takes for title sequences is precisely this distinction from its other uses in narrative cinema—title sequences in Hollywood films use long takes for

their duration and continuous nature as an unedited shot, not for the more familiar dramatic mise-en-scene associated with them: *long* as in length of time between edits. The complex long takes in both *Touch of Evil* and *The Player* are exceptional, special cases of Prologue mode openings, atypical of how longs takes appear in title sequences. Lengthy camera runs have provided a background for typography since the Silent Period: some are live action, as in the first superimposed text::image composite in *Merry-Go-Round* (1923) designed by Fred Archer[Figure 6.8, LEFT-TOP]; others are static landscapes, such as in *Son of the Sheik* (1926) [Figure 6.8, LEFT-BOTTOM], or matte paintings, as in *Dracula* (1931) [Figure 6.8, RIGHT-TOP], while others have movement that does not distract from the typography, as with dancers in *Rumba*, or the approaching train in *Sleepers West* (1943) [Figure 6.8, RIGHT-BOTTOM]. In providing an uninterrupted background for the titling, long takes have a specific, material utility for the

Figure 6.8 A selection of title cards from title sequences using a long take to create a background for superimposed or composited crediting: (LEFT-TOP) live action in *Merry-Go-Round* (1923); (LEFT-BOTTOM) matte painting in *Son of the Sheik* (1926); (RIGHT-TOP) graphic logo-background in *Dracula* (1931); (RIGHT-BOTTOM) static live shot of the falcon statue in *The Maltese Falcon* (1941)

addition of text; many of the "superimposed credits" appearing in title sequences produced before 1940 are actually just a double exposure. By shooting the title cards as white-text-on-flat-black the credits could be printed over live action footage when making the answer print for distribution to theaters; this 'darkroom' process, known as "B-roll," was invented by the southern California photographer Frank Archer who was the head of the Art Titles Department at Universal Pictures from 1920 to 1925.[13] Although this B-roll technique was replaced by optical printing during the 1930s, the long take persisted in title designs into the 1970s even after it was no longer a technical necessity.[14]

The Prologue mode's immediate connections between peritext::text do not require the elision of its pseudo-independence. The dominance of *narrative function* enables a direct focus on narrative enunciation, making the distinction of titles from story a product of labeling and text-on-screen: *credits* (David Bordwell's stylistic "excess") separate the title sequence peritext from the purely narrative sequences in the main text. The "discontinuity editing" common to cut scenes does not preclude the presentation of narrative backstory in their arrangement, nor does it impact the semiotics of text::image in the title cards' design. The quantity, presence, or absence of title cards during these openings is a stylistic choice, not related to their expository role. Being dominated by the *narrative function* means the audience ignores the title cards as irrelevant, making the credit sequence "separate" from the opening narrative scenes only in the incidental sense that they are delineated by the presence of composited text and theme music. This integration allows a more complete illusion, assimilating the narrative presentation to the demands of realism. Because the traditional pattern of highlighting the *crediting function* places the typography in the central space on-screen, the fundamental conflict between *crediting* and *narrative functions* becomes obvious in Prologue mode designs during the end years of the Studio Period. The priority for legibility Merle Armitage discussed in 1948—the size and placement of credits—supercedes any concern with the typographic composition or the visibility of background imagery, limiting the *narrative function* until Fitzgerald resolved this conflict in 1958.

The live action long take that appears behind the title cards in *White Zombie* [Figure 6.9] makes the traditional opposition of *crediting* and *narrative functions* apparent. While there are only six title cards, their large typography partially or fully obscures the background long take, hiding the narrative actions that are already difficult to see behind the lettering that fills the *same* space on-screen. This problem is so important that the first scene, contiguous with the conclusion of these titles,

Figure 6.9 All the title cards in *White Zombie* (1931)

specifically explains their significance and clarifies what the typography hides: the long take shows a funeral at a crossroads, following "Voodoo custom." Without the characters talking about the events hidden behind the title sequence, their contents and *narrative function* would not be apparent, their discussion drawing attention to the conflict between these functions that the audience otherwise ignores.

Expository Texts

The associations created in the Prologue mode opening range from simple and direct statements of backstory that are immediately apparent, to designs where the distinction of opening credits and beginning of story are completely identical, as in *Touch of Evil*. For those simple beginnings structured as a "formal" presentation, even though they may employ a text to establish the narrative, their difference from the function of the preface in a written text becomes obvious when the roles and functions identified by Genette for the literary preface are compared to those of the narrative prologue in motion pictures such as *The Maltese Falcon* (1941), or in serials such as *Flash Gordon Conquers the Universe* (1940), or in later film-series such as *Star Wars* (1977). In each case, a scrolling text "narrates" backstory for the audience, an exposition whose relationship to the *fabula* establishes the horizons of expectation for the drama. This recurring feature of title expositions is a traditional use that transcends their periodization.

Voice over narration, introductory monologues, and on-screen texts that explain the events of the drama are a common part of Hollywood narratives. This function for opening texts is a recurring feature of their presence in feature films. The alternation of titles and tableaux in early films such as *Ali Baba and the Forty Thieves* (Pathé, 1902) or *Uncle Tom's Cabin* (Edison, 1903) invoke a narrative function through the identification of the scene following its narrative introduction.[15] The function of these texts as *headings* served a narrative role that will appear *between* the opening sequence and the first dramatic scenes, mediating the start of the *fabula* in later Silent Period designs such as the title sequence for *The Cat and the Canary* (1927) by Walter Anthony [Figure 6.10]. The stylistic and visual differences between the production credits that include the title card with the film's name, the cast listing marked "The Players," and the superimpositions that make the live action preamble that shows the two wills left behind by Cyrus West distinguish credits from preamble. Extracting the narrative from Anthony's design requires the audience to watch and decode the live action events shown using the same skills they will need for the rest of the film. The interplay of intertitles and shot-sequences make the role of these texts as explanatory elaborations that inform and direct the interpretation of the live action an explicit part of the enunciations they produce. The monstrous hand with fur and pointed nails that grasps and shows the audience the instructions written over the second will foreshadow the events of the drama without revealing their precise development.

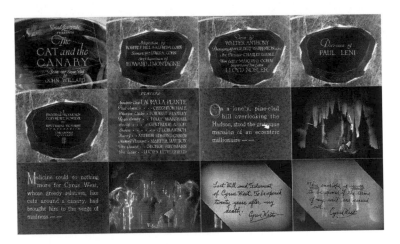

Figure 6.10 All the title cards in *The Cat and the Canary* (1927)

The distinction between the credits and the preamble narrative explicitly separates the crediting function from the narrative elements, enabling a clear demarcation of functions and roles in the opening sequence, dividing it into two particular elements/sections: the credits and the preamble. These differences are marked by fades that separate one piece from the other, as with the vertically scrolling text that follows the credit sequence in the Studio Period design for *The Maltese Falcon* (1941) [Figure 6.11]. This simple introduction acts as a "spoiler" for the mystery that follows (as does the background image shown throughout the title sequence). The narrative that scrolls up the screen is *not* "stage setting." The events described are "backstory" only in the technical sense that they occur before the narrative; their significance for the mystery contained by the film is precisely that they resolve it before it begins:

In 1539, the Knight Templars of Malta, paid tribute to Charles V of Spain, by sending him a Golden Falcon encrusted from beak to claw with rarest jewels —— —— but pirates seized the galley carrying this priceless token and the fate of the Maltese Falcon remains a mystery to this day —— ——

In presenting this "explanation" of the film's title, it also resolves one of the central mysteries of the narrative: *what is the mysterious package delivered to Sam Spade?* The assumption that audiences needed to have a clear explanation of what was going on in the story as early as possible reflects studio demands imposed on the production that

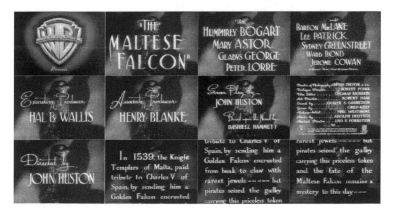

Figure 6.11 All the title cards in *The Maltese Falcon* (1941)

challenge and counter the dramatic potentials offered by ambiguity and mysteries that are gradually resolved during/as the narrative.[16] When this same explanation of the missing Falcon that is the central focus in the story is delivered by the "Fat Man," actor Sydney Greenstreet as the mastermind "Kasper Gutman," who explains the statue's significance to "Sam Spade" (Humphrey Bogart), the audience already knows this story from the "spoiler" contained in opening title scroll. Its inclusion in the diegetic mise-en-scene is redundant, a confirmation of what the viewers have concluded based on the information provided *before* the start of the narrative.

A similar "spoiler" effect appears in the science fiction film *Dark City* (1998) where "Dr. Schreber's" opening monologue (played by Kiefer Sutherland) that runs prior to the title sequence explains *all* the events happening in the drama. It is an expository monologue that, unlike both *The Maltese Falcon* and *The Cat and the Canary*, comes before the credits as an opening pan down from blackness into stars then through wisps of cloud in to a large, crowded city of tall buildings that ends with Sutherland's character on a causeway with his back to the camera:

> First, there was darkness. Then came the Strangers. They were a race as old as time itself. They had mastered the ultimate technology—the ability to alter physical reality by will alone. They called this ability "Tuning." But they were dying. Their civilization was in decline, and so they abandoned their world, seeking a cure for their own mortality. Their endless journey brought them to a small, blue world in the farthest corner of the galaxy. Our world. Here, they thought they had finally found what they had been searching for. My name is Dr. Daniel Poe Schreber. I am just a man. I help the Strangers conduct their experiments. I have betrayed my own kind.

The credits only begin after the city has fallen asleep, the cars and trains slowly coasting to a stop, rending this narrative and the live action sequence that it introduces as a protracted preamble that comes before the credits themselves. While this opening monologue does not explain the *future* events of the narrative, it does resolve the central dramatic mystery and conflict in advance of its presentation. The threatening and mysterious events that begin the story, and the disorientation experienced by "John Murdoch" (Rufus Sewell), are not shared by the audience; even the series of murders that are the focus of the detective's investigation are transformed by this initial

narration, their significance reduced to an unimportant distraction from the emerging (and "real") conflict that is the film's actual story about humans and their alien-captors; the "director's cut" released on video without this narrative demonstrates the terror *not* knowing this background information has—transforming the drama significantly; director Alex Proyas has explained the removal of this introductory monologue in the "director's cut" as a reflection of how it was only added because of instructions from the studio,[17] an addition that parallels the placement of the scrolling text in *The Maltese Falcon*. The impact that these opening narratives have on the events of the following drama link the Prologue mode's "preamble" to the *fabula* as a transformative device that cannot be regarded as independent of the story. In announcing the premise of each narrative, these textual preambles provide information that, because of its redundancy with revelations within the narrative, conflict with the development of the drama.

Unlike these motion picture texts, the six types of preface that Genette describes are all concerned with keeping the reader's attention— getting the reader to not only read the book, but read the *entire* book— an effect entire distinct from the "spoilers" appearing in sequences contained in both the Studio Period design for *The Maltese Falcon* and the Contemporary Period opening to *Dark City*—and in directing that attention in specific ways that contribute to how their interpretation of the text proceeds.[18] None of Genette's six roles is particularly important for the Prologue mode, or for any production where the audience has already paid before the show begins. Their application to cinematic paratexts is limited, but can be recognized as potential concerns for television programs—especially those on commercial television where the title sequence might become an opportunity to change channels and watch a different program; however, even in the cases of TV shows, the prologue created in a title sequence is focused on establishing narrative parameters that have a specifically informational role that renders them directly essential to the program that follows. The form the connections take is insignificant when compared to their degree of integration and fluidity of movement between *crediting* and *narrative functions*.

The title scroll contained in Dan Perri's influential opening for *Star Wars* (1977) that inaugurates the Logo Period has a specifically informational role [Figure 6.12].[19] The distinction between it and both *The Maltese Falcon* and *Dark City* is immediately apparent: the opening text scroll (the "crawl" that apparently moves out, into space) for *Star*

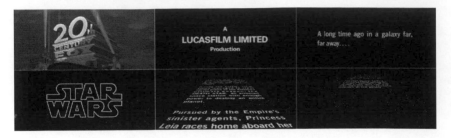

Figure 6.12 Stills showing the title scroll in *Star Wars* (1977)

Wars explains only the cause for the events shown immediately following this opening sequence:

> It is a period of civil war. Rebel spaceships striking from a hidden base, have won their first victory against the evil Galactic Empire.
> During the battle, rebel spies managed to steal the secret plans to the Empire's ultimate weapon, the DEATH STAR, an armored space station with enough power to destroy an entire planet.
> Pursued by the Empire's sinister agents, Princess Leia races home aboard her starship, custodian of the stolen plans that can save her people and restore freedom to the galaxy.

This is a narrative that misleads its audience—the stolen plans do not save "Princess Leia's" (played by Carrie Fisher) home world, but result in its destruction. In place of the more common introductory text that acts as a "spoiler," this opening sequence uses the narrative information to misdirect the audience, creating an expectation for events that do not happen. Knowledge of the "Death Star" gives an urgency to the drama that would otherwise be missing, creating tension in scenes—such as the decision by "Uncle Owen" (played by Owen Lars) to have the droid's memory wiped—that would otherwise lack it. The narrative function dominates the opening for *Star Wars* to the (almost) complete exclusion of credits. There are only three title cards after the studio logo, the identification of production personnel and cast are entirely absent from this design, facilitating a rapid movement into the development of the *fabula*. This immediacy emphasizes the mediating role of the narrative text proving a preamble for the drama's events. The closeness of the links between title sequence and narrative is different from other designs only in degree: the rapid shift from credits into drama has historical antecedents in

the integration of narrative events and credits in openings such as *Touch of Evil* (1958) or even the much earlier example of *White Zombie* (1931). The connection is not a result of the scrolling text, but of the proximate movement between these sequences and their introductory role in the opening scenes of the fiction itself.

The interpreted "transformation" of *credits* and *opening sequence* into *fabula* is an autonomous recognition, one that does not require a conscious action by the audience for its exposition to proceed as an integral part of the narrative. Narrative integration offers a broad range of linkages, some slight and others immediately apparent. The ideological assumptions about the idealized audience and their ability to parse the resulting work becomes apparent in the morphology and structure of these designs, refracted through the exposition itself. The average, idealized reader's engagement with the dynamic of peritext::text makes the distinct shifts between crediting and narrative functions into unitary, singular conclusions, when they are actually interpenetrating and converging aspects of the same ongoing interpretive action that identifies, then converts those details called *syuzhet* into *fabula*. No matter how apparently self-contained the title sequence is, understanding the exposition depends on the nuances of lexical expertise and the ambivalent play of recognition and expectation that guides *any* semiotic interpretation.

Notes

1. Brower, S. "Hollywood's Lost Title Designer," *Print*, vol. 65, no. 4 (August 2011), pp. 87–90.
2. Billanti, D. "The Names Behind the Titles," *Film Comment*, vol. 18, no. 2 (May–June 1982), p. 64; Tuchman, M. "Wayne Fitzgerald Interviewed," *Film Comment*, vol. 18, no. 2 (May–June 1982), pp. 66–69. See also "How to Bestow a Title," *TV Guide*, vol. 10, no. 29 (July 21, 1962), pp. 22–24.
3. "Pacific Title & Art Studio to Be Liquidated," *Variety*, June 8, 2009, http://variety.com/2009/digital/markets-festivals/pacific-title-art-studio-to-be-liquidated-1118004696/ retrieved July 7, 2017.
4. Bordwell, D., Staiger, J. and Thompson, K. *The Classical Hollywood Cinema* (New York: Routledge, 1985), p. 27.
5. Betancourt, M. *The History of Motion Graphics: From Avant-Garde to Industry in the United States* (Rockville: Wildside Press, 2013), pp. 223–228.
6. Tybjerg, C. "The Mark of the Maker: Or, Does It Makes Sense to Speak of a Cinematic Paratext?" *Limina/le soglie del film: Film's Thresholds*, ed. Veronica Innocenti and Valentina Re (Udine: Forum, 2004), p. 481.
7. Rosenbaum, J., Welles, O. and Bogdanovich, P. "Orson Welles' Memo to Universal: 'Touch of Evil,'" *Film Quarterly*, vol. 46, no. 1 (Autumn 1992), pp. 2–11.

8. Rebentisch, J. *Aesthetics of Installation Art* (Berlin: Sternberg Press, 2012), p. 187.
9. Gaudreault, A. and Barnard, T. "Titles, Subtitles, and Intertitles: Factors of Autonomy, Factors of Concatenation," *Film History*, vol. 25, no. 1–2 (2013), p. 90.
10. Betancourt, M. *Semiotics and Title Sequences: Text-Image Composites in Motion Graphics* (New York: Routledge, 2017), pp. 92–100.
11. White, M. and Ali, J. *The Official Prisoner Companion* (London: Hachette Book Group, 2009).
12. Cavna, M. "Guardians of the Galaxy Vol. 2 Has One of the Most Joyous Opening Sequences in Years," *Chicago Tribune*, May 9, 2017, www.chi cagotribune.com/entertainment/movies/ct-guardians-of-the-galaxy-vol-2-opening-sequence-20170509-story.html retrieved May 12, 2017.
13. Dawson, M. "Fred Archer: A Southern California Innovator," *LA's Early Moderns: Art, Architecture, Photography*, ed. Victoria Dailey, Natalie Shivers and Michael Dawson (Los Angeles: Balcony Press, 2003), p. 264.
14. Betancourt, M. *The History of Motion Graphics* (Holicong: Wildside Press, 2013).
15. Gaudreault, A. and Barnard, T. "Titles, Subtitles, and Intertitles: Factors of Autonomy, Factors of Concatenation," *Film History*, vol. 25, no. 1–2 (2013), pp. 85–86.
16. "Memo: Jack Warner to Hal Wallis," September 6, 1941, Warner Bros. Collection, File: 2056—MALTESE FALCON (1941) Story, Box: THE MALTESE FALCON quoted in K. D. Edwards, "Corporate Fictions: Film Adaptation and Authorship in the Classical Hollywood Era," dissertation, 2006, p. 335.
17. Blake. "Alex Proyas Interview—*Dark City* Director's Cut and More," *Screenanarchy*, June 24, 2008, http://screenanarchy.com/2008/06/alex-proyas-interview-dark-city-directors-cut-and-more.html retrieved May 12, 2017.
18. Genette, G. *Paratexts: Thresholds of Interpretation* (New York: Cambridge University Press, 1997), pp. 196–199.
19. Billanti, D. "The Names Behind the Titles," *Film Comment*, vol. 18, no. 2 (May–June 1982), p. 65.

7 Conclusions

The Paradoxes of Cinematic Paratext

Thus title sequences are marginalized within media studies. Gérard Genette's theory of "paratext" unambivalently refers only to those internal elements (text::image composites) identified with the *crediting function*, precluding their *narrative function* because his theory casts these elements "out" of the *fabula*. Low-level interpretations of title cards affirm this exclusion. Ironically, although paratext describes a range of materials and practices *around* feature films, television programs, and even video games, the ambivalence of relations between the title sequence and main text demonstrates the necessity for analysis. The common assumptions about their production, structure, and organization as a fundamental part of cinema challenge any attempt at theorization. Titles seem so obvious that they do not *need* consideration to understand. There is almost no theory concerned with title sequences and their relationship to narrative, even though they are often mentioned when considering paratexts in motion pictures, affirming a critical overlap and convergence between the historical film studies (often concerned with narrative films and the history of theatrical cinema) and its expansion/extension into both media and cultural studies.

The title cards themselves are always defined by their form as text::image composites that "label" production, personnel, and actors. This definition finds support in Genette's concept of paratext, especially in the separation of peritext::text that seems definitional for the title sequence. This seemingly unquestionable assertion of the title sequence as descriptive information supports the critical view of title sequences as a direct parallel to Genette's theory of paratext, while simultaneously denying the need for a more careful theorization since their function is precisely limited. However, this shift from literary

theory to motion pictures is productive of apparent paradoxes specifically when the "pseudo-independent" titles become a component in the exposition of *fabula*, a reminder that any uncritical transfer from one field to another is problematic. Paratext or peritext can only be unproblematically applied to those sequences that are wholly dominated by the *crediting function* to the exclusion of any narrative relationship. Such titles rarely appear in cinema. The recognition of "narrative" in a sequence of events (*syuzhet*) whose relationships construct the *fabula* is a product of lexical expertise. As the *narrative function* becomes a concern for title design and organization, this intratextuality reveals the assumption made by "paratext" that the title sequence is separate from the larger narrative construct.

The "classic" understanding of the title sequence always assumes it is located at the beginning of the film, appearing before the narrative itself. This title sequence is only a film opener (or occasionally conclusion). It indicates the parameters of the narrative without participating in narration, making its recognition and pseudo-independence obvious. The *crediting function* masks the possibilities for *narrative function*, making the distinction of peritext from main text seem inevitable and unquestionable. In Studio Period title sequences such as *A Message for Garcia* (1936) [Figure 7.1], the title cards' role as "label" is explicit; there is no potential confusion between their meaning as "opening identifier" that provides production information in the film title and the *fabula*. However, the titles for *A Message for Garcia* are an example of the Allegory mode: its implied connections are indirect, evoked by the stuccoed walls; the audience's comprehension of the architecture as an allusion to Cuba (and Latin America generally) depends precisely on their past knowledge and experiences. The titles act as a label, and as an anticipation of narrative defying their marginal placement, drawing these assumptive-openings into close proximity to the *fabula*, they are necessarily separated from/by their placement *outside*, mediating and distinguishing the beginnings of *syuzhet*. This linkage between the opening and the narrative requires a decryption to become evident. Its evocation of *place* only becomes apparent in retrospect as the narrative develops.

Genette's theory seems to produce an absolute distinction between the title sequence and the narrative events of the *fabula*. For critical analysis, the set of assumptions described by the *crediting function* mask the recognition and consideration of any *narrative function* a title sequence could perform in relation to the main text. Theories of cinematic paratext typically reify this exclusivity, ignoring the ambivalence and dualities of title sequences' enunciation. Difficulties for

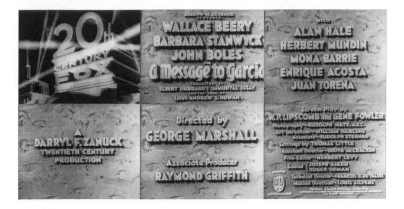

Figure 7.1 All the title cards in *A Message to Garcia* (1936)

paratext begin with how the *narrative function* entangles titles with both *syuzhet* and *fabula*. To remain a title sequence, it cannot engage in storytelling; yet the audience easily and fluently interprets both the *crediting* and *narrative functions* as parallel and ultimately converging engagements with the title sequence, a narrative role that creates an "excess" of signification to undermine and contradict the absolute distinction of title sequence and *fabula*.

Contra-Genette, the *crediting* and *narrative functions* are *not* antithetical, mutually cancelling actions, but parallel distinctions fluently engaged by their viewers: [1] as "label," the information presented comes from the main text, crediting its creation, and [2] as "narrative," the titles are subservient to the *fabula* of the main text. These ambivalent and overlapping roles reflect a state of information where what would otherwise be mutually exclusive potentials are simultaneously recognized and understood without difficulty. Even though the titles are wholly a reflection of the main text, at the same time they employ stylized imagery and audio-visual techniques reserved for transitions, dream sequences, or montages that condense time. These digressions from the realist main narrative establish the title sequence as a stylized enunciation, allowing the audience to readily identify the title sequence as a distinct internal unit apart from other sequences in the motion picture. This ease of separation remains constant across the history of title design, even when the credits are tightly integrated into the narrative in designs such as *Touch of Evil* or *The Player* where the opening long take/title sequence moves continuously from *crediting*

to *narrative functions* in a design that is *not* a pseudo-independent sequence within the motion picture as a whole.

Typography and Pseudo-independence

Understanding the title sequence as a pseudo-independent unit is a historical convention that gives it a special role—*liminal*—arising from its enunciative function as marking a distinction between the text as a whole and other texts coming before or after it. The size, style, and placement of typography has a determinate role in the articulation of intratextual relations. Motion pictures are organized by *sequences* whose lexical interpretation interfaces between lower and higher levels of complexity. The intratextual connections of peritext::text are the 'natural' progression of semiosis: higher-level sequences are composed from lower-level statements that organize découpage, articulated via editing, text::image composites, with musical cues through the synchronization, and using optical effects to identify transitions between parts in the continuous progression of moving images. Audience understanding is always an imposed, invisible causality that interprets *syuzhet* (events) and abstracts it into *fabula* (plot). The artifice that results from viewer engagement appears coherent only because the semiotics creating the higher-level *fabula* turn the lower-level intratextual elements into an invisible material masked by its role in more complex engagements. In reading, one does not consider the alternative arrangements of the individual letters that form the words; a similar effacement of the formative organization of imagery, sound, and text in motion pictures distinguishes between attention to narrative content, and attention to formal assembly.

Because the traditional approach to title design begun in the Silent Period highlights the *crediting function* by placing the typography centrally on-screen, any engagement with narrative was understood as diminishing the labeling and crediting roles for title sequences. The later conflict between *crediting* and *narrative functions* emerged in the Designer Period from an assumed opposition of functions. Affirming the distinctions of peritext::text limits close dramatic integration of title sequences and narrative events, as film historians André Gaudreault and Timothy Barnard explain about early film:

> We should remember that, because most films lasted no more than a minute in length, people working in kinematography had to wrangle with a true plethora of film strips. We should also remember that, given the brevity of each picture, a film screening

was of necessity made up of several such pictures. Each picture was thus decked out with a unique heading to make it possible to distinguish it from the many other views on the market. The heading in question also made it possible to give a quick idea of the picture's content, to construct programs, and, on a poster, to give the customer a sense of the particular qualities of the program on offer. The title given to each film carried out these functions splendidly.[1]

Their description of "titles" during the Early and Silent Periods precisely illustrates both the *crediting function* identifying production and its foundational role as *peritext*. The problem of integration with the narrative is the question of *how* autonomous the title sequence is—its pseudo-independence—a false conflict with being a "label" once the credits start performing narrative roles as well. These roles are conventionally separated from the narrative progression, but as Gaudreault and Barnard note, the shift to longer productions (culminating in the feature length film) progressively attenuates the role of credits as label, adding narrative roles for typography prior to the introduction of synchronized sound in 1927. The *narrative function* in title sequences such as Walter Anthony's design for *The Cat and the Canary* (1927) links peritext::text and continues to be a focus even after the "Talkies" begin: the audience integrates the typography as part of the "opening" to the narrative. Title sequences in films such as *White Zombie* (1931) are "independent" of the narrative only because of the theme music and how the on-screen text obscures the visible action. This traditional model for type placement forces an engagement with its lexical content, unquestionably separating the title sequence from the rest of the story. This morass of elements enables the higher-level distinctions of credits and narrative as specific, independent parts, but it does not preclude their simultaneous engagement or recognition.

Historically, the *narrative function* exists outside of and parallel to the *crediting function*, linked by their semiotic role within the motion picture as a whole. The historical importance of the Designer Period, apparent in designs by Saul Bass such as *The Man with the Golden Arm* (1955) and Wayne Fitzgerald's *Touch of Evil* (1958), arises from how these expositions resolve the assumed conflict between what the Studio Period understood as incompatible *crediting* and *narrative functions*. Designer Period sequences such as the Modernist, reductive titles in *The Man with the Golden Arm* prioritizes the graphic composition. The use of the International Style challenges the established conventions of

type placement and visual form in Hollywood, minimizing all the other visible elements so the typography dominates in spite of its smaller on-screen size, eliding the potentials for a direct narrative connection entirely. Fitzgerald's resolution is more easily assimilated by the traditions of Hollywood, and enables a more complex intratextual connection between sequences. The placement of typography in *Touch of Evil* accommodates the traditional size and prominence for on-screen text by locating voids in the screen composition ("type hole") allowing the addition of large, superimposed title cards as counterpoint to the narrative action. Both appear on-screen together in *Touch of Evil*. Credits are visible without interfering with the background live action. These designs maintain the pseudo-independence of the title sequence, but employ radically different design approaches to establish its separation and pseudo-independence from the narrative.

The ideological aspects of pseudo-independence are masked by this apparently autonomous status as peritext: ideology proceeds as an inherent assumption, beyond question or consideration precisely because the organization of the title sequence shifts between the isolation of *crediting function* and the invisible integration of *narrative function*, their interaction displacing other meanings from consciousness. The dynamic of naturalism::stylization affirms the same erasure of ideology: understanding cinematic realism as/in creating the mere appearances of everyday life, the phenomenal world as it appears to our senses is an ideology that masks the particulars of *which* depictions compose these "mere appearances." The title sequence is an essential mediator of audience interpretations: an instruction about *how* to understand the motion picture, asserting a "passive" audience engagement, one that accepts the depictions without question. This role for the titles establishes the appropriate ways for the audience to interpret: these openings are a statement discouraging oppositional challenges to the established lexical codes. Intratextuality unifies this construction of peritext::text, giving its development and progression a coherence as an autonomous *fact* about how the world is organized, in the process reinforcing the particular ordering on view, affirming the distinction between fiction and reality that the conclusion of *The Holy Mountain* attempts to challenge. Any recognition of realism as artificial potentially demystifies its superficial lack of articulation and construction: the titles enable the assertion of the work as "mere appearance" while making the ideology of that presentation unquestionable.

The Ideology of Naturalism::Stylization

Hollywood has viewed the credits as a 'distraction' for decades, an interruption interfering with the dramatic realism of the motion picture. This conception can be seen in the ideological "force" of realism that promotes the elimination (or minimization) of the title sequence to start the *fabula* immediately. However, the 'invisibility' of titles has been an ideal for commercial cinema since the Silent Period, as the film historian and documentary theorist Paul Rotha observed in 1930: "a well-titled film is one in which the titles harmonize with the visual images so perfectly that their presence *as titles* is not remarked."[2] The *crediting function* for openings cannot be avoided. Since the title sequence conventionally signifies the start/conclusion of the narrative, the role of narrative in title sequences is always already a given, unavoidable because narratives *must* begin and end. The conception of text on-screen as an abstraction, *stylized*, explains the elided title sequence in motion pictures such as *Sherlock Holmes* (2009) [Figure 7.2] that leaves only the required credits that start the story, the production company logos, but embeds them within the diegetic space on screen; an elaborate main-on-end designed by Danny Yount comes at the conclusion, providing a dramatic ending beyond what appears in the narrative. It is a formal construction guided by the ideological concerns of realism. The attempt to "disappear" the credits into the narrative demonstrates a desire to produce motion pictures comparable to reality, able to displace lived experience and in the process make its idealized fantasy real.

How the audience understands the peritext::text distinction when watching any title sequence is *not* an either/or opposition. The propositional conflict between peritext::text makes the degree of realism the critical focus, conceiving of the audience as passive, easily manipulated, uncritically accepting and embracing whatever they encounter in the motion picture, the ideological and political aspects of traditional viewership makes the manipulated complicit with their own manipulation, but powerless to challenge it, and possibly even unwilling to consider it is happening. It reifies this historical assumption that audiences are *not* sophisticated readers consciously choosing their critical or uncritical engagements with the text. Such a passive conception of viewership is incorrect. The audience interprets these designs as part of a state of information where meaning develops from the lower-level découpage. These articulations form the title sequence as a particular enunciation in the motion picture as a whole. The range of naturalism::stylization is another lower-level marker

Figure 7.2 Logo graphics embedded in the on-screen space of *Sherlock Holmes* (2009)

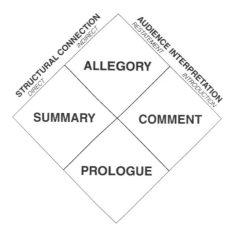

Figure 7.3 Title sequences employ four expositional modes to organize their narrative function. These different types depend on both a *structural connection* of paratext::text, and an *audience interpretation*. The various combinations possible for these paired potentials are displayed in this truth table matrix

for these same issues of *narrative function*. How closely integrated peritext::text are determines whether the audience will interpret the title sequence as a distinct section, as an introduction flowing into the narrative, or as entirely absent. The relationships between these sequences identify the ideological dimensions of realism::stylization as an interpretive constraint.

Audience engagement and structural organization interact to link enunciation and ideology via narrative semiosis [Figure 7.3]. The statement posed by the credit sequence cannot be disregarded as anterior or extraneous to the elaboration of *fabula*. The Allegory, Comment, Summary and Prologue modes are created by the necessary and sufficient conditions of [1] the structural connection between the title sequence and the narrative (an opposition of direct::indirect linkages) and [2] how the audience interpretation of the *fabula* as suggested in the title sequence (as the opposed pair introduction::restatement). Titles are the *literal* beginning or ending of the film narration, as the scrolling credits at the conclusion of *The Holy Mountain* demonstrate by negating the Brechtian rupture posed by Jodorowsky's final fade to white. The titles assertion that the "film is only a film" is ideological. It negates this Brechtian rupture that *violates* the realist (bourgeois) ideology, assuming the passivity of its audiences, demanding 'entertainment' whose contents and meanings are safely contained, and once separated, remain distant from life.[3]

The intratextual connection between title sequence (peritext) and main text reveals how the semiotic engagements of "innocent" and "sophisticated" viewers[4] produces these distinct units of exposition; the simple and complex variants of these four modes correspond to different potential interpretations of *narrative function*. The simple forms of each mode tend toward an immediate recognition and develop from an unproblematic morphology and structure: the associated narrative elements are readily apparent, requiring a minimum of prior knowledge to identify them within the title sequence. The simple variants, due to their explicit construction, appear so immediately comprehensible and their connections to the narrative are so obvious they do not appear to require theorization or analysis. The complex modes, in contrast, develop explicitly from "sophisticated" audiences using their established, specialized knowledge about the narrative to recognize those *events* in the title sequence. This use of *external* recognitions—whether intertextual, or simply intratextual, is irrelevant since they are outside the pseudo-independent sequence—draws attention to the incompleteness of enunciation and the determinate role that audience engagement has in *all* narrative semiosis.

The *indirect* modes of association both share an ambivalence in relation to the narrative that makes the "sophisticated" engagement central to their elaboration as *fabula*: the Allegory mode specifically depends on audience recognition of an *excess* to their symbolic presentation that links the title sequence with the narrative; the Comment mode requires the audience to *already* know the story for its statements about the *fabula* become coherent. These indirect interpretations transform ideological considerations into symbolic form. Comment mode designs act as an indirect introduction, without the ambivalence common to allegorical constructions. "Symbolic" meanings reveal the fractal repetition between low-level identifications of symbolic meaning (the rebus title card), the mid-level pseudo-independence of the title sequence, and the higher-level connection of title sequence to narrative productive of *fabula*. These expositions emerge from the combination of rebus mode title cards and synchronization to articulate the additional, hidden signification that defines their indirect connections to narrative. Only a conscious decision by the audience, prompted by the recognitions of rebus mode title cards, can transform either Allegory or Comment mode designs into an immanent engagement with the *fabula*. Distinguishing the Comment mode from the Allegory mode is more than a difference in emphasis and organization: it makes a *statement* about the narrative without specifically identifying *what* those contents are.

The *narrative function* dominates the *direct* modes, mediated by the viewer's understanding the title sequence as a restatement of the story, or as its beginning—whether the title sequence is a self-contained, pseudo-independent unit, or integrated with/into the progression of *syuzhet*. The dynamic between realism::stylization is a literal constraint on these designs, making their ideological content into their material form. Summary mode encapsulates the narrative as a cause-effect sequence that cannot be interpreted as "backstory." Audience understanding of the Summary mode is determined by title placement, typically either beginning or ending the motion picture. This location-dependence does not *introduce* the *fabula*. It creates a superficial misconception of these designs as "spoilers" (anticipation) or "nostalgia" (recapitulation). In contrast, Prologue expositions are integrated into the narrative immediately, typically as specifically *openers*, as the (literal) beginning of the *fabula*; when placed at the conclusion, Prologue modes are understood as "epilogues." Their narrative function makes the ideological heritage of nineteenth-century melodrama, the attempt to realize a total illusion, a mythic, total cinema, readily apparent in their design.

Connective interpretations act to elide the narrative distinctions between peritext::text, unifying the production. Both direct and indirect expositions describe a range for *narrative function* in title sequences. The elaboration and development of *fabula* within the title sequence is a commonplace element of commercial media production. Realism::stylization apparent as the *crediting function* enables a *formal* distinction from the rest of the motion picture that masks its ideological content; the dominance of *narrative function* is also a dominance of *syuzhet*, apparent from the essential narrative information the titles provide. The historical development of the Prologue mode makes the ideological dimensions of realism::stylization emerge in the demand for an immediate connection to the *fabula*, an easing into or out of the story. This role for titles as a component of the naturalism shown on-screen has been the foundational concern of such designs in Hollywood films since the distinct roles for intertitles and text-on-screen developed in the 1910s from the earlier "cinema of attractions."[5] The distinction between the title sequence and the other sequences within the narrative demonstrates the enduring power of these realist aesthetics for commercial motion graphics.

The implicit demand that audience engagement unquestionably accept the contents of realist depictions is neither simple nor readily explained by the passive::active opposition that gives criticism a privileged position. Conflicts over and between credits and story—

historically apparent in the limitations on *narrative function*—reveal the assumed challenge of the title sequence as interrupting the illusion of life projected on-screen. Those designs where the title sequence is minimized at the start and maximized as a spectacle at the conclusion (redressing any missteps in the narrative finalé) are assertions of a specifically realist ideology that affirms its established order through the narrative events of the fictive world on screen.

Titles establish "unity" by asserting established lexical codes as the only appropriate and correct way to interpret the motion picture. Thus this ideological critique ultimately becomes familiar: the ways realist ideology develops *in* the title sequence reflects the same development of ideology in realism generally. The novelty of this analysis lies with the distinctions arising from *how* ideology organizes its material support in peritext::text dynamic. Realism is an ideological constraint informing the design of titles, governing their placement, significance, and role in the narrative itself. It offers narrative intelligibility as a pure enclosing of "life" as a series of unalterable formulas that obscure their arbitrary nature with the appearance of necessity. They cannot be another way. In creating a world, cinematic realism attempts to make depiction into fact.

Notes

1. Gaudreault, A. and Barnard, T. "Titles, Subtitles, and Intertitles: Factors of Autonomy, Factors of Concatenation," *Film History*, vol. 25, no. 1–2 (2013), p. 83.
2. Rotha, P. *The Film Till Now: A Survey of the Cinema* (London: Jonathan Cape, 1930), p. 298.
3. Getino, O. and Solanas, F. "Towards a Third Cinema," *Afterimage*, no. 3 (Summer 1971), pp. 16–35.
4. Maltby, R. "A Brief Romantic Interlude: Dick and Jane Go to 3 1/2 Seconds of the Classical Hollywood Cinema," *Post-Theory: Reconstructing Film Studies*, ed. David Bordwell and Noel Carroll (Madison: University of Wisconsin Press, 1996), pp. 438–439.
5. Gaudreault, A. *Film and Attraction: From Kinematography to Cinema* (Chicago: University of Illinois Press, 2011).

Index

Printed and bound by CPI Group (UK) Ltd, Croydon, CR0 4YY

22/10/2024

01777627-0005